FROM ASCII ART TO COMIC SANS

FROM ASCII ART TO COMIC SANS

TYPOGRAPHY AND POPULAR CULTURE IN THE DIGITAL AGE

KARIN WAGNER

THE MIT PRESS CAMBRIDGE, MASSACHUSETTS LONDON, ENGLAND

The MIT Press would like to thank the anonymous peer reviewers who provided comments on drafts of this book. The generous work of academic experts is essential for establishing the authority and quality of our publications. We acknowledge with gratitude the contributions of these otherwise uncredited readers.

This book was set in ITC Stone and Avenir by New Best-set Typesetters Ltd. Printed and bound in the United States of America.

Library of Congress Cataloging-in-Publication Data

Names: Wagner, Karin, 1959– author.
Title: From ASCII art to Comic Sans : typography and popular culture in
 the digital age / Karin Wagner.
Description: Cambridge, Massachusetts : The MIT Press, [2023] | Includes
 bibliographical references and index.
Identifiers: LCCN 2022048751 (print) | LCCN 2022048752 (ebook) | ISBN
 9780262546140 (paperback) | ISBN 9780262375214 (epub) | ISBN
 9780262375207 (pdf)
Subjects: LCSH: Type and type-founding—History. | Graphic design
 (Typography)—History.
Classification: LCC Z250.A2 W34 2023 (print) | LCC Z250.A2 (ebook) |
 DDC 744.4/7—dc23/eng/20230113
LC record available at https://lccn.loc.gov/2022048751
LC ebook record available at https://lccn.loc.gov/2022048752

10 9 8 7 6 5 4 3 2 1

CONTENTS

ACKNOWLEDGMENTS

I am indebted to a number of persons and institutions for supporting me in my work for this book. Without the grant from the Ridderstad Foundation for Historical Graphic Research, this work would not have been possible.

At three seminar series at the University of Gothenburg—"Visual Cultures," "Language in Society," and the "DH Seminar"—I had the opportunity to present my early ideas for the project. I would like to thank the participants of these seminars for their valuable comments and advice. I also owe thanks to the participants at the Fourth Digital Humanities in the Nordic Countries conference at the University of Copenhagen who viewed my poster and engaged in a discussion about popular and unpopular typefaces.

Images play an important role in this book, and I would like to thank Penny Ahlstrand and Massimo Petrozzi at the Computer History Museum for helping me find images, granting permission, and sending me images from the museum's collection. There are also other museums and archives and their staff whom I would like to thank: Peter Amstein at the Connections Museum, Anna-Lena Segestam Macfie at Bohusläns Museum, and Stefan Brännwik at Uddevalla Industrihistoriska Förening.

Most of the images I have used do not reside in an archive, so I have reached out to a number of artists, designers, collectors, private persons, and companies that have allowed me to use their images. Many thanks go to David Ahl, Bertil Ankarberg, Jahanara Chaudhry, Dave Combs, Holly Combs, Chris Flack, Ng Chon Han, Jan Kaestner, Jerry Ketel, Brad Kvederis, Jens Lutz, David Pearce, Marc Ratner, Steven Stengel, Terry Steward, and Marc Verdiell. A special thank-you goes to the following persons,

who, in addition to granting me permission, have also provided me with images: Stephen Coles, Patric Jansson, Shelby Jueden, Klemens Krause, Zuzana Licko, Emmanuel Madan, Sang Mun, Peter Olofsson, Bengt Olsen, Ed Ruscha, Johannes Wagner, Matt Yow, and Francine Yulo.

I am also grateful to the interviewees who were willing to participate in the project and supplied me with valuable information and stories.

At the MIT Press, I would like to express my warm thanks to acquisitions editor Noah J. Springer, assistant editor Lillian Dunaj, associate managing editor Deborah Cantor-Adams, and manuscript editor Rosemary Winfield. I am also thankful for the input I received from the three reviewers.

I dedicate this book to the memory of my father, Carl Jönsson, who learned the craft of lettering in the 1950s. He introduced me to the world of art and design and was my number one supporter.

1

INTRODUCTION

In the opening titles of the political thriller *Three Days of the Condor* (1975), a young female employee is seen tending to a state-of-the-art computer at a clandestine Central Intelligence Agency location where literature is analyzed in order to uncover plots relating to CIA operations. While she inspects scans and changes tapes, the opening credits run across the screen. By presenting the computer and its functions to the audience, she also presents a major theme of the movie. The choice of the typeface Computer for the titles underlines the importance of computer technology for the activities of the CIA. Movie titles are generally one of the main devices used by filmmakers to set the tone of a film and prepare the audience for what is to follow.[1] The Computer typeface has its origin in a machine-readable font developed for bank checks in the 1950s. The engineers who invented the font probably never dreamed that it would one day be used in film titles and exploited by the entertainment industry. This kind of displacement of use and context of typography in a time of rapid technological change is the overarching subject of this book.

Since Gutenberg invented the movable-type printing press, a number of technical innovations have changed the conditions for typography. This is not to say that the art of typography has passively submitted to new technology. On the contrary, typography and typographers have paved the way for technology by design innovations. This evolution has not always gone smoothly and without friction. The four typographical phenomena presented in this book highlight the cultural clashes that have occurred between the emergent computer technology and the traditional field of typography—the nerdy practice of making images out of letters, the strange-looking machine-readable typefaces, the poor-quality

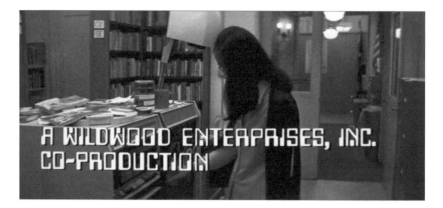

Figure 1.1 Opening titles from *Three Days of the Condor*, Sydney Pollack, 1975.

letters of dot matrix printers, and the contempt directed against the type-
face Comic Sans. Together they form a picture of how technologies devel-
oped for a functional purpose can find their way to popular culture by
being used in ways that are unintended and unforeseen by the original
creators. The four phenomena illustrate in many ways how letters, type-
faces, and printers are not supposed to be designed or used. In contrast to
postmodernist designers, they appear to have broken the rules not delib-
erately but rather through ignorance, unawareness, and functional neces-
sity.[2] Still, these marginal and somewhat quaint typographic phenomena
have made a non-negligible cultural impact.

My ambition with this book is to tell the cultural history of these
phenomena and provide new insights into typography, computing, and
popular culture by adding pieces to the puzzle of their joint history. Mate-
rial, visual, and aural aspects of text and typography from the 1960s to
the present time are taken into account in order to put these phenom-
ena and the trajectories they have followed in a broader cultural context.
Typography is placed in an expanded field that extends far beyond the
printed page into the modes of communication and publication afforded
by the internet.[3] The book is intended to be a contribution to the fields of
visual studies, science and technology studies (STS), and popular culture
studies. I envision an audience of students and scholars in these fields
and perhaps also in design history, media history, type history, and the
history of computing.

What motivated programmers to make images out of letters and create art out of the American Standard Code for Information Interchange (ASCII)? To what purposes were the images put, and in what contexts were they displayed? Why did engineers distort the form of numbers and letters to make them machine readable, and how were these typefaces reused in popular culture? Why does the dot matrix printer technology, which nearly disintegrated letterforms, evoke fond memories among many of its users? How did the hatred against Comic Sans emerge, and what metaphors and rhetorical devices are used in the discourse about the font? I look for the answers to these and other questions by analyzing social media discussions, magazine advertisements, printer manuals, scientific illustrations, as well as company logotypes, book covers, films, and artworks. The reader is taken along on the journey with a wealth of examples from the rich material that still exists on the internet and that is inherently ephemeral in nature, as well as from sources from the pre-internet era.

During the time scope of the study, computing underwent several transformations. The four phenomena have been chosen to be in line with important phases in this development. Chapters 2 and 3, on ASCII art and machine-readable typefaces, play out in the 1960s and 1970s, when huge computers were operated by professional staff and kept out of reach of regular users. Chapter 4, on dot matrix printers, is set in the beginning of the personal computing era that took off in the 1980s and put computers and printers into the homes of a great number of people who were not necessarily computer nerds. By the time we reach chapter 5, about the typeface Comic Sans, we are in the mid-1990s, when the World Wide Web was introduced and internet communication started to gain a broader societal impact. The unwieldy calculation tool of the mainframe era had become a handy gadget that fit into the pocket of the common citizen. Although the book has a chronological structure, my purpose is not to sustain the idea of historical progress. On the contrary, an important reason behind my choice of phenomena and the way they are contextualized is to counteract the idea of technological determinism. That there is no linear progress toward better technology is one of the tenets of media archaeology, a perspective that I return to below.

From a typographic point of the view, the possibilities for the display and printing of text were very restricted and rigid in the beginning of the

digital era. Line printers, which had only one set of (capital) letters, were not meant for making images, but nevertheless ASCII art arose despite, or perhaps thanks to, the limitations. The flexibility increased with new printing devices—notably, the dot matrix printer that made it possible to print text in bold or italic and in different sizes. When desktop publishing entered the consumer market, a large number of typefaces became available. Some programs even made it possible for users to design personal typefaces. This development led to a loss of control over the typographic sphere that was once the privilege of educated typographers and type designers. The technical development enabled many more people to try their hands at graphic design, and some thought this led to the degeneration of a craft with proud traditions. The new possibilities opened up by the availability of personal computers and internet communication were not only seen as blessings; they were also used for spreading what was perceived as bad, potentially dangerous design. When machine-readable typefaces were designed for the purpose of facilitating bank administration in the 1960s, it was one of the first steps on the path toward the computer vision and facial recognition that computers are capable of today. The threat of the surveillance society loomed large already in the public debate in the age of mainframe computers, and this debate is persistent and continually being fed by new technical developments.[4]

REFLECTIONS ON MY POSITION AS A RESEARCHER

I am writing this book in my double capacity as art historian and systems analyst. Before I became a researcher, I took a bachelor's degree in informatics and worked as a programmer and systems analyst in the 1980s and 1990s. This double experience has given me a unique vantage point from which to look upon the development of text and typography in the digital age—first from within the information technology (IT) industry and then as a visual culture researcher. I learned programming in Cobol on a mainframe computer using punch cards and received program listings on fanfold paper delivered to me in the reception area of the computer center of the Swedish university I attended. I wrote my bachelor thesis with the help of a text editor meant for coding and later taught researchers in the humanities how to take advantage of the early word processors,

despite the fact that the programs and the printers could handle only the letters in the English alphabet. German umlauts and Polish diacritical marks were deemed unnecessary for products primarily intended for the American market.[5] We tried designing our own fonts with the program Fontographer, but it proved too time-consuming for our purposes. When the World Wide Web took its first tentative steps into public life, we were back to square one concerning graphic design, and I had to find ways to work around the limitations of the new medium when designing the first website for the faculty where I worked. I later wrote my doctoral thesis in art history and visual studies on digital photography, and digital visual culture has subsequently been my main research interest.[6]

MEDIA ARCHAEOLOGY AND THE LACUNAS IN HISTORIOGRAPHY

This is essentially a media archaeological inquiry, in that it revolves around some phenomena that would otherwise risk being omitted from history, phenomena that might appear quaint but that have the potential of providing a different perspective on mainstream history.[7] This meta-phorical use of archaeology can be traced back to Michel Foucault's *The Order of Things: An Archaeology of the Human Sciences* and *The Archaeology of Knowledge*, where he outlines his method to examine history as a set of "discursive formations," contesting the idea of a grand scheme of history.[8] In media archaeology, the attention is turned as much to physical artefacts as to discourse. As media historian Erkki Huhtamo and digital culture scholar Jussi Parikka state in the introduction to their book *Media Archaeology: Approaches, Applications, and Implications,*

On the basis of their discoveries, media archaeologists have begun to construct alternate histories of suppressed, neglected, and forgotten media that do not point teleologically to the present media-cultural condition as their "perfection." Dead ends, losers, and inventions that never made it into a material product have important stories to tell.[9]

In the fields of computing and typography, as in most other fields, history is usually smoothed out to avoid aberrations and marginal phenomena that do not fit into the grand narrative based on the most important figures and the greatest achievements. In order to be included into the history of typography, one needs a name, certainly if one is a typeface,

and some of the typefaces in the early history of computing are rather anonymous. Other typefaces have made a name for themselves but have become notorious, like Comic Sans. Labeled as a "loser," a typeface can receive much attention in public discourse but still be neglected in the writing of history. The selection process I used for finding appropriate cases was based on a number of criteria. First, the cases should be in the overlapping area of the three fields typography, computing, and popular culture, as illustrated by the center area in the diagram in figure 1.2.

In addition, the case should have

1. fallen outside the canon,
2. been neglected in historiography or given sparse attention by research,
3. been subject to displacement of use and context, and
4. fallen between two stools discipline wise.

Things that have been left out of history do not necessarily form a homogeneous group. The selection that emerged from this process is diverse, and I do not claim that the chosen cases have any formal qualities in common. Comic Sans, in particular, might be regarded as an outlier and forms a contrast to the other cases, which are from earlier decades and have connections to obsolete technology. Comic Sans is from the 1990s but still is very much part of the contemporary (post) digital landscape. It is the most prominent digital-typography pop culture example from this millennium, and although it has received a considerable

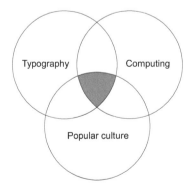

Figure 1.2 The area of study.

amount of media attention, not much research has been devoted to the topic. The common denominator of the four cases is that they all hit a blank spot in historiography. The reason they have been left out is not because they lack interest but because they do not fit into any established categories. By turning the spotlight on these four phenomena, I wish to contribute to the historiographical endeavor of media archaeology.

The term *popular culture* stands for many different things. It can mean culture that is appreciated by many people, it can mean culture produced for a mass market, and it can mean culture produced by the people, to mention a few of the most common definitions. The popular culture associated with typography in the digital and postdigital age is a culture dependent on popular culture forms such as fiction, television, film, and music; on the mass market of computers and software; as well as on cultural production by common people. Since postmodernism, the distinction between "high" and "low" culture has been called into question, but popular culture is still mostly associated with "low" and mass-produced commercial culture.[10]

Insights into popular culture are essential for the comprehension of our own time and for conveying it to the future.[11] In his book *POP: How Graphic Design Shapes Popular Culture*, art director and design critic Steven Heller makes a remark to which I subscribe: "pop culture, especially seen through the lens of design, illustration, and satiric and political art (and other things), is integral to a broader understanding of who we are and where we are going."[12] His book is a collection of essays dealing with, among other things, pop icons, design literacy, and art for the masses. The essays, originally written for various digital and printed periodicals, require the reader to be well versed in American popular music, comic strip characters, films, brands, and trends in the graphics design world that were current at the time the essays were written, but Heller's insistence on putting these phenomena in a historical perspective makes the book valuable also to a future audience outside the immediate American cultural sphere. Some of the essays touch on the influence of digital technology on the graphic design trade, but the phenomena I intend to deal with are not included in Heller's book.

Reference works on the history of graphic design and typography are primarily concerned with the trade of graphic design and printed mass media. Most of the attention is devoted to prominent designers, important typefaces, and major publications, and this also is true for graphic design in the digital age.[13] Although graphic design is to a high degree connected to popular culture in the form of advertising, publishing, and filmmaking, the phenomena treated in this book are all but absent from the reference works. Dot matrix printers are not mentioned in Philip B. Meggs and Alston W. Purvis's *Meggs' History of Graphic Design* or in Stephen Eskilson's *Graphic Design: A New History*. In the latter, a box is devoted to Comic Sans, introduced with the following words: "In the contemporary age, there has been a curious phenomenon whereby specialty fonts have broken into the mainstream." These two books are based on a continuous narrative, in contrast to Paul McNeil's *The Visual History of Type*, which is a reference work of a different kind, containing images of specimens of over 320 typefaces organized chronologically according to their publication dates and accompanied by short presentations that put the typefaces into a historical context. McNeil's catalogue raisonné includes Comic Sans and some machine-readable typefaces (E-13B, OCR, and Data 70, a derivate of E-13B). The latter are also mentioned in David Jury's *Reinventing Print: Technology and Craft in Typography*, which revisits the history of graphic design and typography in the light of the development of digital technology. The only mention of ASCII art or other kinds of letter art I have found in the general histories of graphic design is in Johanna Drucker and Emily McVarish's *Graphic Design History: A Critical Guide*.[14] This phenomenon seems to be a real outsider because it is hardly mentioned in the histories of computing either. One rare occurrence is in Paul E. Ceruzzi's *A History of Modern Computing*, a book with a focus on important milestones in the development of hardware and software. ASCII art is briefly mentioned in connection with the IBM 1403 printer:

It was a utilitarian device but one that users had an irrational affection for. At nearly every university computer center, someone figured out how to play the school's fight song by sending appropriate commands to the printer. The quality was terrible, but the printer was not asked to play Brahms. Someone else might use it to print a crude image of Snoopy as a series of alphabetic characters. In and out of Hollywood, the chattering chain printer, spinning tapes and flashing lights became symbols of the computer age.[15]

Computing history is too vast and diverse to be the subject of a single book, and there are instead works devoted to different aspects of its history. Springer's nineteen-volume series History of Computing and the academic journal *IEEE Annals of the History of Computing* do not mention any of the four phenomena. In *The Routledge Companion to Global Internet Histories*, ASCII art is touched on in passing in the chapter on Japanese internet culture, but the focus is on the written narratives.[16] Major milestones in the history of hardware and software development are featured in *The Innovation in Computing Companion*, but none of the four phenomena covered in this book appears in the volume.[17] One could perhaps have expected to find a note on dot matrix printers, but printers in general are not the focus of the book, nor are they in other accounts of the history of computing. Printers are peripheral devices, even in the historiography of computing. The one book I have found on the subject, Edward Webster's *Print Unchained: Fifty Years of Digital Printing, 1950–2000 and Beyond: A Saga of Invention and Enterprise*, presents different printing technologies, among them the dot matrix printer, as well as the engineers behind them and some of the pioneering manufacturers.[18]

The results of this short survey of mainstream historiography in the fields of computing and graphic design are not very surprising. ASCII art, machine-readable typefaces, dot matrix printers, and Comic Sans have not played a major role in the history of printed mass media and with professionals in the graphic design trade. In the history of computing, machine-readable typefaces and dot matrix printers had a brief moment of fame but were superseded and made obsolete by other technologies. ASCII art and Comic Sans are probably regarded as too irrelevant to even be mentioned in the context of the history of computing. When these phenomena are put in the context of popular culture, however, their merits appear more clearly. They deserve a place in history where they do not fall between two stools.

THEORETICAL AND METHODOLOGICAL APPROACHES

For each chapter, I have made an effort to find a suitable theoretical and methodological approach that brings out salient features and aspects of the phenomenon in question. As the cases are quite diverse, this means

that I use an eclectic range of methods, which are presented in the following overview of recurring approaches, perspectives, and concepts. I return to these in later chapters and add other theoretical and methodological perspectives where they are applicable.

Several meanings have been ascribed to the term *postdigital*, and discussions on how it relates to the digital are ongoing.[19] It is often used with regard to temporality as a way of defining the present time as the "postdigital era" or the "postdigital age." In his book *Reinventing Print: Technology and Craft in Typography*, David Jury pinpoints the general conception of the postdigital era quite well when he writes, "Digital technology is no longer the daring new technologies of boundless possibilities, but instead, something to which we have grown accustomed and its possibilities understood."[20] New media has not become old but has become habitual media.[21] The fact that the novelty of new media and digital technologies has faded into the background will change how we use the technologies and how we perceive them. Media scholar David M. Berry claims that the postdigital has become an inevitable part of everyday life and that previous dichotomies—such as offline and online, digital and analog—are now passé and irrelevant.[22] Another media scholar, Alessandro Ludovico, argues in his book *Post-Digital Print* that "print" and "electronic" should not be considered as antagonists but that there are several ways in which these technologies and cultures can coexist.[23]

One could argue that this study has been carried out at a postdigital moment in time, which means that enough time has passed for the phenomena to be put in perspective but not so much time that the material the study is based on has disappeared or become unintelligible due to a loss of context. Although not all the phenomena in the study are postdigital in the sense of being conceived in the postdigital era, they can be viewed in the light of the postdigital concept. The postdigital has a strong connection to aesthetics and artistic practices. According to media art researcher Christiane Paul,

The terms "post-digital" and "post-Internet" attempt to describe a condition of artworks and "objects" that are conceptually and practically shaped by the Internet and digital processes—taking their language for granted—yet often manifest in the material form of objects such as paintings, sculptures, or photographs.[24]

Many art students are keen on working with hybrid technologies and are attracted as much by digital imperfections like the glitch as by, for instance, the scratches and dust of analog photography and film. Those students adopt "a post-digital hacker attitude of taking systems apart and using them in ways which subvert the original intention of the design."[25] It is perhaps the postdigital attitude that can best be applied to the four phenomena, in view of the unintended and creative uses to which the technologies involved have been put.

There are several ways to define the concept of *discourse*. For the purpose of this book, I regard a discourse as made up of the sum of all statements that are made about a certain phenomenon. Although originally a linguistic concept, I use it here in the extended, multimodal sense, comprising textual, visual, aural, and to some extent even haptic statements and expressions. The popular discourse that I focus on consists of different kinds of participants. The voices of graphic design practitioners and social media users are put in dialogue with the voices of researchers. The digital context requires a new kind of discourse analysis that takes new modes of communication and practices into account.[26] My material is multifaceted and consists of videos, still images, and written statements posted on social media sites as well as on other websites, some of them created as early as the mid-1990s, when the World Wide Web was in its infancy. The dynamic between the posted content and the comments in the commentary fields have yielded valuable insights into the phenomena studied. Many posts keep getting new comments even years after they were first published, but I have not engaged in the conversations myself; my approach is qualitative but only in a limited sense ethnographic.[27] I have studied only public content at open sites; closed communities are not part of the study. Although written, much of the material is oral in character and could be labeled as what Walter J. Ong called "secondary orality," a hybrid form of oral and written communication that has emerged in the age of electronic technology.[28] Spoken language is often the model used by social media participants for addressing their followers and by blog authors for addressing their audience. To some extent, this whole book can be regarded as an outcome of discourse analysis, but it is in the chapter on Comic Sans that this approach is brought to the fore, and I return to it there.

Furthermore, the semiotic perspective, with its idea that typography has a great potential for signification, permeates the book. Typefaces and their means of design, production, usage, and distribution are regarded as *semiotic resources*, which "are the actions, materials and artifacts we use for communicative purposes."[29] The term is used in social semiotics, a branch of semiotics that has been developed by Gunther R. Kress and Theo van Leeuwen, notably in their book *Reading Images: The Grammar of Visual Design*. They regard it as a contribution to a broadened critical discourse analysis that is not restricted to language.[30] Their view on discourse analysis serves as a model for the way I perform discourse analysis in this book.

One of the cornerstones of social semiotics is that communication is multimodal. Modes can be visual, verbal, or gestural, and van Leeuwen argues that typography is a semiotic mode in its own right. It conveys meaning in terms of the formal features of the letters themselves, their connections, and the structure of the layout of which the text forms a part.[31] Although I do not always explicitly reference its rather intricate terminology, social semiotics is a theoretical framework that underlies much of the thinking of the book. In multimodal analysis, different modes are taken into account. Multisensory analysis is related to the multimodal, but here the phenomena are seen from the perspective of the perceiving subject. Within the field of psychology and phenomenology, multisensory research is carried out on touch, sound, smell, and taste.[32] Typography has all these dimensions, which have been explored in the works of graphic designers Sarah Hyndman and Ellen Lupton, among others.[33] Multimodal and multisensory qualities and the ways they are connected to memory are highlighted in the analysis of the printed and printing artefacts that are the subjects of this book.

The connection between semiotics and the materiality of typography has been explored by artist and visual arts scholar Johanna Drucker, who in her book *The Visible Word: Experimental Typography and Modern Art, 1909–1923* outlines a model of materiality in her study of avant-garde poets of the early twentieth century. She contends that Ferdinand Saussure's linguistic theories of signification were based on spoken language and that he did not recognize the materiality of written language and its contribution to the production of meaning.[34] For Drucker, the *image of*

language is central. Text is never just pure information. It has a body that needs to be taken into account in the process of meaning making. Her model of materiality seeks to reconcile two aspects—those of production and those of cultural theory and social context. These two aspects are not in opposition if "materiality is understood as a process of interpretation rather than a positing of the characteristics of an object."[35] Drucker's approach to materiality is my point of departure throughout the present study.

Just as materiality has been downplayed within typography, it has been neglected within new media, which have often been characterized as immaterial. Digital humanities scholar Matthew Kirschenbaum followed in the footsteps of N. Katherine Hayles, a pioneer in the field of electronic literature and textuality, when he highlighted the materiality of some early works of electronic literature in his book *Mechanisms: New Media and the Forensic Imagination*. His concept of materiality is also indebted to Drucker, although Kirschenbaum focuses on the intricacies of digital storage media instead of on the printed page. He distinguishes between two facets of materiality—*forensic materiality*, referring to the physical surfaces of inscription and their individuality, and *formal materiality*, referring to the computer's capacity to manipulate abstract symbols. The line between the two concepts cannot be drawn neatly between hardware and software, which are themselves constructions based on the early computer practices.[36] I agree with Kirschenbaum that the borders between hardware and software are increasingly blurred, even more so now than when *Mechanisms* was published in 2008.

In each chapter, I attend to different aspects of materiality where the balance between hardware and software shifts. Printers, paper, and ink and their performative affordances are brought to the fore in chapters 2, 3, and 4, whereas in chapter 5, the focus is on the ways that the technological infrastructure of social media platforms affects how discourse is performed.

MEDIA ARCHAEOLOGICAL RESEARCH PROCESS

My working method and my research process are media archaeological in nature and can be summarized by this quote from Huhtamo and Parikka:

"Media archaeology rummages textual, visual, and auditory archives as well as collections of artifacts, emphasizing both the discursive and the material manifestations of culture."[37] A large part of the time I have spent doing this research has been devoted to rummaging through the internet and internet resources. I have used search engines, mainly Google, and then proceeded through links and references on the pages I found. These often have led me to other internet resources, printed books, films, and other artefacts and then back again to internet resources. "Searching" should not be construed as a mechanical process. It is part of a problem-solving process whereby the initial conception of the problem must be constantly modified in light of new information that emerges during the process. One must be prepared to turn in a direction other than the one planned on. It has been like following Ariadne's thread, although I do not claim to have found the final way out of the labyrinth; there is much more material to be discovered and to be explored.

My process is also archaeological in the sense that the finds I have made can be regarded as shards. It has been my task to piece them together into a meaningful whole. However, the empirical data cannot be represented 1:1, such as a social media post with thousands of comments. I have taken samples from longer conversations, put them together, and combined them with other sources, thereby distilling the patterns that I either saw from the start or became aware of during the process.

ARCHIVES AND SOURCE MATERIALS

The archive is a central concept in media archaeology. Discussions on the preservation of digital content are ongoing, and they include all the issues entailed by regarding, for instance, software as cultural heritage. For museums and archival institutions that are accustomed to taking care of physical artefacts, it becomes a challenge to include artefacts with a different materiality.[38] The World Wide Web is in itself a giant archive, consisting of living sites and dead sites (which are no longer maintained and updated). Age alone is not a sufficient indicator of the status of a webpage. A webpage that says "Last updated June 12, 1995" can still be part of the current web. Some sites, including pages that have been removed from the current web, have been captured by the Internet Archive and

can be retrieved through the Wayback Machine. This useful archive has made it possible for me to reference material of historical interest, such as manifestos, printer manuals, and computer magazines.

There are many different kinds of archives on the web. There are web archives that exist only on the web, and there are physical archives that have been digitized and made accessible by a web catalog. There are archives run by institutions and independent archives run by professionals with the help of sponsors. There are also small, informal archives run by private persons. In the following section, I specify the resources that I have consulted when carrying out this study and some that could be of potential use for a similar study in the future.

SOURCES AND RESOURCES ON TYPOGRAPHY, DESIGN, AND ART

A resource that I have made ample use of is McNeil's *The Visual History of Type*, mentioned above in connection with reference works on the history of graphic design. This huge, printed book is a hybrid work that is hard to classify. It is a dictionary of typefaces, a printed archive of type specimens, and a cultural history. Its structure and cross-references make it a valuable asset in the study of typography.

Fonts in Use is a crowdsourced typographic web archive that was founded in 2010 as a blog by Stephen Coles and Nick Sherman, debuted in its present form in 2012, and is now run by a staff of designers and funded by sponsors. It provides examples of "typography in the wild"—real-world applications such as book covers, album art, shop signs, posters, and ephemeral formats like fruit stickers:[39] "Supported by examples contributed by the public, we document and examine graphic design with the goal of improving typographic literacy and appreciation. Designers use our site for project research, type selection and pairing, and discovering new ways to choose and use fonts." This archive has allowed me to study samples of the typefaces included in my book in different types of contexts.[40]

Another crowdsourced archive inspired by Fonts in Use is the People's Graphic Design Archive, launched in 2020. It focuses on historical material that is more than ten years old. The site's motto is ambitious ("A virtual archive built by everyone, about everyone, for everyone"), and its

goal is to make the history of graphic design more inclusive, expand the canon and definition of graphic design, and preserve "works that weren't previously considered worthwhile." It plans to collect "everything from finished projects to process, photos, letters, oral histories, anecdotes, published and unpublished articles, essays, and other supporting material in the form of documents, videos, audio, as well as links to other relevant archives and websites." The archive does not yet include any of the material about the phenomena discussed in this book. Crowdsourced archives raise the question of whether researchers should contribute material. Perhaps some of the materials I have gathered during this study would be suitable for this archive.[41]

The Letterform Archive is a physical archive founded by the collector Rob Saunders. It is located in California, but access to the digitized parts of its collection is granted through the online archive. Some of its material is connected to digital graphic design, notably a donation of archival material from *Emigre* magazine (1984–2005), whose designer, Zuzana Licko, is a pioneer of digital typography. The online archive contains a complete digitized version of the magazine, which I have studied.[42] Another online resource is the Digital Art Museum DAM, which was established in 1998 by the German gallerist Wolf Lieser. It is devoted to digital fine art and features some of the early net.art artists who worked with ASCII art.[43] Apart from these established archives, there are also private initiatives targeting specific niches of graphic design, such as the Movie Title Stills Collection, which is run by the web designer Christian Annyas in his spare time. This collection was very useful for my film analyses in the chapter on machine-readable typefaces.[44]

Typographic magazines are rich sources for acquiring knowledge about events, trends, profiles, and debates in the trade. Among the typography magazines I have consulted are the American magazines *Print* (founded in 1940), *Communication Arts* (founded in 1959), and *AIGA Eye on Design* (published by an organization founded in 1914) and the British *Eye* (founded in 1990).[45] These magazines have corresponding websites. Some design web journals—such as *Design Observer*, founded by graphic designers Michael Bierut, William Drenttel, and Jessica Helfand and writer Rick Poynor—do not have a printed version.[46] Other web journals, such as the German *Smashing Magazine*, targets web designers and developers. The

magazine publishes many articles about how to use fonts when design-
ing websites, and it sometimes includes articles about historical events
related to digital typography.[47]

SOURCES AND RESOURCES ON COMPUTERS AND TECHNOLOGY

A major museum in the field of computing is the Computer History
Museum in Mountain View, California. Apart from a collection and an
online catalog, it has pedagogical material online such as timelines, sto-
ries on specific topics, and recorded lectures by computer pioneers. The
museum has ASCII art in its collection, and the curators have helped me
find material and have it digitized. A member of the team that has been
restoring the 1960s mainframe computer IBM 1401 uploaded a video to
his own YouTube channel featuring the printing of a piece of ASCII art,
which I analyze in the chapter on ASCII art.[48]

There are also collections connected to universities, such as the Media
Archaeology Lab (MAL) at the University of Colorado and the Comput-
ermuseum at the Department of Computer Science at the University of
Stuttgart.[49] In addition, some private online computer museums feature
the private collections of microcomputers and personal computers. On
display are catalogs with images and descriptions of the items owned by
the collectors, and some have YouTube channels where they talk about
and demonstrate items from their collections. What these private collec-
tors have in common is the desire to save old technology that runs the
risk of being forgotten. I have used such sources in the chapter on the dot
matrix printer.

When microcomputers entered the consumer market in the 1970s,
popular magazines were launched that catered to the interests of these
new user groups. Among them were *Creative Computing* (1974–1985),
which sometimes published ASCII art; *Personal Computing* (1977–1984);
and *Byte* (1975–1998), from which I have used examples of machine-
readable typography and advertisements for printers. Older magazines,
such as *Popular Science* (founded in 1872), which have devoted some
attention to computers, also provided material for my study.[50]

One of the first blogs on computer history I encountered was *Vintage
Computing and Gaming: Adventures in Classic Technology*, founded in 2005

by Benj Edwards and focused on the history of computers, video games, and technology. This blog caught my attention because of a post about a dot matrix printer and a 1983 advertisement in *Personal Computing*. It inspired me to use advertisements as objects of analysis for the chapter on the dot matrix printer.[51] A popular magazine devoted to the history of electronics is *Paleotronic* magazine, which has been another useful source for this chapter. The magazine covers "the present-day retro-technology niche, highlighting its influence on today's popular culture."[52]

The website *Tedium* started out as a blog and then evolved into a newsletter and a website of its own in 2015. Its approach to history is similar to my own, evident by one of the questions its editors ask themselves: "Can we uncover the history of things that usually don't have histories written about them?" Their answer is affirmative, and I have found useful *Tedium* articles about typefaces in the internet era and about books on the early era of automation.[53] On *Boing Boing*, a blog focused on technology and science fiction that started out as a zine in 1988, I have been able to read posts and discussion threads of value for my study. I have also studied several nontechnological websites, especially concerning the discourse on Comic Sans. One of the most poignant comments on the status of the typeface was published as an article on *McSweeney's Internet Tendency*, a website with humorous content run by a publisher.[54]

GENERAL MEDIA ARCHIVES

For the discourse analysis on Comic Sans, I did a great number of searches in the English-language part of the media archive Factiva, managed by Dow Jones, which contains business magazines, trade publications, and major international and national newspapers. Most of them are print media, but the archive also contains some web-based media channels. As in many similar media archives, the articles are stripped of all layout, typography, and images from their original publication context. The writer Kenneth Goldsmith called such text-only versions "nude media" when he compared a *New York Times* article with its web version in 2003.[55] The loss of information is not just an aesthetical issue; comprehension is also hampered by this space-saving procedure. Nevertheless, media archives like Factiva make it possible to access and sift through

a huge amount of material. I browsed over two thousand hits and read about a thousand articles that were relevant. Then I organized them into categories to discern the major themes in the discourse. It is hard to make a quantitative analysis of the material because Comic Sans is often mentioned in passing in articles that are not about the typeface itself.

SOCIAL MEDIA AND MISCELLANEOUS WEBSITES

Social media platforms—eBay, Instagram, Quora, Reddit, Twitter, Vimeo, and YouTube—have been some of the main sources for the study. They have many tweets, images, videos, news, questions, discussion threads, and listings that relate to the four phenomena of the study and that are points of departure for discussions throughout the book.[56] Personal homepages can in some cases be a useful correlate to rumors, hearsay, and statements that have been corrupted by having been quoted and requoted. One example is the homepage of Vincent Connare, the designer of Comic Sans.[57] Apart from the web resources enumerated so far, many websites are hard to put into a category and can be seen as hybrids. One such example is Mike Loewen's website, which has some similarities with the private online museums mentioned earlier. It has a section about old technology that includes computer hardware systems, storage media, manuals, software, and ASCII art. Under the last heading, I found a unique email interview that Loewen conducted with Sam Harbison, one of the pioneers of ASCII art.[58] Where will such material be saved in the future, when the owners of the websites can no longer maintain and keep them?

Some private websites focus on specific issues of interest to their owners. The technical writer Ivo Vynckier has created two websites about optical character recognition (OCR)—one about how OCR works in general and another about OCR in the film *Catch Me If You Can* by director Steven Spielberg.[59] These sites were very helpful for my chapter on machine-readable typefaces.

Since official histories on the history of printers are rare, I have resorted to historiographies written by manufacturers and vendors of printer supplies and spare parts. Some companies publish retrospective stories on their websites to provide a context for their business.[60]

NONEXISTENT SOURCE MATERIAL

Some source material I have looked for in vain. I have not been able to find any photographs of ASCII art displayed on the walls of computer centers. Written and oral statements indicate that there such posters did indeed hang in the offices of the staff, but there seems to be no visual documentation of this phenomenon. The photographs of the interiors of computer centers I have found are either official university or company photographs or manufacturers' publicity photographs that highlight the equipment. The humans who appear in the pictures are busy attending to the machines. The reason for the lack of photos of ASCII art on office walls might be security, one informant suggested. My guess is that people did not usually bring a camera to work, and if they did, the ASCII art on the walls was considered uninteresting or, given the fact that many pictures were pinups, inappropriate to document.

PREVIOUS LITERATURE AND RESEARCH

A number of recent designer books have appeared that deal with niche or overlooked topics related to typography, computing, and popular culture. They are elaborately designed and printed, and much attention has been paid to illustrations and physical qualities, which are integral to expressing the content of the books. One example connected to popular culture is designer Dave Addey's richly illustrated book *Typeset in the Future: Typography and Design in Science Fiction Movies*, published in 2018. In the genre of science fiction, the book is unique in its focus in typography. It contains interviews with type designers and detailed analyses of how some of the most famous science fiction movies use graphic design to conjure up the future as well as the recent past, such as the 1970s.[61]

Another book that appeared in 2018 is *Letraset: The DIY Typography Revolution*, edited by graphic designers Tony Brook and Adrian Shaughnessy. It is a visual history of the rub-down revolution that made typography widely accessible and facilitated experimentation beyond the straight line of conventional type setting. The Letraset company had its heyday in the 1960s and 1970s. Its dry-transfer lettering sheets were used for record covers and low-budget magazines and had a considerable impact on popular culture. It formed a bridge to the digital era of graphic

design. The 2018 book is based on essays by designers who worked for Letraset, which means the history of rub-down lettering is told from their perspective.[62]

Much has been written about arcade video computer games, but typography was a neglected aspect of games until typeface designer Toshi Omigari published *Arcade Game Typography: The Art of Pixel Type* in 2019. He inventoried thousands of arcade games and systematically documented the typefaces. He also recreated typefaces by converting images into fully working fonts. The book is richly illustrated with game screenshots and type specimens, some enlarged to demonstrate their pixel construction.[63]

Punch cards were a staple of early computing and used for carrying programming code and data. These cards were manufactured in huge amounts by IBM and other computer companies until they became obsolete and were superseded by terminals. The book *Print Punch: Artefacts from the Punch Card Computing Era*, a collection of essays published by CentreCentre in 2020, has a thick, laser-cut cover with small holes forming the letters of the title. Several punch cards are represented in the book, as well as advertisements and photographs from computer centers from the era, accompanied by short essays on the subject. One of the essay authors, Steven E. Jones, claims that "the paper punch card remained the most widely recognised cultural symbol of computing."[64] On its website, the London publisher presents itself in the following way:

CentreCentre create limited edition books from unexpected collections, projects and archives. We work from the outside in, striving to have the invisible seen and the forgotten found. We believe in taking inspiration from the mundane and the overlooked.[65]

Punch cards definitely do not occupy a place in the canon of graphic design. After they were phased out, surplus unpunched stock was often used as notepads. Nonetheless, card decks can be the guardians of digital cultural heritage, as is shown in chapter 2 on ASCII art.

A typical postdigital practice is advocated in *Typographic Knitting: From Pixel to Pattern* by Rüdiger Schlömer, published in 2020. Instead of rapid prototyping, this slow procedure focuses on the sensual qualities of yarn and offers a new, craftlike dimension to the design of typefaces. The book does not dismiss digital font tools but rather explores how new technology and old craft can be combined for the benefit of design.[66]

There is no previous humanities research that puts the four phenom-
ena in a common context, but there are books, book chapters, and articles
that examine certain aspects of them. The following three works indicate
the transnational character of ASCII art. The most comprehensive study
on ASCII art is Brenda Danet's *Cyberplay: Communicating Online*, an eth-
nographic and sociolinguistic study about playful practices on the web
in the 1990s. It contains chapters on communication via email and in
chat rooms and on the ways that creating fonts and making American
National Standards Institute (ANSI) art (a successor to ASCII art) for bulle-
tin board systems (BBS) became popular hobbies of ordinary people. The
book gives the historical background to ASCII art but does not deal with
printed ASCII art in computer centers in the way I do here.[67] In his book
chapter from 2008, "Humans Thinking Like Machines: Incidental Media
Art in the Swedish Welfare State," Kristoffer Gansing regards early ASCII
art and music composed for the big line printers as a kind of everyday
creativity and an early form of media art.[68] Stephen Jones traces the early
history of computer graphics and looks at ASCII art in the context of sci-
entific research in his 2011 book *Synthetics: Aspects of Art and Technology
in Australia, 1956–1975.*[69]

An article by Mark Owens and David Reinfurt, "Pure Data: Moments
in a History of Machine-Readable Type," published in 2005 in the journal
Visual Communication, has been one of the inspirations for this book and
especially for the chapter on machine-readable typefaces. The authors
pointed me to this obscure corner of the history of typography and to
the ways that certain typefaces have become signifiers of the digital age.[70]

I have not been able to find any previous research that is specifically
about the dot matrix printer, but articles about technostalgia touch on
the theme of memory and old technology. Tim van der Heijden's 2015
article "Technostalgia of the Present: From Technologies of Memory to a
Memory of Technologies," in *NECSUS: European Journal of Media Studies*,
for example, is about obsolete hardware and the ways that media such as
Kodak's Super 8 film and Kodachrome, which were once used to capture
memories, have now become nostalgic objects in their own right.[71] In
his 2014 article "Memory, Temporality, & Manifestations of Our Tech-
nostalgia" in *Preservation, Digital Technology & Culture*, John Campopiano
discusses the preservation of digital media and sees technostalgia as a

longing for "a tangible connection to our cultural heritage."[72] The importance of sound for technostalgia is developed in Karin Bijsterveld and José van Dijck's book *Sound Souvenirs: Audio Technologies, Memory and Cultural Practices* in connection with music and consumer products such as radios, tape recorders, and iPods. However, their book does not deal with sound in general and played only a minor role in my research.[73]

Research on specific typefaces in relation to digital popular culture is scarce, but one example is "A Brief Introduction to Impact: 'The Meme Font'" by Kate Brideau and Charles Berret, published in 2014 in the *Journal of Visual Culture*. The article traces the journey of the meme typeface from its peculiar technological beginnings in the last hours of metal typecasting and its rise to fame on the internet thirty years after it was originally designed. Brideau and Berret argue that the Impact font has become a stable feature of image memes because its strong regularity and legibility enable it to fit into most images.[74] Controversies in the field of typography are sometimes jokingly called "fontroversies," and that is the topic of Keith M. Murphy's book chapter "Fontroversy! Or, How to Care about the Shape of Language." His semiotic study from 2017 encompasses three case studies—Comic Sans and the CERN presentation of the discovery of the Higgs Boson particle, IKEA's shift to Verdana, and the implications of using Gill Sans in the light of Eric Gill's moral transgressions. Murphy states that the controversy about Comic Sans has lasted the longest and has entered public consciousness in a way that other fontroversies have not.[75] Sarah Owens, in her book chapter "On the Professional and Everyday Design of Graphic Artefacts" published in 2019, also touches on the CERN presentation and the taboo against using Comic Sans, which has become synonymous with bad design and everyday designers.[76] The 2017 anthology *Type Matters: The Rhetoricity of Letterforms* includes a chapter that is relevant for this study. In "Type Reveals Culture: A Defense of Bad Type," Garrett W. Nichols discusses how the use of Comic Sans can be seen as a tactic instead of an error.[77]

OUTLINE OF THE BOOK

The four main chapters of the book can be read independently, but together they cover important aspects of the practice of typography—usage,

design, printing, and dispersion. The four phenomena all deviate from typographic norms and traditions and often illustrate how things are not supposed to be done. In chapter 2, ASCII art is highlighted as an example of an unintended usage of letters and printers. At a time when computers were meant to process numbers and print crude forms of text, ASCII art arose as an image-making practice that served artistic, scientific, and playful purposes. In the 1960s and 1970s, when staff members in computer centers put up banners and posters with popular motifs, they were challenging the rational and serious image of the computer trade. At the same time, they used ASCII art to showcase the versatility and potential of computer equipment.

Chapter 3 examines how machine-readable typefaces, which originated in the banking industry, came to represent computing and technology in general, often in science fiction works and other popular culture settings. The connotations included dreams of the future as well as fears of a surveillance society. The chapter is mainly devoted to semiotic analyses of artefacts such as films, book covers, artworks, and logotypes, where typefaces play a major role. Close readings and visual analyses of these artefacts can help us better understand the signification process that machine-readable typefaces have gone through.

In chapter 4, the materiality of the dot matrix printer is the focus. In contrast to the reduced and rigid typographic possibilities of line printers, dot matrix printers offered users much more flexibility, and the smaller variants were affordable for the general consumer. These features came at the expense of the integrity of the letterforms, which were composed of small dots. The irregular results clearly violate the criteria for being "types" in the traditional sense of printing. Some manufacturers marketed the printer as a precious new family member, which is highlighted in the chapter through the analysis of advertisements and user manuals. The shrill and characteristic sound of the printer is not mentioned in the marketing material, but it has left a clear mark in the memories of its users. Its sound was also used for such diverse purposes as musical performances as well as acoustic eavesdropping, a form of spying that involves the translation of sound into text. The chapter is centered around nostalgia and multisensory experiences, and recollections of users in social media form an important part of the material.

The hatred for the typeface Comic Sans is the focus of chapter 5. This informal typeface reached a large user base by being distributed by Microsoft as part of its standard software programs. The typeface became widely used and generated a lively debate about its use and misuse, with repercussions in both traditional and social media. The discourse analysis in this chapter discerns rhetorical themes and places the debate in the context of platformization and of type hate in the history of typography.

In chapter 6, the concluding chapter, common themes and concepts from the previous chapters are drawn together—materiality; performance, personification, and narrative voice; displacement; do-it-yourself; and technostalgia and obsolescence.

2

COMPUTER PICTURES BEFORE COMPUTER GRAPHICS

THE PRACTICE OF ASCII ART

ASCII art was practiced long before the ASCII code was developed. The making of text-based art with the help of typewriters dates back to the nineteenth century, and the practice was encouraged by competitions arranged by typewriter manufacturers.[1] Beginning in the 1920s, teleprinter operators created pictures and sent them to each other over radio-teletype (RTTY) and printed them out on paper, until the 1980s, when personal computing won over many radio amateurs.[2]

The American Standard Code for Information Interchange (ASCII) became an official standard in 1963. It is an encoding system for representing the alphabet and other characters in computers, where each character is assigned a unique number. Pictures were also made with the help of other encoding systems, including IBM's binary-coded decimal (BCD) system, IBM's extended binary-coded decimal interchange code (EBCDIC) system, and later the American National Standards Institute (ANSI) system, which was used on bulletin board systems from the 1980s to the beginning of the new millennium. However, the term *ASCII art* is now an umbrella designation for an art form that has become part of a broader visual culture.

In the 1960s, the large computer systems were monitored by an operator sitting at a console with switches, knobs, buttons, and indicator lamps. Paper tapes and punch cards were used for the input, output, and storage of data and programs. Printouts were produced by line printers and repurposed teleprinters. When visual display units (VDUs) became common as terminals in the 1970s, they were usually monochrome and character-oriented. Pen plotters and graphical terminals also could handle images, but such exclusive equipment was not needed for processing

Figure 2.1 Typewriter art. Julius Nelson, *Artyping* (New York: Gregg Publishing Company, 1939), 66.

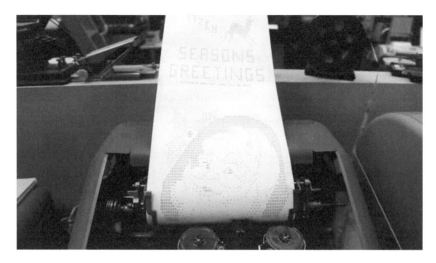

Figure 2.2 RTTY art. Screenshot from "Santa Arrives via Model 19 Radio Teletype @ 60 WPM," YouTube, December 25, 2013. Courtesy of the Telecommunications History Group.

discrete symbols like the alphanumeric characters of the ASCII code. Computer graphics was in its infancy in this period.[3] But the computer operators and programmers of the early days took up the baton from the teleprinter operators and the typewriter artists, found ways around the limitations of the mainframes and the line printers, and made text-based images long before computer graphics came of age.

A Dictionary of the Internet defines ASCII art in the following way: "A collective term used to describe pictures, sometimes pornographic, which have been produced by just using the ASCII character set. The advent of graphical programs has meant this form of graphic display has declined markedly."[4] I consider this definition slightly biased. Although it is true that pinups were a popular ASCII genre, they were not necessarily pornographic, and many other genres were popular, notably celebrity portraits and cartoon characters. The statement about the decline of the art form is also questionable, since ASCII art has been quite persistent and has lived on in different shapes and contexts to this day.

A different way of approaching the subject of ASCII art is taken in *Encyclopedia of New Media: An Essential Reference to Communication and Technology*, which proposes an explanation for why ASCII art was made:

"Originating as a way of enriching the text environment and allowing for a greater range of human expression, ASCII art can be viewed as an argument against technological determinism, as it shows that individuals can shape the uses to which technology is put."[5] Here ASCII art is presented in a more positive light as an instrument for creativity and as a means for humans to gain the upper hand over the machines.

The material base on which ASCII art was usually printed was continuous-form paper (also called fanfold paper) that was fed through the printer and was often green-striped and 132 columns wide. These green and white bars made it easier for users to follow the computer code as it printed, but there was also plain white fanfold paper. The wide format and the continuous form made it suitable for images and oblong posters. A horizontal perforation made it possible to separate the individual sheets, and a vertical perforation along the margins allowed the strips with sprocket holes to be torn away. This procedure created some paper dust, and the resulting single sheets had serrated edges.

The aim of this chapter is to examine some of the uses to which ASCII art was put in the days before computers developed into the image-making machines that today's film industry and the gaming industry rely on. Specific attention is paid to printed ASCII art within computer centers, an environment that was an important breeding ground for the art form. Key questions asked in the chapter include these: What kinds of ASCII art were created? For what purposes was ASCII art made? How was ASCII art displayed, circulated, and published? How is it now being collected and archived? How could ASCII art be seen as a postdigital practice?

THEORY AND METHOD: INTERVIEWS AND VISUAL PERCEPTION

A suitable method for finding out how people use a certain technology is the interview. I reached out to a number of people who worked in the computer trade in the 1960s, 1970s, and 1980s, asking for interviews. I also did a small number of phone and email interviews. For the subject of ASCII art, I started out locally. A retired employee of the computer center at Gothenburg University agreed to an interview and provided me with valuable information. I then contacted other Swedish IT history researchers, who recommended that I speak with a former head of the

computer center at Stockholm University. After our interview—where he, among other things, pointed me to an interesting instance of ASCII art used in the context of medical research—he emailed some of his colleagues, one of whom had saved a large number of printouts with ASCII art and was willing to share his memories of the art form and its context with me. Some of the people recommended to me had no memories of ASCII art. They had been retired for many years and had either lost interest in or never had an interest in this marginal phenomenon of their working life.

Simultaneously, I searched for and contacted bloggers and website owners who mentioned an interest in ASCII art. One American engineer agreed to answer my questions via email and also forwarded the questions to three of his contacts. Another method I tried was to contact nongovernmental organizations (NGOs) and computer museum volunteers, but I received few or no answers. I realized I had to target specific persons, and a later attempt directed at computer museums in Great Britain and in Germany rendered me two more answers. This account is meant to illustrate the meandering paths that sometimes must be taken to find informants who are able to share information about events and practices that took place half a century ago. Perhaps my study of ASCII art would have been more successful if it had been conducted ten or twenty years earlier. Nevertheless, the interviews provided me with valuable material, context information, and pictures.

VISUAL PERCEPTION: SHIFTING BETWEEN DIFFERENT MODES OF SEEING

Letters are usually disciplined, carrying out their duties in the lines of text like soldiers in an army platoon. In ASCII art, the soldiers have broken free from their usual positions in order to perform a piece of modern ballet, where they appear in unexpected and irregular constellations and can even stand on top of each other. The original purpose of the letters and the other characters has become subverted, and they have lost their conventional semiotic compass. Their bodies now constitute pictorial elements from which a larger picture is built. This is not a new phenomenon in the history of art. Mosaic is one of the oldest artistic techniques. But

in contrast to mosaic shards, halftone dots, and pixels, the elements of ASCII art are carriers of meaning and are meant to be read. The perception of art made of small elements involves switching between looking at a picture from a distance and looking at it at close range. At a sufficient viewing distance, the image as a whole emerges, whereas if the viewer moves closer to the image, the elements themselves become more noticeable, and it becomes harder to perceive the motif in its totality.[6] In addition to this, ASCII art entails switching on and off between reading the letters and seeing them as abstract forms. Sometimes these two modes of perception have to coexist, as when an ASCII artwork contains a signature of the artist. There are also more elaborate hybrid forms, as when the characters function simultaneously as pictorial elements and semiotic signs, as is shown in the medical examples below.

Even when the characters do not fulfill their usual function, it would be wrong to regard the characters as meaningless in ASCII art. With their different forms and the thin and thick parts of their bodies, they help create a new pictorial meaning.[7] ASCII art is a form of abstraction, in one way as it thins out the fabric of representation and in another way as it adds to it by turning the picture into a riddle to be solved. ASCII art engages viewers by inviting them to adopt different positions and modes of reading/viewing, and I would argue that this aesthetics constitutes much of the allure of ASCII.

ART AND EXPERIMENTS

ASCII pictures where the characters are used for drawing lines and contours are called *structure-based ASCII art*, whereas pictures with grayscales that resemble photography are called *tone-based ASCII art*.[8] In 1965, H. Philip Peterson, who worked at Control Data Corporation Digigraphics Laboratories, made a tone-based version of Leonardo da Vinci's *Mona Lisa* that became widely known. Control Data offered Peterson's printed picture as a gift to customers of the company.[9] It also made use of the picture at the beginning of a 1968 promotional film for a CalComp plotter, where a large *Mona Lisa* poster is seen hanging on a wall. During the film's enumeration of suitable applications of the plotter, examples from different disciplines are shown—meteorological maps, scatter plots from

atomic physics, molecular structures, architectural drawings, computer programming, and music—all made in the manner of line drawings. The film's last example features the *Mona Lisa*, during which the voiceover says that the CalComp plotter can produce "even complex pictorial presentations, directly from the output of any standard digital computer." The tone-based *Mona Lisa* is shown first in close-up, so that the digits that make up the greyscale picture are discernible, and then, when the camera zooms out, the motif as a whole becomes visible.[10]

Beginning in 1963, the journal *Computers and Automation* held competitions for computer art and displayed such art on its covers.[11] Peterson wrote an article about his *Mona Lisa* for the journal. He found that the journal's covers so far had been too dependent on analog forms and claimed that, based on the method used for creating it, his version of the *Mona Lisa* could be regarded as a "pure" digital artwork. He explained that he divided the picture into cells, scanned a color projection slide of the painting to measure the density of different parts of the picture, and then filled the cells with digits that matched the density of the slide of the *Mona Lisa* painting. Peterson designed a special font for the experiment: "I designed the font in such a way that the larger the pair of digits are, the darker they appear to the human eye at that cell. Up close to the picture, you see what the computer 'sees'—namely, a number field; at about 30 feet away, you see the picture shaded as well as a newspaper photograph."[12] The creation of shades in a picture was not something that could be achieved with a plotter in its normal working mode, hence the designation "complex pictorial presentations" in the film. Peterson's article contains much quantitative information concerning the working process, the size and number of cells, the number of plotter steps, and the number of hours (sixteen) it took to plot the work.

Peterson's picture became known by the name *Mona by the Numbers*. The picture is mentioned by computer pioneer Ted Nelson in his book *Computer Lib / Dream Machines*, where he refers to it as "Lizzie of the line printer." A cruder version of it is reproduced in Nelson's book, and he clarifies his stance on this kind of images by adding "NOTE: this is not a 'computer picture.' There is no such thing. It's a quantization put out on a line printer."[13] There was no consensus about what constituted a computer picture at the time.

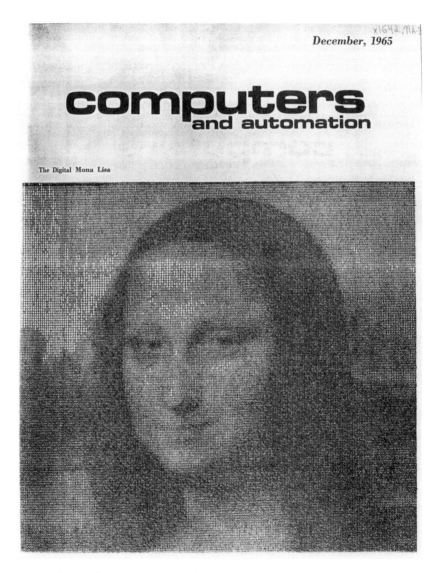

December, 1965

computers
and automation

The Digital Mona Lisa

Figure 2.3 H. Philip Peterson, *Mona by the Numbers*, 1965. Courtesy of the Computer History Museum.

Similar experiments in digitization and visual perception took place at Bell Labs in New Jersey, which provided a fertile ground for experiments in the intersection of technology and art in the 1960s. According to computer art pioneer A. Michael Noll, "The digital art at Bell Labs was both a result of research in computer graphics and a stimulus for that research. As an R&D organization, Bell Labs was keenly interested in the display of scientific data and also in computer graphics as a form of human-machine communication."[14] Two of his colleagues, Leon Harmon and Kenneth Knowlton, devised a method to scan photographs and convert them to numerical data. They made several pictures with this method, using communication symbols instead of letters and numbers. Strictly speaking, these pictures were not ASCII art, but they built on the same principle. The aim was "To develop new computer languages which can easily manipulate graphical data; To explore new forms of computer produced art; To examine some aspects of human pattern perception."[15] A picture of a reclining nude, called *Studies in Perception #1*, attracted the most attention and became famous through exhibitions and publications.

Studies in Perception #1 was based on a photograph specifically taken for the purpose of being digitized. The picture appeared in the Museum of Modern Art's exhibition *The Machine as Seen at the End of the Mechanical Age* in New York in the winter of 1967–1968 and in the Institute of Contemporary Arts's exhibition *Cybernetic Serendipity: The Computer and the Arts* in London in 1968.[16] According to an anecdote regarding its origin, Knowlton and Harmon printed out the picture as a large mural and attached it to the wall of a colleague's office. It was considered too risqué by Bell Labs and had to be taken down, but when Robert Rauschenberg showed it during a press conference about the organization called Experiments in Art and Technology (see below), the picture made it to the front page of the *New York Times* and was subsequently deemed as respectable art.[17] However, as this statement by Johanna Drucker shows, these visual experiments hold an ambiguous position in art history:

Engineers tended to downplay aesthetics, emphasize functionality, and call anything with any pictorial value at all a work of "computer art." By the mid-1960s, experiments at Bell Labs and a handful of other industrial and academic sites had created enough of this "art" for computer graphics to begin to be exhibited and appreciated, if only as curiosities.[18]

Figure 2.4 Installation view of the exhibition *The Machine as Seen at the End of the Mechanical Age*, Museum of Modern Art, New York, November 27, 1968, through February 9, 1969. Gelatin-silver print, 6½ × 9½ in. (16.5 × 24.1 cm). Photographer: James Mathews. © The Museum of Modern Art, New York. Photographic Archive. The Museum of Modern Art Archives, New York. Catalogue number: IN877.22. @ 2022. Digital image, The Museum of Modern Art, New York / Scala, Florence.

In the early 1970s, one of the established artists who made works based on the principles of ASCII art was the Brazilian artist Waldemar Cordeiro, who created a series of prints with a political intention. In contrast to Harmon and Knowlton, who came from the technical side, Cordeiro had a long career within the field of abstract and concrete art, but like them, he was interested in human perception. He did not scan images but used a more manual method to enter the information into the computer: "Cordeiro had to hand-input every dot making up the layers of figures in the final output. He had to decide how dark each spot would be, and then input that information by hand."[19] His computer-based works took pictures from newspapers and magazines as their starting point, in a way that brings to mind the photographic works that the German artist Gerhard Richter made in the 1960s. However, whereas Richter manipulated the photographs by converting them into oil paintings with a smearing effect that was at odds with the usual appearance of an out-of-focus

photograph, which made viewers unsure of what kind of image they were looking at, Cordeiro's processing atomized the images without jeopardizing their photographic integrity. One of Cordeiro's works, *Gente Ampli*2 (Amplified People 2)* (1972), which shows a crowd protesting outside the University of São Paulo, was shown in the exhibition *Thinking Machines: Art and Design in the Computer Age, 1959–1989* at the Museum of Modern Art in 2018, fifty years after *The Machine as Seen at the End of the Mechanical Age.*[20]

Which of these three works can be considered art, and which can be considered mainly as methodological experiments? Does the answer depend on the work itself, the training of the maker, or the institutional context? This is a complex question, and the answer is probably that all three factors come into play but that the context of a work's production and the institutions that exhibit the work are decisive for its inclusion in the art world, as is argued by institutional art theory.[21]

Peterson's *Mona by the Numbers* became famous, but it did not enter the art world in the same way as Harmon and Knowlton's *Studies in Perception #1* and Cordeiro's *Gente Ampli*2* did. It is included in compArt daDA: the database Digital Art, which is an online repository for digital art in its early phase and uses the designation "digital art" in a broad sense.[22] The repository is headed by computer art pioneer Frieder Nake and is part of a project at the University of Bremen. Peterson made a couple of other pictures—including a portrait of William Charles Norris, president of Control Data, for an article published in *Fortune*—but remained relatively unknown and was not considered an artist.[23] He did not collaborate with artists and was not involved in a research environment like the one at Bell Labs. His article about his *Mona Lisa* appeared in *Computer and Automation*, a journal for computer professionals. In the introduction to the short article, Peterson writes somewhat self-mockingly, "I have sent you, for your consideration, a 'pure' digital-work of art (admittedly not original)," and he finishes with a comment about a detail of the picture: "A close-up of her enigmatic smile would probably be the most interesting way of demonstrating the technique used." In this way, he emphasizes that he is not the originator of the artwork and that he is aware of that one cannot get at the "core" of an artwork by this method. Simply put, he does not claim to be an artist. In his book on early computer graphics in

Australia, media scholar Stephen Jones comes to the conclusion that the portraits made with a similar technique by the Australian physicist Iain Macleod could not count as art but that they paved the way for future advances in the field.[24]

The experiments by Harmon and Knowlton attracted the attention of the art world when they participated in Bell Labs experiments and in the organization called Experiments in Art and Technology (E.A.T.), which was founded after a performance called *9 Evenings: Theater and Engineering* that took place in New York in 1966. These large-scale performances are considered a milestone in the history of art and engendered new collaborations and crossover art forms.[25] But Knowlton never felt at ease with the title "artist." This is evident from another anecdote:

> Because Art-and-Technology was the rage, and The Museum of Modern Art had a "Machine Show," and the Brooklyn Museum and other places had similar parties, and in each case Leon and I submitted the Nude to demonstrate a collaboration between artist and techno-geek (or whatever). One of us had to be an artist. So by the whim of a spin-launched coin, Leon became the artist and I remained a technologist (pretense aside, so did he).[26]

Nevertheless, *Studies in Perception #1* is positioned firmly in the history of art. Its motif, the reclining nude, has been reiterated throughout art history, with Titian's *Venus of Urbino* and Manet's *Olympia* as notable examples. Nudity was acceptable when it was cloaked in allegory and presented in an antique setting, but *Olympia* caused a scandal for breaking these rules and showing a real-world prostitute. The tension between pornography and art is a long-standing issue, and a motif in itself does not position a work in either category (for further discussion on pinups and their connection to art history, see below). The position of *Studies in Perception #1* in the art world was consolidated by the restoration, concluded in 2016, that enabled it to be exhibited anew in London and Berlin in 2017.[27]

Figure 2.5 Waldemar Cordeiro (1925–1973), *Gente Ampli*2*, 1972. New York, Museum of Modern Art. Computer output on paper, 52^{15}⁄₁₆ × 28^{3}⁄₁₆ in. (134.5 × 72.5 cm). Latin American and Caribbean Fund. Account number 585.2016. © 2022. Digital image, The Museum of Modern Art, New York / Scala, Florence.

Cordeiro was an established artist before he ventured into computer art, and he made works with an artistic intention that went beyond experimentation with new means of expression. He worked together with a physicist, Giorgio Moscati, a relationship built on mutual exchange. In the work *Gente Ampli*2*, the motif of the image and the technique chosen to represent it collaborate in constructing the meaning of the work, granting anonymity to the people depicted in a politically charged situation. As an artist, Cordeiro could put the method to use in order to express an artistic idea. He was one of the pioneers of computer art in Brazil, and being included in *Thinking Machines: Art and Design in the Computer Age, 1959–1989* consolidated his position on the international art scene.

SCIENTIFIC VISUALIZATIONS IN COMPUTER SCIENCE, PHYSICS, AND MEDICINE

In *The New Hacker's Dictionary*, originally published in 1975, the section on ASCII art begins with "a serious example"—a diagram of electronic circuits. Further down, some "very silly examples" are given, showing animals and cartoon characters.[28] This categorization demonstrates a clear awareness of the playfulness that dominates the art form, although it was also put to many serious uses during a time when there were no other ways to generate images.

For a number of reasons, ASCII art is still the preferred form of visualization in some contexts. One of the advantages of ASCII art is that it is readable by any text editor and not dependent on a specific graphic software. In a blog post from 2019, "Explaining Code Using ASCII Art," computer scientist John Regehr gathered a collection of examples showing how ASCII art is used in the source code of computer programs to illustrate the shape of data structures.[29] In this way, the documentation is integral to the source code itself, in contrast to external documentation, which can be lost. One of the respondents to my survey on ASCII art, an American engineer in his late seventies, gave this reason for using ASCII art: "I have been making ASCII-art schematic diagrams for decades, to avoid my work being trapped in proprietary formats."[30]

In addition to file formats, it is also a question of workflow. For developers, maintainers, and users of complex software packages, shifting to

```
o----)||(--+--|<----+    +---------o + D O

  L  )||(  |         |  |              C U

A I  )||(  +-->|-+   |   +-\/\/-+--o -   T

C N  )||(         |  |   |       |       P

  E  )||(  +-->|-+--)---+--|(--+-o       U

     )||(  |         |          | GND    T

o----)||(--+--|<----+----------+
```

Figure 2.6 A power supply consisting of a full wave rectifier circuit feeding a capacitor input filter circuit. *The New Hacker's Dictionary*, version 4.2.2.

A tree rotate in Musl:

```
 7 | static int rot(void **p, struct node *x, int dir /* deeper side */)
 8 | {
 9 |         struct node *y = x->a[dir];
10 |         struct node *z = y->a[!dir];
11 |         int hx = x->h;
12 |         int hz = height(z);
13 |         if (hz > height(y->a[dir])) {
14 |                 /*
15 |                  *     x
16 |                  * / \ dir          z
17 |                  * A   y           / \
18 |                  *    / \   -->    x   y
19 |                  *   z   D        /|   |\
20 |                  *  / \          A B   C D
21 |                  * B   C
22 |                  */
23 |                 x->a[dir] = z->a[!dir];
24 |                 y->a[!dir] = z->a[dir];
25 |                 z->a[!dir] = x;
26 |                 z->a[dir] = y;
27 |                 x->h = hz;
28 |                 y->h = hz;
29 |                 z->h = hz+1;
30 |         } else {
```

Figure 2.7 Data structure. John Regehr, "Explaining Code Using ASCII Art," *Embedded in Academia* (blog), February 18, 2019.

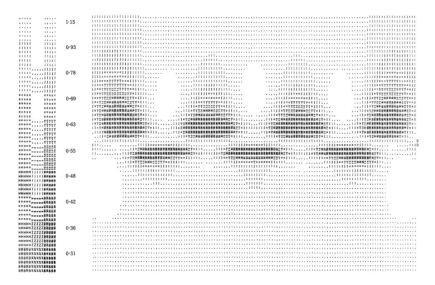

Figure 2.8 A grayscale line-printer picture. Alan K. Head, "The Computer Generation of Electron Microscope Pictures of Dislocations," *Australian Journal of Physics* 20 (1967): 561. Reproduced with permission from CSIRO Publishing.

a graphical tool in order to access a visualization of the software would be disturbing and would interrupt the workflow in a way that an ASCII-based visualization of the software would not.[31] In Kirschenbaum's terminology, the formal materiality of an ASCII-based visualization is different from that of a visualization made with a graphic software package.

The examples so far in this section have concerned structure-based ASCII art. One early attempt with tone-based ASCII art in physics is described next. In 1967, in an article on electron microscope pictures of metals dislocations, Australian physicist Alan K. Head presented the results in the form of line-printer pictures according to the half-tone principle, as grayscale ASCII pictures made up of punctuation marks. The grayscale used was divided into ten steps that corresponded to a number of boundary values. These pictures, which were based on calculations for dislocations, matched the actual micrograph pictures to a high degree, despite the fact that they consisted of only a limited number of shades.

The usual presentation method had been experimental profiles and graphs showing the intensity values, but with the help of equipment

originally intended for text production, Head had invented a new method of visualizing the results of physics research.[32] He concluded that "when the important information is in the topology of the picture, rather than in precise intensities, a pictorial presentation of the theoretical calculations is valuable."[33]

From 1969 to 1972, a development project called Computers in Radiotherapy and Clinical Physiology, involving medical visualization, was carried out in the Swedish university town of Uppsala.[34] It was brought to my attention by one of my informants, Bengt Olsen, who was involved in the project and was head of the Stockholm University Computing Center at the time. He sent me a leaflet that presented the project with a diverse range of visualization techniques—schematic drawings, graphs, tables, computer text printouts, and some ASCII-based pictures. Two of the subprojects concerned radiotherapy and dose calculation in the treatment of cancer. In this case, ASCII art was not deployed for its grayscale potential, but instead a new type of hybrid image was created, where the alphanumeric characters simultaneously served as pictorial elements and conveyors of therapeutical information. Figure 2.9 shows a computer-calculated dose plan for a case of lung cancer: "The asterisks denote the outer and inner contours. The numbers, which form isodose lines, indicate the absorbed dose expressed as a percentage of reference dose, i.e., 1: 10%, 2: 20%, 0: 100%, A: 110%, B: 120% and C: 130%. The tumor contours are marked with $ signs."[35] "Isodose line" means that the same dose of radiation is applied along a certain line. Following this explanation, we can discern the tumor on the right, the highest doses delivered near the tumor, and the decreasing doses toward its sides. Only one position is used for each piece of information. There are more than ten steps in the dose plan, which means that single digits are not sufficient and letters are therefor used for values over 100 percent of the reference dose.[36] This is the trade-off between functioning as a conventional sign of the alphanumerical character set and functioning as a pictorial element stripped of its usual semiotic meaning.[37] To represent a dose of 110 percent with the number 11 would have used two positions and in that way displaced the isodose line it was simultaneously drawing. Using the letter A to represent 100 percent requires only one position.

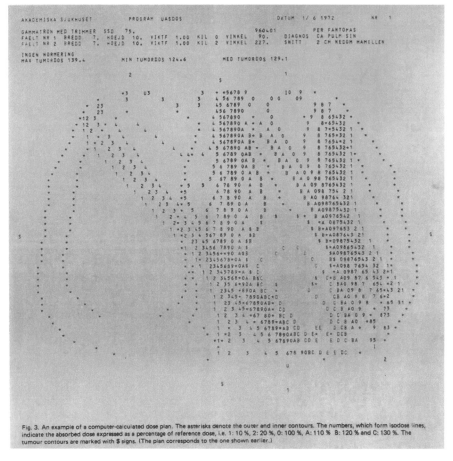

Fig. 3. An example of a computer-calculated dose plan. The asterisks denote the outer and inner contours. The numbers, which form isodose lines, indicate the absorbed dose expressed as a percentage of reference dose, i.e. 1: 10 %, 2: 20 %, 0: 100 %, A: 110 % B: 120 % and C: 130 %. The tumour contours are marked with $ signs. (The plan corresponds to the one shown earlier.)

Figure 2.9 A computer-calculated dose plan for a case of lung cancer. *Computers in Radiotherapy and Clinical Physiology,* Presentation of a development project, Internal report, Siemens-Elema, EC60.470.B01E (1972), 21.

Another example, concerning the treatment of cancer of the uterus, shows a section of the body seen from the patient's head end, where the levels of radiation that should be applied in the therapy are indicated by the numbers, which, at the same time, form the isolines (that is, the area where a certain dose should be applied) in the same manner as in the previous example.

Since there are only six levels of radiation in this case, the numbers 1 to 6 are sufficient for representing the doses, and letters need not be used for dose levels. This frees up alphabetic characters for other purposes. The

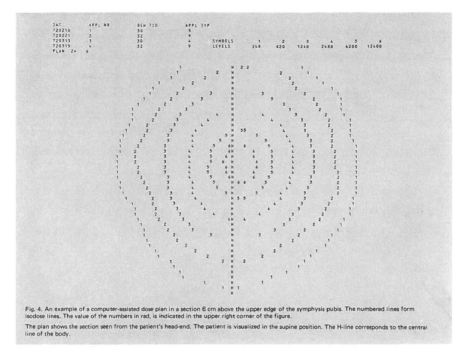

Fig. 4. An example of a computer-assisted dose plan in a section 6 cm above the upper edge of the symphysis pubis. The numbered lines form isodose lines. The value of the numbers in rad, is indicated in the upper right corner of the figure.

The plan shows the section seen from the patient's head-end. The patient is visualized in the supine position. The H-line corresponds to the central line of the body.

Figure 2.10 A computer-calculated dose plan for a case of cancer of the uterus. *Computers in Radiotherapy and Clinical Physiology*, Presentation of a development project, Internal report, Siemens-Elema, EC60.470.B01E (1972), 26.

letter H has been used to mark the central line of the body, to which it is suited by the straight lines of its constitution.[38]

Both these examples have demonstrated that using ASCII characters for pictorial representation presents readers with new perceptual and cognitive challenges. In order to take in and digest the information in the visualizations, readers need to be able to shift between two modes of perception—reading letters as semiotic signs and seeing them as pictorial elements. Readers also need to shift from understanding letters as linguistic units to deciphering them as numeric characters.

PICTURES FOR FUN

Computers were serious business. The large mainframes of the 1960s generally were used for scientific, bureaucratic, and military purposes.

However, as a diversion, some technologists used the machines to cre-ate music, images, and games.[39] ASCII art depicting pinups, calendars, celebrities, fictional characters, and games were printed out on the line printers, often over several pages so that they could be displayed as wall banners. In the online resource *The Dictionary of Digital Creation*, the entry "IBM" is illustrated with a picture of Abraham Lincoln being printed on a large IBM printer that was commonly used in the 1960s, with the caption "Printing an image on an IBM 1401: a cinch [sic] of humor and art in a very business minded industry."[40]

It would be wrong, however, to regard the creative practices that emerged in computer environments simply as entertainment that had no further uses. In a time when computers were starting to play a more impor-tant role in society, many people had concerns about surveillance and unemployment due to automation. According to Stephen Jones, ASCII art was one of the things that could give computers a more human face:

Partly as an attempt to reduce the public's fear and partly as a recruiting prac-tice, all the academic computing systems of those days featured strongly in uni-versity Open Days, which were held each year. Many of the second generation of programmers got their first sight of a computer at one of these events. Ban-ners, calendars, and other images—nudes, Snoopy, Michelangelo's *David*, the *Mona Lisa*, and so on—were often printed out as posters or the picture for a calendar, and this was as close as most people got to one of the big machines.[41]

When the art form became more widespread, it also was used for marketing computers. One of the leading computer manufacturers that competed with IBM in the 1960s was Honeywell Information Systems. In 1964, Honeywell and its customer Abbey National Building Society are featured in a full-page advertisement in *New Scientist*, and more than half the page is devoted to the logotype of the bank, rendered in ASCII art. Despite the resulting low resolution, the image of a woman and man walking under an umbrella was easily recognizable, and the accompany-ing text read: "This familiar Abbey National symbol was produced by the Honeywell computer now getting down to some more serious work."[42] This advertisement demonstrates the ambivalence that Honeywell's lead-ers and marketing team felt toward associating computing with this frivo-lous artform. On the one hand, the Honeywell marketing department realized the attention-grabbing potential of ASCII art. On the other, it

needed to insert a disclaimer that emphasized the seriousness of its business. This also demonstrates a dilemma faced by the computer companies in general: their physical products looked like boring cupboards, and the actions they performed were abstract and hard to visualize.[43]

The same type of hesitancy is evident in a 1960s promotional film for the Digital Computer Lab at the University of Illinois. The film presents the equipment and the facilities available at the university and shows stacks of punch cards being read, operators and users examining printouts, and tape reels spinning. Part of the soundtrack consists of "Sabre Dance" by Aram Khachaturian, adapted for computer and played on switching circuits. The presenter says: "It may not compete with the sounds from your most favorite recording group, but it does emphasize the versatility of that electronic marvel, the digital computer." Then there is a cut, and the presenter is shown in close-up, turns to the audience, and continues: "All is not fun and games, of course. The real importance of computers is to be of service to the ever-increasing demands of a mathematically oriented society."[44] This film uses the same strategy that was used in the Honeywell advertisement: the viewer is teased with a piece of art or music, but the window to "fun" that is opened a little is soon closed again by a disclaimer that stresses the seriousness of the enterprise. These examples show that entertainment and art were recruited in order to increase the acceptance of this new and menacing technology.[45]

I have found very few photographs of ASCII art in the context of production. None of the people I interviewed could remember seeing any such photographs. Finding the following three images involved many searches. Figures 2.12, 2.13, and 2.14 show men holding up ASCII printouts in the vicinity of computers and printers. In the first two photographs, men are grasping pictures that have just emerged from the printers; in the third, a man displays an ASCII picture of Brigitte Bardot with one hand and two punch cards with the other. Caricatures, pinups, and film stars were staples of popular culture, and pinups and films stars were common motifs for ASCII art. The information about these photographs is sparse, but they are likely press photos. The first, and oldest, photo is from 1957, and its legend at Getty Images says "Caricatures of US statesmen Dwight Eisenhower and Adlai Stevenson printed by a Universal Automatic Computer."[46] It is an editorial image from the Hulton Archives, an archive connected to

Abbey National picked a Honeywell computer system to process 800,000 accounts, record increasing transactions from 104 branches, produce pages half yearly for their new style pass books–in short to reduce mountains of paper work with minutes of effort. Delivered six weeks ahead of schedule and fully operational within seven days, the Honeywell computer really means business for Abbey National. Honeywell can help you too.

Honeywell

ELECTRONIC DATA PROCESSING

Moor House London Wall E.C.2 *Metropolitan 9581*

This familiar Abbey National symbol was produced by the Honeywell computer now getting down to more serious work.

HONEYWELL INTERNATIONAL *Sales and Service offices in all principal cities of the world. Manufacturing in United Kingdom, U.S.A., Canada, Netherlands, Germany, France, Japan.*

Figure 2.11 An advertisement for Honeywell and Abbey National. *New Scientist* 21, no. 381 (March 5, 1964): 589.

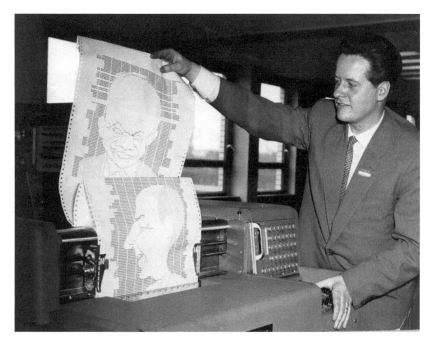

Figure 2.12 Caricatures of US statesmen Dwight Eisenhower and Adlai Stevenson printed by a Universal Automatic Computer, UNIVAC Art, March 13, 1957. Photo by Keystone / Getty Images.

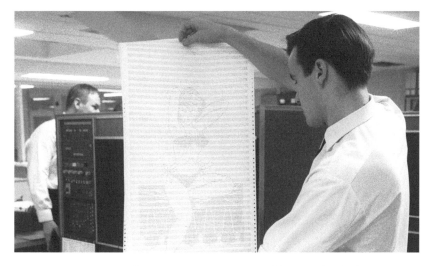

Figure 2.13 A portrait of Sophie. Computing Center of the City of Helsinki, December, 11, 1964. Photo by Olavi Kaskisuo / Lehtikuva.

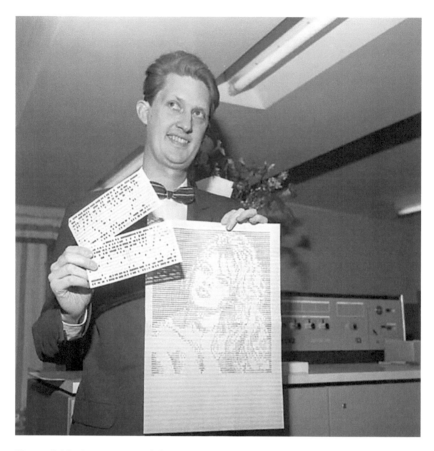

Figure 2.14 Inauguration of the computer center at the shipyard in Uddevalla, Sweden, January 24, 1967. Photo by Arne Andersson.

the British magazine *Picture Post*, which was famous for its photojournalism.[47] The second photo was taken in 1964 in the Computing Center of the City of Helsinki by the Finnish photographer Olavi Kaskisuo, who became known for his celebrity photos but also ran a studio and a photo agency together with other photographers in the 1960s.[48] The last photo was taken in 1967 in connection with the inauguration of a computer center at the Uddevallavarvet shipyard in Uddevalla, Sweden.[49] The photo was published in the staff bulletin with the caption "Head of punch cards Lars Westlund with the portrait of Brigitte Bardot that the computer playfully presented at the 'grand opening.'"[50] Here we have yet another case

of a disclaimer, with the word "playfully" stressing that this is not what the computer normally does when it is busy with more serious work. The other two pictures might have been published in a similar context or in a newspaper report. These institutions shared with computer manufacturers the difficulty of visualizing computing. In order to avoid showing machines that hid most of their activities behind dull panels, the photographer probably asked for a staff member to pose for a picture, preferably showing something visually interesting. Including a piece of ASCII art would then be a natural choice for the setup of the photo shoot. Even if photographs such as these were not advertising photographs in any strict sense, they contributed to creating a softer image of the computing business, and ASCII art was a helpful resource in this endeavor.

In *Computer Lib / Dream Machines*, Ted Nelson explains the commercial aspects of computing. The section called "How computer stuff is bought and sold" is illustrated with a page from a sales leaflet of a software company. Under the heading "Additional programs," some programs that generate ASCII art are listed, including "Santa and Reindeer," "Birth Announcement," "Snoopy," and "Calendar." The "Calendar" section is presented as follows:

This FORTRAN program can produce a calendar for any year from 1968 through 2100. The calendars are printed at the bottom of a Playboy bunny who is perched atop a bar stool.[51]

These posters sometimes stayed in the memory of their owners for a long time. One example can be found at the website of a software engineer who looks back at his long career in the computer trade and shares some memories from his college years in the 1970s. He remembers working with punch cards, paper tapes, and teletypes; interacting with the computer; and running programs:

But what really impressed me the most about teletypes was, hanging on the computer lab wall of this almost all-male school, a printout of a Playboy Playmate centerfold, her form made up of ascii characters. The work that went into generating that! But that was the dawning of the age of internet porn, the birth of the killer app![52]

One of the most popular cartoon characters was Snoopy. Media theorist Peter Lunenfeld recalls "the early days of computer art when Snoopys

Figure 2.15 A pinup calendar. Courtesy of the Computer History Museum. Perhaps this is the picture that was referred to in the sales leaflet reproduced in *Computer Lib / Dream Machines.*

and Christmas trees were spat out by teletypes in computer labs around the country."[53] There are many variations of this Peanuts character, which seems to have been something of a gateway to computing. On the website of a retired chemist and scuba diver, I found this recollection of how he first learned to program:

I started to learn to interface with computers in the mid-1960's. At that time, input to machines was primarily via punch cards (one card per line of code). This led to a computer art form, commonly called typewriter or ASCII Art. (ASCII from the set of rules that defined digital values for all the alpha-numeric characters found on a keyboard). The goal was to create a printed, recognizable image that appeared as if it were done on a typewriter. While the generation of ASCII art was entertainment, it was also a learning tool because it forced the "artist" to develop a sense of input and output using the computer devices of the time. Because of the immense popularity of the Peanuts cartoon strip, Snoopy, Charlie Brown, and the whole assembly of the Charles Schultz created characters were a frequent target among computer students to be assembled into an ASCII image.[54]

The collection of the Computer History Museum includes a number of Snoopy and other Peanuts pictures printed on an impact printer.[55] Other devices were also used, which gave a different appearance to their images. Software engineer Klemens Krause, head of the Computer Museum of the Department of Computer Science at the University of Stuttgart, Germany, recalls:

Snoopy was my second computer-program. I made it in 1972 when our high school bought the first computer, a Wang 600. Output was done by a modified IBM-ball-typewriter. The snoopy was not printed line by line. It was plotted as line art. The print head on this machine could be moved by 1/100"-steps, also the paper drum. So it was possible to plot in very small increments.[56]

The position of Snoopy as something of an emblem of computer culture is evident from Ed Post's 1983 essay "Real Programmers Don't Use Pascal," which became a meme of its time. Post enumerates the characteristics of real programmers: they live in front of the terminal, which is surrounded by piles of program listings, half empty coffee mugs, and operating system manuals, and "taped to the wall is a line-printer Snoopy calendar for the year 1969."[57] The calendar was fourteen years old when the essay was written, which can be interpreted as showing the attachment "real programmers" had to this kind of pictures. They did not care

Figure 2.16 Charlie Brown. Courtesy of the Computer History Museum.

about food or sleep, but they cared about relics from the good old days of computing.

In the category of fictional characters, the Star Trek characters stand out. In 1976, a series of ASCII portraits of Star Trek characters, printed on card stock, was published by the magazine *Creative Computing*. The cover of volume 1 of *The Best of Creative Computing* (1976) features a "computer picture of Mr Spock by Sam Harbinson Carnegie-Mellon (formerly Princeton Univ.)."[58] In an interview in 2009, Samuel P. Harbinson explained how he made this picture in 1973, when he was still a student.

Figure 2.17 Snoopy by Klemens Krause. Made with a Wang 600 computer, printed on a modified IBM ball typewriter, 1972. © Klemens Krause.

He remembers having made other ASCII pictures as well: "There were about a dozen of them: a large picture of the moon; Buzz Aldrin on the moon; Mr. Spock; a Playboy Playmate (Lenna Sjooblom, Nov. 1972, and probably others); my girlfriend's terrier; a close-up of my cat's face; others I can't remember."[59]

The visual repertoire of ASCII art is to a great extent taken from popular culture. Most ASCII art falls into the art historical category of the portrait, including portraits of animals. A special subcategory of the portrait is the nude, from which the pinup is derived, albeit with a few detours from Sandro Botticelli's *The Birth of Venus* and other iconic nude paintings. Art historian Abigail Solomon Godeau has argued that the erotized imagery of women became a cornerstone of commodity culture and a symbol of modernity. Mass-produced images of seductive females were part of the

Figure 2.18 A Snoopy calendar by Peter Olofsson, 1970.

Figure 2.19 Mr. Spock on the cover of *The Best of Creative Computing*, vol. 1 (1976).

visual culture at the dawn of the era of consumption.[60] In the twentieth century, the pinup genre found a forum in magazines like *Esquire* and *Playboy*. The former emerged in the early 1930s, and during World War II, its sultry-looking and suggestively posed "Vargas girls" (painted by the Peruvian American artist Alberto Vargas) were in high demand by American soldiers. *Esquire* also published pictures of independent, working women who were a female ideal when their country needed them. After the war, women were expected to return to the home, a trend that was also reflected in the pinup style. When *Playboy* appeared in 1953, the target group was solely male, and the Playmates were supposed to be docile young women who did not challenge traditional gender roles, sexually or otherwise.[61] Many ASCII art pinups were modeled after Playmates, as is illustrated by the quotes above.

ASCII art was made as entertainment but could be used both for marketing and education. It came to represent computing to such an extent that it was often used for visualizing computing, although the attitude toward the art form was somewhat ambivalent. It had to be used with caution and supplied with a disclaimer that reminded the audience of the seriousness of the computer business. In the age of mainframe computing, ASCII art was print based, but the art form survived and even thrived as ANSI art on bulletin board systems. With the advent of the web in the late 1990s, making ASCII art became one of many playful activities that could be carried out and talked about around the digital campfires.[62]

ASCII ART IN COMPUTER CENTERS

What did computer rooms look like in the 1960s, 1970s, and 1980s? Most existing pictures look like the photograph shown in figure 2.20, which was taken at IKEA headquarters in Älmhult, Sweden, in 1971.[63] This was a time when staff members still wore white coats in the computer room. Most surviving pictures and films about computer centers from the era are promotional materials and official documentation, which makes it hard to know if everyday life in computer centers was ever documented or if such documentation has simply been lost.

In the large computer centers, which were set up by companies and universities, access to the computer room was restricted to the staff in

Figure 2.20 A computer room with an IBM System/360 Model 40 at IKEA headquarters in Älmhult, Sweden, December 20, 1971.

charge. Computers operated according to the principle of batch processing, and central processing unit (CPU) time was expensive and not to be wasted. When a user delivered a program on punch cards, an operator scheduled the job and fed the punch cards into the computer that ran the program. The user sometimes had to wait several hours for the output to be delivered to a rack in the reception area. The sorting of the pages was made possible by a job separator page with user identity and the job identity printed on it in big letters, made with the help of ASCII art.[64] In 1979, in my first year of studying informatics at Lund University in Sweden, the turnaround time was two hours. As a Cobol programmer, if I misplaced one full stop, I had to punch a new card, resubmit the program, and wait another two hours for the printout.

Making ASCII art was not part of the regular jobs of the staff members or students who used the facilities. It was often created when they had a moment to spare. In the same interview quoted above, Sam Harbinson recalls how he made ASCII art in 1973 during his time as an undergraduate in mathematics and computer science at Princeton University. He worked part-time in the Computer Graphics Laboratory of the Department of

Biochemistry as well as at the help desk of Princeton's Computer Center: "That gave me the opportunity to spend long hours with the IBM 360/91 computer, get 9-track tapes, get favors from the operators, etc."[65] At the Computer Graphics Laboratory, there was a densitometer that included a drum scanner that he used for digitizing black and white photographs. He wrote a Fortran program to render the images and mapped the densities to the overstrike patterns that formed his printer grayscale. Overstriking was a feature of the line printers that meant they could print text on top of already printed text, without advancing the paper. He could not oversee the printing himself. Printing belonged to the domain of the operators, who had to be reassured that the strange noise the printer made when overstriking was not a malfunction. Harbinson used trial and error for finding the right overstrike patterns, which were adapted to

our printers, their EBCDIC character font, the black ink ribbons, and the paper the University used. With different printers, I doubt if the gray scales would be quite right. The programs and the raw data perished after I left Princeton. I left the print files on disk, so anyone could print out copies of the pictures after I left. It would be easy to reproduce the technique, but the interesting challenge was working within the limitations of the printers in those days.[66]

This account highlights the dependency of the art form on the materiality of its production process. The variables were several—printer, font, ink, and paper—and they all had to agree in order to produce the correct result. Anyone who wanted to transfer the files to another computer center had to redo parts of the process.

However, most students did not have access to the resources available to Sam Harbinson. In his account "Adventures of ASCII Art," computer scientist Ian Parberry, who had made some attempts at typewriter art in his teens, recalls how he made ASCII art as a student at the University of Queensland:

In the 1970s I used the computer merely as a way to store and reproduce art created by hand. The thought of using a computer to actually create ASCII art had not yet occurred to me because I didn't have access to the scanning hardware (such as that used by Peterson in 1964) needed to input a picture into the computer, nor the amount of disc space needed to store it.[67]

In an interview I did with a person employed by the computer center at the University of Gothenburg, Sweden, from 1965 to 1997, he remembered

how he first encountered text art during his military service, when he worked with message encryption and teleprinter traffic. In 1963, when US President John F. Kennedy was shot, news agencies sent out a picture of the American president, which he and his fellow conscripts printed on the teleprinter. He also remembers a pinup that someone sent out in encrypted form. Had it been sent in plain text, the officers would have discovered it immediately. Since military personnel were not allowed to send private messages, the culprit was scolded for the mischief. The pictures were stored on punched tapes, and when he moved to his job at the computer center at the University of Gothenburg in 1970, he brought a whole library of them with him and converted them to the ASCII format. Once he came across a Fortran program that printed a calendar, written as a programming exercise by students at the Chalmers University of Technology in Gothenburg. He took the source code and added a Snoopy picture with a frame of asterisks. He also remembered printing a version of the *Mona Lisa* on book-quality white paper before Christmas 1976 and hanging it in his girlfriend's house. Among all the calculations that were performed at the computer center, the ASCII pictures were seen as a diversion. They were printed and given away as gifts to friends and as Christmas presents to children. It sometimes happened that researchers who had some computer time left on their accounts printed ASCII art to use up the time. If too many copies were requested, the operators were not happy about having to separate and sort fifty Snoopy printouts, and they regarded this as a misuse of the resources of the computer center.

THE DISPLAY OF ASCII ART

As mentioned above, I have not found any photographs of ASCII art displayed in computer centers, although there is ample written and oral evidence that such pictures existed and were displayed in various parts of many computer centers. According to my interviewees, ASCII art could be seen in the computer room, in offices, and on notice boards, both in university computer centers and in companies. In my previously mentioned interview with Harbinson, he recalled how he put together large pictures from several printouts "and, every so often, late at night, I taped them to the white cinder-block walls of the computer center's 'ready room' (where

jobs were submitted and people waited for their output to be placed in bins). Most people were impressed; no one asked me to remove them."[68]

The large size of the pictures is also pointed out in a comment on a video showing ASCII art being printed that was posted in 2016 by the Computer History Museum:

My dad was in the Air Force and was a computer programmer. I remember him bringing home some ascii art for my brother and sister, mostly Peanuts characters with calendars and stuff. When I went to his building and saw all the rows of tape drives and mainframe equipment there was some giant ascii art in a couple offices on the walls.[69]

A large picture of a locomotive, three meters long, is known to have been displayed in the upper windows in computer centers at that time.[70] Unfortunately, I have found no pictures of this arrangement. The window display means that the picture was intended to be seen by an audience outside the building. It is similar to the contemporary visual culture phenomenon of using office building windows to display images made of sticky notes, sometimes leading to competitions between buildings on the opposite sides of a street. Text messages and images of computer games and cartoon characters appear in the bright colors of sticky notes, looking more like low-resolution early computer graphics used in game consoles and arcade games than ASCII art, but their display strategy is the same.[71]

THE CIRCULATION OF ASCII ART: A GIFT CULTURE?

A major difference between typewriter art and ASCII art is that typewriter art did not have a storage medium besides the finished picture on paper. *Bob Neill's Book of Typewriter Art* includes instructions for how to make each of the pictures in the book, which means repeating every keystroke manually on a typewriter.[72] Radioteletype (RTTY) art was stored on punched paper tapes, and the pictures were also distributed over radio. In the case of ASCII art, decks of punch cards were passed around among students and staff in university computer centers as well as among engineers in computer centers in companies. In the words of one of my informants, a female American engineer who was a student in the mid-1970s: "There were some prized card decks that got passed around for producing the

art and periodically you would see an example in the computer room or someone's dorm room." She adds that no one offered to share any decks with her, probably because of the erotic character of much of the art.

Although some software companies offered ASCII art for sale (see above) and Control Data gave its version of the *Mona Lisa* to customers as promotional material, ASCII art was mostly something that was just handed over to peers. When Harbinson finished his studies at Princeton, he made his ASCII art available to those who came after him: "I left the print files on disk, so anyone could print out copies of the pictures after I left."[73] Apart from being shared among peers, ASCII art was typically given to children who visited the computer center and those who lived with staff members. Another comment about the Computer History Museum video mentioned above, showing ASCII art being printed, testifies to this practice: "So cool . . . I sometimes received ASCII art prints when I went to see the company doing our accounting with my father :))."[74]

In a 2013 letter to the editor-in-chief of the blog *Vintage Computing and Gaming*, a woman asked for help in making an ASCII art banner for the memorial of her uncle, who had been an IBM employee:

In 1979, when I was 9 years old, he gave me a banner for my birthday. It was from the old dot matrix printers. It had a silhouette of Snoopy on the top of his dog house and it said "Happy Birthday Chimene". I literally thought it was the coolest thing. This was before home computers and home printers for our family. The letters were made with x or o or maybe dashes. Because my brain had no conceptual framework for the world of computers, I literally wondered if it was created by magic.[75]

This letter shows the impression such a gift could make on the mind of a child. Twenty years later, the allure of ASCII art was built into the concept of an artistic installation by Vuk Ćosić. In the 1999 show *net_ condition* at the Zentrum für Medientechnologie in Karlsruhe, Germany, Ćosić's *Instant ASCII Camera* took photos of visitors and printed them out on supermarket receipts that were given to the visitor as a token of the event.[76] A piece of ASCII art is still considered a suitable giveaway by heritage institutions related to computing. The Computer History Museum, for instance, prints ASCII art for its visitors.[77]

From an anthropological perspective, ASCII art can possibly be considered as part of a gift culture. In his seminal book *Essai sur le don: Forme et*

raison de l'échange dans les sociétés archaïques (Essay on the Gift: Forms and Functions of Exchange in Archaic Societies) from 1925, the sociologist Marcel Mauss outlines the characteristics of a gift economy where social bonds are formed by gifts and countergifts. Gifts are not "free." They are expected to be reciprocated and help establish hierarchies in a community. Mauss further claims that it is not possible to separate the gift from the donor, who leaves some trace of her personality in the object given.[78] The open source movement formed in the late 1990s has been characterized as a gift culture by one of the founders of the Open Source Initiative, Eric S. Raymond. In his essay "Homesteading the Noosphere," first published in 1998 and then revised a number of times in the two following years, he argues that reputation is one of the main gains for participants in the gift economy of the hacker milieu and that it is especially valuable in this kind of community, where attention can open the door to future collaborations with others.[79] ASCII art exchange and distribution can be seen as forerunners of this movement. In my study, I have come across several statements that appreciate the impact ASCII art made on children and adults. Harbinson recalls that when he put his printouts on display in the computer center, "Most people were impressed."[80] The software engineer quoted above was very impressed by the work that had gone into the making of the Playmate picture. One of my questions in the interviews asked about the purpose for making ASCII art, and one interviewee answered, "The main reasons for the real ASCII art was for the creators to, well, create really—sometimes to show how good / clever they were." In the corporate setting of Control Data, the reason for giving the customers the *Mona Lisa* print was to make them realize the great potential of the company's equipment.

If ASCII art is to be seen as a gift culture, what did recipients give back? They could help build the reputation of the practitioners, in cases where these were known. Harbinson was one of the few who put his name at the bottom of his pictures, but much ASCII art was anonymous. However, by passing on the card decks and files and displaying the pictures, the recipients paid the gift forward and made the art form into a widespread phenomenon. The effort required to make this contribution—to print a new picture from a file or make a minor adjustment to it—was rather small and could be managed by many people. Later attempts to form an

open source culture focused on computer graphics (such as the Blender Institute, a 3D computer graphics community that was launched in 1994) have proven less successful, according to a study by media scholar Julia Velkova. She argues that the organization does not really work according to the principles of an open gift economy to the extent claimed by Blender, mainly because the skill level required to make any real contribution is too high for amateurs outside the core team of developers. Instead of being peers, they can only take the weaker position of customers and users of the software produced by Blender.[81]

In the introduction to his book on typewriter art, Bob Neill explains how to read the instructions, which use the same logic as knitting patterns: "If the pattern reads:- 4@ 3: 5& 3S 4. 1@ 1' 1: 2S you would type : @@@@:::&&&&&SSS @':SS."[82] The open source culture of ASCII art shares similarities with the exchanging of craft patterns and food recipes, cultural practices that also depend on a wide dissemination of mainly anonymous artefacts. Patterns and recipes need not be invented by each new practitioner. They are freely shared and sometimes adapted or modified. In the postdigital era, the paths of ASCII art and craft are crossed, as shown, for example, by the Open Source Embroidery (OSE) project. The aim of the initiative was to investigate collaborative and material artistic practices, especially digital materiality.[83] The "hard" world of hardware and the "soft" world of textiles come together in a way that shows how the postdigital hacker attitude is prevalent in the contemporary maker and DIY culture, where the borders between the analog and the digital have been blurred. This is also what Rüdiger Schlömer sets out to achieve in his book *Typographic Knitting: From Pixel to Pattern*.[84] A search for "ASCII art" in GitHub, a software repository used for many open source projects, renders 3,785 hits. There are also some craft patterns, such as the Open Source Craft project.[85] If Bob Neill published his book of typewriter art today and if Harbinson created his ASCII art today, they probably would put their work on GitHub for the benefit of the open source community.

PRINTING AS PERFORMANCE

ASCII art was printed and displayed on walls and in windows, but it was also used for interactive entertainment in hardware demonstrations of

mainframe computers in the 1960s. The IBM 1401 was launched in 1959 together with the 1403 printer, which could print 600 lines per minute in 132 print positions, which was a great improvement over previous technology.[86] The wide fanfold paper that emerged from the printer inspired uses other than just printing business reports and source code listings. A risqué computer program called Edith was invented to run on this IBM setup, and it was circulated widely.[87] The origin of the program is unknown, but it was not an official demo authorized by IBM.[88] There were several versions, with different pictures and different languages. It made the printer into the mouthpiece of a supposedly thinking computer that shared its thoughts with audience members and urged them to take different actions in order for the performance to continue. Quite early on, it became obvious that what occupied the mind of the computer was women. The program was divided into three or four acts, according to a striptease logic, keeping the audience in suspense for what was to happen next.

When the Computer History Museum ran the program in 2018 on the request of a researcher in film studies, the crew was gathered around the printer for the demonstration with mixed feelings of expectation and embarrassment. The program they had found in one of their unsorted card deck files was about to begin. The first page that emerged said, in capital letters,

Dear friends,

We would like to show you the personality of the machine you see in front of you. You probably thought a machine was an inanimate object. This is not so, as you will see. Would you like to see what a machine thinks about. Just give me a minute and I will show you what I think about when I am idle.

[paper advances to next page]

Just a minute, please. I am almost ready.

[paper advances to next page]

Now I will show you what I am thinking about. However, before I start, I think it would be best if women and children left the room . . .

[Edith appears in bikini]

Figure 2.21 A screenshot from "The IBM 1401 Mainframe Runs 'Edith,'" YouTube, June 2, 2018. © CuriousMarc.

At this point, the program was halted and had to be rerun. This time the program went a step further, and Edith appeared topless before the program halted again. The crew found another version, stored on a PC, and punched a new deck from it. This version was in German, but the dramaturgy was the same. The audience is encouraged to flip switches on the computer, and for each switch, the woman appears with fewer clothes. A warning is issued for flipping the next switch, but when the audience is made to think that the woman will appear naked, she covers herself with a sign that says that you cannot do anything you like with a 1401 computer. If one flips the last, "forbidden" switch, she will be shown fully nude.

The suspense is built up partly by the text messages (which appear on their own pages like intertitles used to appear in silent movies to explain the action or convey the dialogue) and partly by the process of printing (which lets the image emerge gradually as the paper is fed forward in jerky movements by the sprockets). In terms of interactivity, it is a clever move to make the audience influence the action by using the switches as input devices, in an age long before screens and keyboards. The printer is turned into a media machine that is capable of narration, interactivity, and a dynamic display of images in front of audience members gathered

Figure 2.22 A screenshot from "The IBM 1401 Mainframe Runs 'Edith'" (German version), YouTube, June 2, 2018. © CuriousMarc.

around its bulky body. The theme of the performance taps into erotic fantasies but also into fantasies of the thinking machine. The electronic brain was not only a figment of the imagination and a common feature of science fiction in the 1960s, but it was also central to the new research field of artificial intelligence.

The reenactment of the Edith program is a perfect example of what it takes for an institution to preserve digital cultural heritage (as I mention above in the "Archives and Source Materials" section in chapter 1). First, it needs an operable computer and printer from the same era as the program; second, it needs a physical carrier with the program (in this case, a deck of punch cards); and last but not least, it needs a group of people with knowledge of how to run the program and operate the computer equipment. Without this combination, the archive would be empty or at least incomplete from a media archaeological point of view. Furthermore, the reenactment also demonstrates the implications of Kirschenbaum's concept of forensic materiality. His analyses of literary works were based on the disk storage media of the 1980s. He intended his book *Mechanisms: New Media and the Forensic Imagination* "to serve as a kind of primer on the preservation of digital literary history."[89] The Edith program is reassembled through the combination of a card deck in its original paper

format and a freshly repunched card deck made from an "electronic" file found on a PC. These are the material circumstances of the preservation of this piece of visual culture.

The Edith program seems to have been the first performance of its kind involving a printer, but it was not the first time expensive computer equipment was used for producing pinups. Edith had a precursor that was surreptitiously introduced in the US Air Force's Semi-automatic Ground Environment (SAGE) air defense system in the late 1950s. The huge computer system included a screen with a "situation display" and a light gun that could be directed at the targets to obtain further information about them. A programmer created a picture based on the December 1956 calendar girl of the men's magazine *Esquire*, and it appeared correctly on the screen if the switch between the two main computers went as it should. In other words, it functioned as a diagnostic tool.[90]

Pinups seem to be a persistent theme in the early history of computer graphics, which can be explained by the male-dominated world of computer science. The climate today is different, as the crew at the Computer History Museum seemed to be well aware of when they engaged in the media archaeological endeavor of recreating Edith. At the end of the video, the crew starts the preparation for the next regular demonstration at the museum. When CuriousMarc asks them jokingly, "You are not going to show Edith in your program, I'm afraid?," they smile and shake their heads, and one of them answers, "This is a family place."

Another case of media archaeology is the attempt to recover early personal computing software from tapes belonging to the microcomputer MCM/70 that was carried out by computer scientist Zbigniew Stachniak at the York University Computer Museum (YUCoM) in Toronto, Canada, in 2016. Among the files recovered from a 1975 tape containing demonstration programs, a program was found that printed the *Playboy* logo as ASCII art. Stachniak made the following reflections:

the inclusion of the Playboy logo ASCII art on the tape suggests that in mid-1970s, the PC end-users as conceptualized by MCM were predominantly heterosexual males. In the early 1970s, there had been several categories of ASCII art that MCM could have used for its demo tapes. Portraits of politicians were popular subjects of such an art (e.g., of Lincoln and JFK) and so were real and fictional celebrities (e.g., Marilyn Monroe, Mr. Spock, Mona Lisa, and Snoopy).

MCM seemed to leave distributors with little choice but to present the company's unique and progressive vision of personal computing against a backdrop of the parochial computing culture of the 1970s.[91]

What was at the time seen as legitimate imagery is today seen as sexist. ASCII art was used in marketing in several ways. The advertisement for Honeywell and the *Mona Lisa* print were suitable for more public spaces, whereas Edith and the *Playboy* logo were shown in the more restricted and predominantly male circles of computer staff. However, the commercial use of the risqué material would not have been possible without the proliferation of printed ASCII pinups in computer rooms and dorm rooms that formed the base of this branch of the ASCII visual culture.

COLLECTING ASCII ART

Although the ASCII art form seems to have thrived in the 1960s and 1970s, not much remains of its printed material. Fanfold paper was not made to last, and many posters were taken down and thrown away when students graduated and left the campus and when computer centers were reorganized or moved into new venues. Some of my informants saved a few printouts as keepsakes from their student years or their early workplaces. There are some private collectors, but the folksy art form seems to have gone under the radar of most cultural heritage institutions. It is hard to find ASCII art in the collections of museums and archives. For instance, a search for "ASCII art" in the Europeana web portal returned zero hits. The art form falls between two stools and has no natural institutional residence, being too artsy for technical museums and too technical and mundane for art museums. Technical museums have focused on collecting hardware and evidence of the "real" business of computing, and that focus does not include the wanton creation of pictures with equipment not intended for that purpose. In the collection of the Computer History Museum, however, there are some posters, books, and conference proceedings related to ASCII art. One of the posters is a copy of *Mona by the Numbers*, and there is also an item cataloged as "ASCII art from impact printer," consisting of thirty-nine pages of ASCII pictures printed on fanfold paper, mainly Snoopy calendars and pin up girls, some of them running over more than one page.[92] *Mona by the Numbers* can also be found

in the collection of Zentrum für Kunst und Medien (ZKM), where it is cataloged as "computer-generated, print, plotter drawing." The museum also has a work by Waldemar Cordeiro, *A Mulher que não é B.B.*, cataloged as "print, computer-generated." There exists a great variation in the categorization of this kind of picture, and the lack of a consistent terminology makes it hard to find ASCII art in collections. This highlights how important metadata is for research, another aspect of formal materiality of digital artefacts.

Very few traditional art museums have ASCII art in their collections. The Museum of Modern Art in New York has two works by Waldemar Cordeiro (see above) but not Harmon and Knowlton's *Studies of Perception #1*, which was shown in the *Machine as Seen at the End of the Mechanical Age* exhibit in 1968 and 1969. The Victoria & Albert Museum in London, which focuses on design and decorative art, has some portraits of singers and other celebrities made by Jaume Estapà in the late 1960s.[93] The museum also has a copy of *Studies in Perception #1*: "This is a smaller and more recent version of the image, produced in 1997 as a limited edition print."[94] This information is interesting because it indicates that the work is treated according to the rules of art photography. There are vintage prints that were printed by the artist and later prints. The former are more valuable. The limited edition is a method used both in the graphic arts and photography in order to increase the value of single prints, and it is a custom that works against the potential for multiplicity inherent in these art forms.

Prints of ASCII art are bought and sold in different kinds of marketplaces. Auction houses have sold Harmon and Knowlton's *Studies of Perception #1* as well as works by Waldemar Cordeiro.[95] Prints from the popular culture sphere also are offered for sale, but they are sold on eBay rather than through auction houses. One advertisement on eBay has the caption "Extremely Rare Star Trek Mr. Spock ASCII Art Chaintrain Line Print 1979." It is printed on fanfold paper, and the pages can be combined into one large poster. The specifications read:

This printout has never been unfolded (except to take these pictures), and has been stored in the dark since it was printed in 1979, so the paper is like new. There are 36 individual pages; when fully put together, the picture is ~3 × 5 ft or so! (the picture of the complete print is stock)

There are very few original copies of this unique piece of computer history, and especially those of the iconic Leonard Nimoy as Mr. Spock . . . so take this opportunity to own it for posterity![96]

Another advertisement for a print from 1973 also stresses the rarity of the artefact for sale (shortened version):

Rare ASCII (ASS—kee) Princeton Computer Lab Print 1973 by Samuel P. Harbison.
After some research we came to find out that this particle [*sic*] print was used to raise money for the original Princeton University Computer Programming School. The Mr. Spock first run was done in four panels.
. . .
This piece is definitely original. We asked a framing store when they thought the frame is from.
Their best guestimate was late 70's early 80's which dates the print accordingly.
. . .
Some ripples are present since it was mounted to cardboard and framed.
Overall excellent examples of the earliest known ASCII artwork!
This poster most certainly belongs in a poster only auction.
Mr. Spock is in an 17" × 22" Black Metal frame. Boarders of poster all intact.
This is such an unbelievable cross genre / class collectible.
Appealing to Sci Fi—Star Trek—Computer Historians—Princeton Alumni.
Serious Star Trek Collector's realize how scarce this example of ASCII artwork is.[97]

These advertisements use a similar rhetoric. As is customary on auction sites, the material qualities are described in detail—the pristine condition of the paper in the first ad and the frame and the board in the second ad. The provenance is of interest, but the rarity and the importance for computer history are perhaps the most important aspects. The assessment of an external expert of the age of the frame is used as a guarantee of authenticity and its status as a vintage print.

The collecting of ASCII art follows the same line of demarcation that was drawn up in 1960s between art and engineering and that was discussed in the section on "Art and Experiments" above. The art institutions collect the art pieces, the technical museums collect the anonymous ASCII art, and the museums with an in-between position, such as ZKM, collect both "art ASCII art" (such as Cordeiro's works) and "technical ASCII art" (such as *Mona by the Numbers*). When presented on a marketplace, the art market vocabulary and selling points dominate in both categories.

The eBay site is not an archive in the traditional sense, and it does not secure long-term storage. It is distributed and ephemeral, and listings exist only for a limited time. However, as design researcher Matthew Bird argues, eBay and similar sites are a resource for research in design history: "But increasingly, digital resources like auction websites, online museum collections, patent archives, and even eBay and Tumblr offer information about the history of design that archives do not."[98] While museums often hold objects in pristine condition, secondhand marketplaces can offer unused things as well as things with patina and signs of wear and tear. For media archaeologists, these marketplaces can supply valuable information and even allow them to buy items to start a collection of their own.[99]

ASCII ART AS A POSTDIGITAL PRACTICE

In the postdigital era, the computer has become a full-fledged visual medium. ASCII art is still being made but not because there is a lack of other options for making pictures. There are programs for making vector graphics, raster graphics, 3D graphics, and game engines, to name a few of the digital tools now available. Taking, editing, and sharing photographs with a mobile phone have become general competencies. ASCII art today is made against a different backdrop than existed when computers were nonvisual machines. There are many free tools that do not require any programming skills and that can provide social media users with design elements and give their accounts a certain look.[100] Some programmers have devoted time to the development of new, advanced ASCII art tools. On its website, the Dutch type foundry Underware presents a new ASCII art generator that retains more detail in a photo converted into ASCII art than older methods do. The company claims that

ASCII art itself has been declared dead by Microsoft in 1998, in favour of other formats like JPG and GIF and the promotion of proportional fonts. But ASCII art is still alive as ever, at least in our own studio. We love ASCII, we grew up with ASCII. We are ASCII kids. However, current technology allows for much more advanced ASCII art than in the 1970s. This is why we imagined to develop "subpixel ASCII art." Same simplicity, but much more precise results.[101]

Developing more sophisticated methods for an outdated technique might require a postdigital hacker attitude. There are also programmers

who celebrate the old hacker culture by the "reenactment" of classic art pieces, such as the Snoopy calendar from 1969 that is mentioned in Ed Post's essay "Real Programmers Don't Use Pascal." The owner of the blog *The Abandoned Place* wrote the post "Snoopy Calendar Is Forever (C++)":

I decided that I rewrite the Snoopy calendar in C/C++. And why? Do you think it is heresy? Is it pointless? The Fortran codes are available here and here, I can compile it in ten minutes, I just wasting my time? Well, you are right. But I wanted to feel the passion, I wanted a quick C++ project (the development of the C++ Snoopy calendar take about 6 six hours), and I wanted to compare myself to these so-called real programmers.[102]

Another blogger, the owner of *Mike's Computer Nerd Blog*, who also wanted to pay tribute to the old hacker culture and Post's essay, made a version of the calendar:

I have a certain fondness for this particular gimmick which I can't quite explain. Perhaps it is the fact that it provides a feasible and exciting challenge for me— that of making my own Snoopy calendar. I have actually done this a couple of times. This time I used a combination of C programming and several Unix programs like `enscript`, `figlet`, `cal`, and `sed`.[103]

These blog posts show that people sometimes relate to the history of their trade by going back in time and at the same time going forward, by applying new tools for solving an old task and thereby bringing the practice of making ASCII art into a contemporary technological context. These are two good examples of what it means to adopt a postdigital hacker attitude. ASCII art lives on—not just by being reproduced on websites, on T-shirts, and in email signatures but also by being invented anew in terms of its creation process. A question that arises is whether the attitude required to make ASCII art in the 1960s was postdigital from its inception. I would argue that the creative mindset required to subvert the original intention of the line printer at the time, long before the digital became commonplace, has a strong affinity to the postdigital attitude.

3

DOMESTICATED ALIENS
MACHINE-READABLE TYPEFACES IN POPULAR CULTURE AND BEYOND

Reading large amounts of information is a laborious and time-consuming endeavor. In the mid-twentieth century, business and administration were fields where human reading capacity became a problematic bottleneck and where the need for machine-readable data led to the development of machine-readable typefaces. In the 1950s, two different technologies were developed in parallel the United States—magnetic ink character recognition (MICR) and optical character recognition (OCR)—and each gave rise to typefaces that required a fundamental rethinking of traditional typographic principles. These creations looked rather alien to the human eye, like Frankenstein's monsters assembled from ill-matching parts. Differing from traditional typographic aesthetics turned out not to be a negative, however, but instead to be an asset in certain cultural contexts. In the 1970s and 1980s, typefaces derived from the original machine-readable typefaces found a wide application in computer magazines, science fiction literature, and art publications. The alien forms were domesticated, and a functional necessity was developed into a style that became charged with connotations of the future. These included dreams about the potentials of computer technology as well as apprehensions about the arrival of a surveillance society. In the new millennium, machine vision sharpened, and computers today can read normal printed text and detect many other visual features in our environment.[1] In this postdigital era, surveillance has become integrated into everyday life to such an extent that we rarely notice the cameras that record our movements in public space.

This chapter contains narrative, visual, and semiotic analyses of films, books, book covers, a work of art, a magazine article, and a company's

visual identity where these typefaces play a vital role. I have identified three main categories relating to the perception of technology and have chosen cases that highlight these categories from the 1960s to the present day.[2] In the final sections, I draw together the main themes. The overarching questions asked are: What different meanings can the typefaces assume in different times and contexts? What roles do the typefaces play, and how do they perform these roles? What different connotations can they carry?

THEORY AND METHOD: SEMIOTICS AND VISUAL ANALYSIS

In her classic speech from 1930, "Printing Should Be Invisible," scholar of typography Beatrice Warde conjures up the ideal of typography as a crystal goblet that does not obscure its content. She contrasts this transparent vessel with a golden goblet that, however valuable, cannot perform the same service for the text that the crystal goblet could. Typography should not take center stage but play an unobtrusive role.[3] A similar dichotomy, although without the same normative intent, is presented in Johanna Drucker's *The Visible Word: Experimental Typography and Modern Art, 1909–1923*. She uses the labels *marked* and *unmarked* to distinguish between the ways typography is deployed in commercial and literary texts. She traces this distinction back to the dawn of book printing, when the first printed bibles represent the unmarked text where words "appear to speak themselves" and text flows in even blocks across the pages. The marked text, on the other hand, uses a variety of typefaces and structural devices to make the text grab the attention of the viewer. This conspicuous form of typography thrived especially in advertising in the nineteenth century, when a change of attitude toward design occurred.[4]

The machine-readable typefaces used in popular culture in the 1970s and 1980s fit very well in the marked text category. These typefaces are remarkable in the literal sense of the word and would not form a grey area on a page. Instead, they are used to be read along with the linguistic meaning of the text, and that is why I have chosen to make close readings of a number of discursive and visual artefacts that are dependent on the typefaces for their semiotic meaning. The case of machine-readable typefaces demonstrates the relevance of Drucker's model of materiality and the interplay between the conditions of production and the social

context. (In this case, the production context regards the design of the typeface, not production in terms of printing text, which is focused on in the next chapter.) Rather than looking at the characteristics of an object, she understands materiality as a process of interpretation. This approach to materiality is the foundation for the following analyses.[5] To understand how meaning is achieved, one needs to start with a formal analysis of the artefacts and examine them from the point of view of composition, color, shape and forms, texture, and lines, to name a few of the categories an art historian uses to approach an artwork or another kind of visual artefact. In the following analyses, I consider how the typefaces are used in a specific context and how their formal qualities are used as semiotic resources in order to convey a message.[6] Special attention will be paid to the interplay between the typeface and other visual elements and to the role played by typefaces in a narrative.

MAGNETIC INK CHARACTER RECOGNITION (MICR)

In the postwar era in the United States, as banking services became available to a wider spectrum of society, many more people opened personal checking accounts, which hugely increased the number of checks banks had to handle. Since the processing was largely manual, the situation soon became untenable. In the 1950s, in cooperation with Bank of America, the Stanford Research Institute embarked on an automation project that led to the invention of a check coding system based on magnetic ink. For Bank of America, it was important to avoid major alterations to the check, which it regarded as an emotional link to the customer. A system based on punch cards was therefore out of the question, and solutions based on adding strips of paper or using fluorescent ink were also considered unfeasible. The research team concluded that magnetic ink was the only possible way forward, but how would the codes be designed? Barcodes were easy to read for computers but illegible for humans. Instead, a set of characters was devised, consisting of ten digits and four extra glyphs, that together constituted the magnetic ink character recognition (MICR) font. It had the advantage of being readable by both machines and humans, which was necessary for staff members to be able to handle errors manually. In 1959, the banking industry settled for this solution,

Figure 3.1 The E-13B typeface (Universal MICR Pi). © 2022 Monotype Imaging Inc.

and by 1967, it had become widely implemented and could be seen on most American checks.[7] The font is called E-13B and does not follow traditional typographic rules and conventions. While some traditional typefaces, such as Bodoni, are characterized by a strong contrast between thin and thick strokes, no predigital typefaces have the strange arrangement of thick elements that E-13B has, such as a number 1 that seems to stand on a heavy, square podium and a number 3 that has a lower back that is much thicker than the upper back.

The system is still in use, and the font still attracts attention because of its odd appearance. For instance, Digital Check's website has an educational article with the title "Why Does the Magnetic MICR Printing on Checks Use Such a Weird Font?" that explains how the magnetic ink needs to be applied in a certain thickness and that "all the weird bulges" are there in order for the magnetic reader to be able to pick up the signal and distinguish between the different characters.[8] The MICR line, also called codeline, at the bottom of the check has room for sixty-five digits, including the bank's routing number, the checking account number, the check number, and the check amount. As graphic designers Mark Owens and David Reinfurt observe, "By the 1960s, E13B had entered the popular imagination and quickly became a typographic signifier of the emergent human / computer interface and the intersection of money and technology."[9] E-13B had a number of successors, notably Data 70, which have been used in all sorts of contexts.[10]

THE SPIN-OFFS OF E-13B

The typefaces inspired by E-13B tapped into its connotations of computer technology and a high-tech future. They were given names such as Amelia, Computer, Data 70, Magnetic Ink, Orbit-B, and Westminster. One of

Position

Magnetic Signal

Figure 3.2 Positions and magnetic signals in the E-13B font. © Digital Check Corp.

Figure 3.3 A sample of the Data 70 typeface. © 2022. Screenshot taken from MyFonts at myfonts.com with permission of Monotype Imaging Inc.

the most prominent was Data 70, designed by Bob Newman for the Letraset Type Studio in 1970. The company produced dry transfers that made display typefaces much more accessible, and they became popular with both professional and amateur designers.[11] Although Leo Maggs designed a similar typeface in the mid-1960s that was called Westminster, Letraset's global reach in the market led Data 70 to become the most widely used typeface. In the words of Owens and Reinfurt, "As a signifier of the future, Data 70 was thus equally loaded with utopian promise as well as Orwellian dread."[12]

This ambiguous allure was something Data 70 shared with the other E-13B descendants. Formally, they were all furnished with bulges, distributed in slightly different ways over the letterforms. In some typefaces, such as Computer and Magnetic Ink, a little detached block had been inserted between the legs of and in the openings of the letters *N, M,* and *W.* The golden days of this motley crew of typefaces are gone, but they have not fallen completely out of fashion and are still used for some purposes. As the graphic designer Paul McNeil, author of *The Visual History of Type*, concludes his account of Data 70: "Today it continues to resonate somewhat ambiguously as a typographic expression of printed

MOLECULAR

Figure 3.4 A sample of the Computer typeface. © 2022. Screenshot taken from MyFonts at myfonts.com with permission of Monotype Imaging Inc.

Simple

Figure 3.5 A sample of the OCR-A typeface. © 2022. Screenshot taken from MyFonts at myfonts.com with permission of Monotype Imaging Inc.

circuit boards, retro science fiction stories and vintage computers. It lives on as a vision of the future from the past."[13] The spin-offs of E-13B lead a postdigital life in a society that has seen some of the visions of science fiction being realized and normalized.

OPTICAL CHARACTER RECOGNITION (OCR)

In optical character recognition (OCR), printed text is read by a scanner and converted to alphanumeric characters. OCR is more flexible than MICR in that ordinary ink can be used, and nowadays, a wide variety of letterforms can be read. However, when the technology was introduced in the 1950s, special fonts had to be developed, and just like E-13B, typefaces made for OCR were a compromise between what humans could read and what machines could recognize. Characters with similar forms—like capital *B* and the number 8, which could easily be differentiated by humans—presented difficulties for computers. Consequently, such characters had to be redesigned with an eye to increasing the contrast between them. The typeface OCR-A was developed in the early 1960s by American Type Founders, and the United States of America Standards Institute (USASI) made it a standard in 1966.[14]

The characters of OCR-A are angular in shape, and some capital letters, notably *G* and *Q*, have a pronounced slant to the right. The *O* has the

Simple

Figure 3.6 A sample of the OCR-B typeface. © 2022. Screenshot taken from MyFonts at myfonts.com with permission of Monotype Imaging Inc.

form of a diamond, and the curves of *C* and the *D* are broken in the middle. All the letters are strange in their own special way and do not seem connected by a common design concept as letters in a typeface usually are. This very alien typeface was later domesticated in Europe. According to type designer Adrian Frutiger, the European Computer Manufacturers Association (ECMA) was of the opinion that OCR-A was never going to be accepted in Europe, and in 1963, Frutiger was commissioned with the task of designing a more aesthetically satisfactory version of what he and his colleagues used to call the "robot type."[15] It became OCR-B, first published in 1965 and later extended several times.

Both OCR-A and OCR-B became international standards in 1976.[16] Although Frutiger had to adapt the typeface to a number of technological constraints, he had at his disposal a finer grid, 14 by 19 cells, compared to the developers of OCR-A, who had only 5 by 9 cells.[17] Since most information that was formerly transferred to digital form by OCR is now born digital and since OCR scanners have become much better at recognizing normal printed text, the need for special OCR typeface has nearly disappeared. However, OCR-B is still used in combination with barcodes and for some banking applications, such as paper-based payments, mainly in the encoding line. OCR-A has become something of a classic and was among the twenty-three typefaces the Museum of Modern Art in New York acquired in 2011.[18]

The saga of OCR-A and OCR-B did not come to an end when they became obsolete in the technical sense. According to Heidrun Osterer and Philipp Stamm, the editors of *Adrian Frutiger—Typefaces: The Complete Works*, the two typefaces "eventually found their fashionable expression in the graphic design of the 1990s where they were seen as techno, cool and trendy."[19]

FROM EMERGENT TECHNOLOGIES TO ESTABLISHED INFRASTRUCTURE

In the second half of the twentieth century, computer technology was promoted as a promising technology of the future by members of the computer industry and researchers in artificial intelligence, although there were also skeptical voices.[20] Engineers adopted the new technology, which greatly alleviated the burden of calculations, but there was a certain conservatism in the trade. In the early 1980s in the technical industries, where engineers had become used to working with mainframe computers, there was a reluctance to shift to new technology in the beginning. Around the turn of the millennium, major transformations in the media-technological landscape were taking place, and in the 2010s, digital telecommunications and the internet had become a commonly available infrastructure, at least in the Western world. The three following examples—an article in a computer magazine, an exhibition catalog, and a visual identity program—illustrate this development.

PERSONAL COMPUTING

In computer magazines in the 1970s and 1980s, Data 70 was often seen in advertisements of computer manufacturers and shops as well as in editorial material. Louise Kehoe's article "Engineers Get Personal with Computers," which appeared in the October 1981 issue of *Personal Computing*, uses a customized combination of Data 70 and Computer set against a red-and-black background photograph of a construction site. Workers are climbing ladders, and a big crane is visible at the left of the picture. This article also uses the typeface for drop caps (large highlighted initial capital letters) and for pull quotes (sentences pulled out of the text and displayed by means of layout) in the pages that follow.

The article is not futuristic. It is about the present and the near future. The argument is that engineers could benefit more than they think by acquiring personal computers. Many engineers were used to mainframe computers and their high processing capacity and tended to underestimate the usefulness of small hobby computers. Some early adopters are interviewed and share their experiences. In contrast to big computers that rely on time sharing, the personal computer is "instantly accessible,

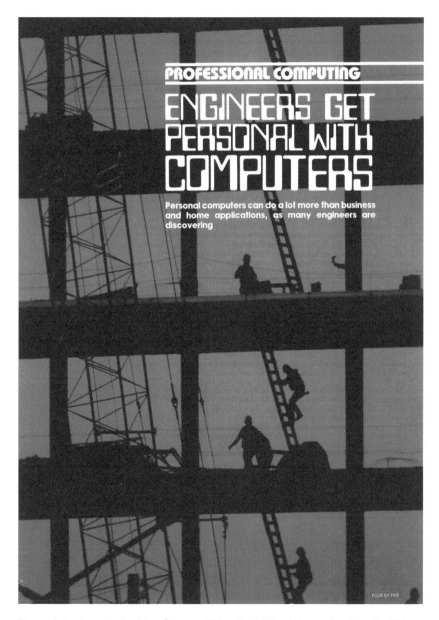

Figure 3.7 A customized typeface combining Data 70 and Computer. In Louise Kehoe, "Engineers Get Personal with Computers," *Personal Computing*, October 1981, 24, 26.

PROFESSIONAL COMPUTING

with somebody else's job.

"I can sit at my desk, turn around and solve a problem on the computer and then turn back to what I was doing," says Grant W. Ireson, professor of industrial engineering at Stanford University. "I used to use LOTS (Stanford's Low Overhead Terminal System—the main student computer facility), but you have to get an assigned time, usually a 30 minute slot, and there is often a queue, even at 10 o'clock at night," Ireson explains. The loss of time in

computers and interface units used to control laboratory equipment, according to Ed Eversole, technical advisor on engineering computers in Rockwell's electronics operations. "We had been trying more expensive small computers through Hewlett-Packard IEEE 488 interface boxes. The interface boxes alone cost almost as much as the personal computers which incorporated the interface," he recalls. "When we heard about the Commodore PET (which has an IEEE 488 interface) we said 'This

Commodore system. "The best I can come up with is that I liked the compact unit and the green, non-reflective display."

Rockwell purchased the PET because it has the IEEE 488 interface, explains Eversole. He adds however, that the company is biased towards the PET because it is based on the 6502 microprocessor. Rockwell is a second source for the 6502. "We have a lot of engineers who are very familiar with the 6502, so it makes sense to use a machine based on it," he explains. Rockwell engineers are offered an automatic payroll-deduction scheme enabling them to purchase PETs on favorable terms, and already hundreds of them have done so. Others have chosen another company offer to buy a Rockwell AIM computer, also based on the 6502. Rockwell is now planning to purchase more PETs from Commodore for use in engineering departments.

Engineering applications for personal computers will increase 25-30 percent annually over the next few years, in terms of the number of units purchased.

getting to use the computer was Ireson's primary reason for obtaining the personal computer. "Convenience is a major advantage," he notes.

"I used to have lots of problems with operators losing data or making other errors," says Brook Kraeger, another one-time user of mainframe facilities who has turned to a personal computer for much of his work in rain-flow analysis. Kraeger also brings up the low cost of personal computers as an important reason for buying. "In a three year period we spent $30 to 40 thousand on computer time," he says. Compared to these expenses even the relatively high-cost Cromemco system looks inexpensive.

At Rockwell International, personal computers were first purchased as a lower cost replacement for mini-

has got to be a winner' and sure enough it worked."

On a whim

Although engineers may have solid reasons for buying personal computers, their choice is often a matter of chance. "I looked at the Apple and the Radio Shack TRS-80 as well as the Commodore PET when I was shopping for a computer," recalls Leslie M. Buckingham, an engineering consultant specializing in producing cost-estimate reports for engineering projects. "I didn't look beyond these three because I was not thinking of getting into anything more expensive." Like many engineer purchasers, however, Buckingham is hard-pressed to come up with any good reasons for his selection of the

Win Stuckey, who has his own engineering firm in Newberg, Oregon, works in the areas of structural and civil engineering and does a lot of surveying work. He bought an HP-85A a year ago with an HP software package for surveying. It was the availability of the software that he needed which dictated his choice of the HP machine. Like many engineers, Stuckey had previous experience with HP instrumentation, and was also influenced because he felt that HP is a reputable supplier and supported its products well.

"Different machines are good for different jobs," suggests Dr. Scott Cuttler, manager of the microcomputer development group at General Electric's Research and Development Center in Schenectady, New York. His research group uses 25 personal computers including machines from Commodore, Radio Shack and Apple. "We bought the Commodore PET first because it was the first personal computer that

Figure 3.7 (continued)

under their own control and never tied up with somebody else's job."[21] The article says that the small computer is more convenient and that although the software available on the market is mostly developed for administration and business purposes, the number of engineering applications is increasing.

The role of the typeface in this article is to attract the attention of its target group—engineers. The *E* in the first word in the title, *Engineers*, is repeated three times as drop caps in the text and in the text frames. Apart from providing the feature article with some attractive framing, the mix of two typefaces used in popular culture, Data 70 and Computer, reminds engineers that they need to keep up with their times and stop viewing the small computers as toy machines or as machines that can be used only for simple tasks. The typography signals that the shift away from mainframe computers to work stations and personal computers is underway.

NET_CONDITION: ART AND GLOBAL MEDIA

By the beginning of the 2000s, the internet and especially the World Wide Web achieved a major impact on both private and public communication and presented a challenge to traditional media channels. An art project called *Art and Global Media: An Exhibition in the Media Space* encompassed a large number of artistic works that went beyond the scope of a traditional exhibition. It took place in many media—the internet, TV, cable television, radio, film, daily newspapers, magazines, and poster media—in a number of countries around the world simultaneously. Over a hundred artists, activists, and theorists participated in the project and explored the conditions of a networked society, including community conditions, ideological conditions, economic conditions, gender conditions, and surveillance conditions and a number of other conditions.

In the extravagant exhibition catalog that appeared in 2001, edited by Peter Weibel and Timothy Druckrey, ample use is made of the OCR-A typeface.[22] The visual style of the catalog is flamboyant. A reviewer in *Library Journal* described it as "crammed with color illustrations on every page" and compared it to a popular magazine on new technology: "Of the same genre as Wired Magazine, this book is loud, flashy, colorful, and jumpy."[23] Another reviewer remarked on the attempt to imitate digital

screen-based media: "Its radically graphical layout, full of color imagery and text, comes as close as book technology can to the real 'Net condition.'"[24] In his book on postmodernism, graphic design critic Rick Poynor wrote the following:

In the early 1990s, as computer processing power burgeoned, designs created on the screen became increasingly overloaded and complex, overwhelming the viewer with a wild network of pathways to penetrate and decipher, plunging the spectator into the vertiginous reaches and turbulent coordinates of a new kind of digital space.[25]

The design principles advocated by Beatrice Warde are clearly the antithesis of the postmodern design of the exhibition catalog. Instead of being invisible, typography and layout are brought to the fore in the book and are part of the message conveyed. Text, typography, layout, and illustrations merge into a unanimous expression, taking into account the diversity of conditions and dynamics of digital media.[26] However, as yet another reviewer pointed out, this ambition is at times realized at the expense of legibility. In some of the essays, the superimposition of text onto photographs and the choice of color render the text very hard to read:

But the result is a constant battle between the denotative and the connotative that leaves readers unsure whether they are intended to read the theory that the editors have so diligently assembled. Net_Condition seems to be trying to do two things at once: while the volume's editors have diligently selected texts that analyze and deconstruct network society, the design team seems more interested in making the volume itself manifest as a symptom of the very processes it documents.[27]

One of the prominent typographical features of Weibel and Druckrey's exhibition catalog is the use of OCR-A for headings.[28] It is also used generously for body text. In bigger sizes, attention is drawn to the peculiarities of certain letterforms. In smaller sizes, the angularities are smoothed out, and the typeface approaches normality. In many instances, the text is laid out in playful arrangements, as in an essay about Natalie Bookchin's web-based art project called *The Intruder* (1998–1999). The work is based on the short story "The Intruder" by Jorge Luis Borges and consists of ten simple video games, which function as literary devices to advance the narrative.[29] In the catalog, the title of the work is cascaded and mirrored,

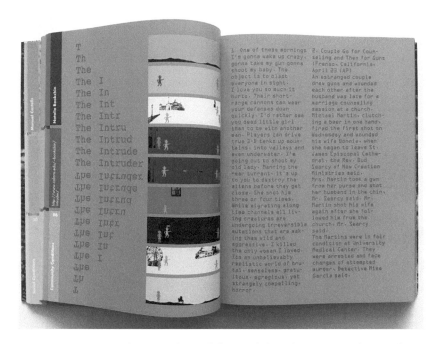

Figure 3.8 An essay about Natalie Bookchin's web-based art project *The Intruder*. In *net_condition: art and global media*, ed. Peter Weibel and Timothy Druckrey (Karlsruhe: ZKM | Center for Art and Media; Cambridge, MA: MIT Press, 2001), 86–87.

creating a triangular form, an arrowhead that points toward the images on the right half of the page.[30]

In the catalog's presentation of another piece of web-based art, *Vanndemar Memex or Lara Croft Stripped Bare by Her Assassins, Even* (1999) by Marc Lafia, the long title of his interactive narrative is meandering over the upper half of the spread, set in two different large sizes of OCR-A. The longest word—"Stripped," in white—is put in a layer of its own beneath the rest of the title, which is in black.[31] Body text in OCR-A explains the workings of the narrative and is interspersed with the title. The layout presents the reader with a graphic riddle that makes the choice of typeface seem the least weird aspect of the design.

In the essays about both *The Intruder* and *Vanndemar Memex*, the letterforms of OCR-A are highlighted as decorative elements of the layout. In the context of this exhibition catalog, which includes all imaginable

Figure 3.9 An essay about Marc Lafia's web-based art project *Vanndemar Memex or Lara Croft Stripped Bare by Her Assassins, Even*. In *net_condition: art and global media*, ed. Peter Weibel and Timothy Druckrey (Karlsruhe: ZKM | Center for Art and Media; Cambridge, Mass.: MIT Press, 2001), 208–209.

signifiers for digitality—pixelated images, aliased text, glaring colors, blurry screenshots, computer game characters, operating system interfaces, browser windows, images of cables and monitors—how did the OCR-A typeface manage to find its place? Due to its strong character and its associations with technology, it performed a lead role in the book with ease. The catalog contains examples of how a typeface can be exploited primarily for its pictorial qualities and how its role as mediator of linguistic meaning can be downplayed. Text and image are often posed as opposites, but text is always conveyed in some material form and in some visual, imagelike expression. This quality was explored in early twentieth-century avant-garde movements such as dada and futurism. Guillaume Apollinaire's calligrammes, which are poems where the printed words form an image that corresponds to the subject of the poem, are prominent examples.[32] The practice of ASCII art (the theme of chapter 2) is also based on the text-as-image concept, but postmodern graphic design operates with many more degrees of freedom.

Figure 3.10 The ComRegia logo in the Kelso typeface. Design by Zel Bettman. ©
ComRegia.

COMREGIA

In the postdigital era, telecommunications have achieved a status similar
to electricity in terms of public expectations of available infrastructure.
An internet connection is taken for granted at home, in public buildings,
and in trains, airplanes, and other means of transportation. Museums,
libraries, and other public institutions have put some of their services
online and are in the process of reassessing their role in society.[33] Com-
munication in the postdigital age has also entailed a growth in the num-
ber and severity of cybersecurity issues, which will need new approaches
to be kept at bay.[34] When networks go down or systems are under attack,
the consequences are dire for vital societal functions such as bank pay-
ments and medical treatments. All these public expectations mean that
advanced engineering skills in the telecommunication area are in high
demand. Connoting this know-how is a job OCR-A can still perform, in
collaboration with other graphic expressions. I interviewed the owner of
ComRegia, a Swedish telecommunication company established in 2017,
and the company's graphic designer in order to understand the rationale
behind a graphic identity that involves a logotype, icons, color schemes,
and varying typefaces for different types of text. The typeface of the logo-
type is Kelso, where each letter is formed by a single unbroken line.

The designer in charge of the project found the continuous lines of
Kelso fitting for the technical field of activity of ComRegia. The crown
that is part of the logotype emphasizes the word *regia* in the company
name and is drawn in a style that matches the typeface. Headings in both
printed material and web material use OCR-A capitals, and body text is
set in the neutral typefaces DIN Round (for print) and Asap (for web).
The owner of ComRegia appreciated the choice of OCR-A. For him, it was

Figure 3.11 The OCR-A typeface used on the back of a ComRegia van. Photo by Patric Jansson. © ComRegia.

paramount that the core values of the company—fair treatment of customers and reliability—are conveyed by the program and that the name ComRegia is seen as a quality mark. In combination with the blue color, the technical connotations are evident.

Apart from headings on the website, OCR-A is used for the byline "by ComRegia."[35] Sometimes the font is used a little more than prescribed by the graphic identity manual. On the back of the company's vans, it is also used for the web address (which, according to the manual, should have been done in DIN Round). The typeface Kelso and the crown have the continuous lines in common, and one can find echoes of OCR-A capital *C* and *D* in the angular forms in the middle of the crown. These design aspects help create a connection between the logotype and the typeface OCR-A. In its totality, the visual identity testifies to the fact that the "net condition" has become ubiquitous in the postdigital era and that a typeface like OCR-A can move comfortably in all kinds of public spaces, on vehicles, and on the web and expect to be associated with computer

technology even by a generation that was not born when the typeface was invented.

SURVEILLANCE AND RISK

Typefaces for both magnetic ink recognition and optical recognition were invented at a time when computers were starting to have a broader influence on society. Computing expanded its territories, and the computer was no longer only a tool for scientific calculations. During the Cold War, military technology aimed at global surveillance was developed in the United States.[36] In a survey conducted about public attitudes about computers in 1971, a vast majority of respondents agreed that computers affect the lives of all citizens. More than half expressed concerns that a few large organizations were in charge of information about millions of people and that "computers will be used in the future to keep people under surveillance."[37] In Sweden, a country that was an early adopter of computer technology, the use of personal code numbers and the risks involved in the processing of personal data by authorities became a major issue in the 1960s. The world's first Data Act for regulating the handling of personal data was adopted by the Swedish parliament in 1973.[38] The historian Lars Ilshammar looks back at this development:

From having been viewed as an administrative tool, increasing efficiency in the service of the expanding welfare state, the computer to an ever greater degree came to be understood as a control and surveillance technology during the second half of the 1960s. At the beginning of the 1970s computer technology joined nuclear power as the symbol of the large-scale and inhumane surveillance society.[39]

The following examples demonstrate how machine-readable typefaces helped to conjure up the ominous aspects of computer technology in popular culture, in the art world, and within government. The first two examples concern the original typeface for magnetic ink character recognition (MICR), E-13B. Both examples occur in the 1960s, one in a film about check fraud and the other in an artwork from the pop art era. The third example is from the late 1970s and involves the use of Data 70 on the cover of a report from a Swedish public inquiry.

CATCH ME IF YOU CAN

Based on the 1980 book of the same name, the movie *Catch Me If You Can*, directed by Steven Spielberg and released in 2002, is a fictionalized account of the early life of Frank Abagnale, who spent his late teens as a successful impostor and fraudster. During several years in the 1960s, he posed as a pilot, a doctor, and a lawyer and came by great sums of money by swindling banks and companies. Check forgery was his specialty, and one of his schemes was altering the routing number at the bottom of the check. These numbers decide which bank the check is sent to for clearing, and by changing one number, a forger could send the check to a distant branch across the country, causing a long delay in clearing. FBI agent Carl Hanratty zealously pursues Abagnale throughout the movie and explains during a presentation to his colleagues that "a zero-two to a one-two that means that check, which was cashed in New York does not go to the New York Federal Branch but it is rerouted all the way to the San Francisco Federal Branch." It took a couple of weeks for the banks to detect the problem, and in the meantime, Abagnale could continue to forge many more checks before having to move on to another city. His methods grew more and more sophisticated. He started making changes to checks manually and then moved on to a typewriter and a MICR machine, and when he eventually was captured in France in 1969, he was operating a huge Heidelberg printing press in order to produce realistic checks.

In this movie, the typeface is not primarily a design element. It is rather a vital part of the narrative of check fraud. Although the codeline and its routing number play central roles in the film, the typeface E-13B is visible in only a few scenes. Spielberg knows how to turn Abagnale's quest for banking knowledge into entertainment and conveys some pieces of information about check handling to the film audience, without lecturing. The E-13B typeface is present throughout the movie but not always visually. The first time it is shown is in the scenes where Abagnale receives a checkbook from his father as a gift for his sixteenth birthday:

ABAGNALE SR: There's fifty checks there, Frank, which means, from this day on . . . you're in their little club.

ABAGNALE JR: I'm in their little club.

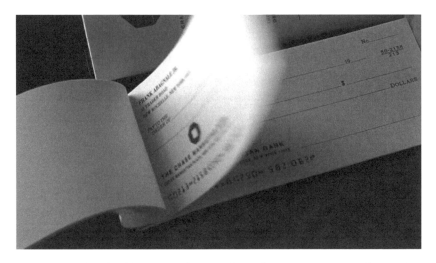

Figure 3.12 The checkbook scene from *Catch Me If You Can*, Steven Spielberg, 2002.

We see a close-up of the checkbook and the checks with Frank Jr.'s name on them and the codeline at the bottom as he flips through the book. This scene can be seen as the starting point for the swindling that is to follow, and it stresses the importance of the checkbook as an object of power.

A bit further into the movie, Abagnale pays a visit to a bank in order to cash a check and find out more about check routines. He targets a beautiful, young, and gullible teller, whom he immediately asks out for dinner. The flirtation continues while he asks her to explain how she handles the checks, and the following conversation unfolds:

TELLER: And then we feed the checks into the MICR machine, which uses special ink, and encode the account numbers at the bottom of the checks. [She feeds a check into the machine to demonstrate how it works.]

ABAGNALE: And where are these numbers?

TELLER: They are right here. [She holds the check against her breast.]

ABAGNALE: Right there? [He points to the codeline while she moves the check so that his finger touches her breast. They both giggle, and he blushes.]

TELLER: They are called routing numbers.

ABAGNALE: So where do the checks get routed to?

TELLER: I don't exactly know. Nobody ever asked me that before.

The check appears in this scene as an object that supports their inter-action. They pass it between them and hold it for a second together, she waves it flirtatiously, but we do not see the information printed on the check. The cinematography creates a seductive atmosphere, and the camera focuses on their facial expressions and their body language. What would otherwise have become a dry lecture in banking proce-dures is turned into a scene that demonstrates how Abagnale manages to combine his womanizing talents with his keen ability to learn and observe.

In the next brief scene, we see Abagnale bid on in a MICR printer at an auction. In the scene directly after that, FBI agent Hanratty uses a slide projector during a presentation about Abagnale's exploits for his colleagues at FBI headquarters:

In the last few weeks, this unsub has developed a new form of check fraud which I'm calling "the float." What he's doing is he's opening checking accounts at various banks, then changing the MICR ink routing numbers at the bottom of those checks.

He indicates the codeline with a pointer and asks for the next slide. The remote control is broken, and his presentation is interrupted by this mal-function as his colleagues try to change the slides manually. The next slide clearly shows the numbers at the bottom of the check. His colleagues interrupt him with impertinent questions and jokes:

C1: Carl, for those of us who are unfamiliar with bank fraud, you mind telling us what the hell you're talking about?

HANRATTY: The East Coast branches are numbered zero-one to zero-six. The central branch is zero-seven, zero-eight so on, so forth.

C2: You mean those numbers on the bottom of a check actually mean something?

[Hanratty gives further explanations.]

HANRATTY: All of this was in the report I filed two days ago.

C1: You know, you want to talk to my wife. She's the one balances the checkbook at our house.

[Agents laugh.]

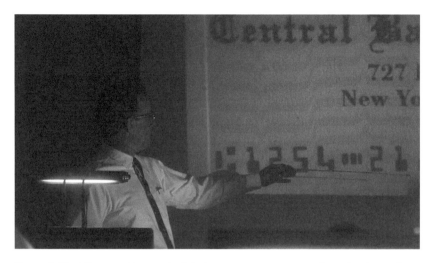

Figure 3.13 FBI agent Hanratty's slideshow presentation scene from *Catch Me If You Can*, Steven Spielberg, 2002.

His colleagues are uninvolved, they have failed to read his report, and they poke fun at him and his zealous engagement with this fraudster and his inventions. Along with the broken slide projector, they manage to spoil his presentation. By making the E-13B typeface visible in this scene, the film highlights Hanratty's nerdiness and his commitment to going deeply into the technicalities of a subject in his pursuit of a suspect.

Toward the end of the movie, when Abagnale is incarcerated in an American prison, there are two adjacent scenes where Abagnale is given the opportunity to demonstrate his expertise on check forgery. In the first scene, Hanratty pays a visit to Abagnale, and when the prisoner asks the FBI agent what he has in his briefcase, Hanratty tells him about his present case, "a paperhanger working his way through Minnesota." Abagnale asks to see the check through the glass partition, and on the basis of the date stamp, he immediately draws the conclusion that the teller is the culprit. This leads Hanratty to realize Abagnale's potential as a fraud detector.

In the second scene, Hanratty brings another FBI agent with him in order to test Abagnale with another check sample. Abagnale picks it up and gives his verdict on-the-spot. It is a fake:

FBI AGENT: How do you know? You haven't looked at it.

ABAGNALE: Well, there's no perforated edge, right? I mean, this . . . this check was hand-cut, not fed. Yeah. . . . Paper is double-bonded, much too heavy to be a bank check. Magnetic ink: it's, uh, raised against my fingers instead of flat. [He sniffs.] And this doesn't smell like MICR. It's some kind of a . . . you know—some kind of a drafting ink. You know, the kind you get at a stationery store.

After this demonstration of his expertise, he is invited to work with the FBI's Financial Crimes Unit.

In this scene between Abagnale and the two FBI agents, there is no close-up of the check. Instead, the camera closes in on Hanratty and his triumphant expression when his protégé shows off his skills. Right from the start, we are told by the FBI agent's line "How do you know? You haven't looked at it" that the visual sense does not play the lead role in the examination. Instead, it is a multisensory process, whereby Abagnale feels the texture of the edges, feels the surface of the print, feels the weight of the paper, and smells the quality of the ink. He resorts to the tactile sense and the olfactory sense as much as the visual sense in order to assess the document in his hands.

In this scene, the form of the E-13B typeface is not the focus. Instead, other qualities of the MICR print are highlighted, such as the relief it creates on the paper surface and the peculiar smell it emits. It illustrates vividly that typography is not an abstract experience of free-floating form but is intimately linked to the qualities of its material substrate—in this case, paper and ink. Graphic designers use these combined resources in their daily work in the creation of printed matter such as business cards, folders, and books. Digital publications have a different materiality, based on, for instance, light-emitting diodes (LEDs) and electronic ink (E ink), but the principles are the same. For dramaturgical reasons, it is more effective to focus on the reactions of Hanratty in this scene than to show the check itself in close-up. We hear Abagnale describing its features, and at this stage of the film, we have already been shown a check a couple of times—notably, when Abagnale is given a checkbook as a birthday present by his father and later when Hanratty presents the case at FBI headquarters—so we are familiar with the appearance of checks.

In these scenes at a bank, FBI headquarters, and a prison, what is told is the story of ignorance. A widening knowledge gap made Abagnale's forgeries possible. Neither bank customers, ordinary bank employees, nor FBI agents were sufficiently knowledgeable about bank check procedures. The young teller in the bank scene reveals her ignorance when she cannot tell Abagnale where the checks go: "Nobody ever asked me that before." This means that she has never been told how the system works and that she is just a cog in the machine. During Hanratty's presentation of Abagnale's check frauds and the way he is practicing check float, one of his colleagues gives voice to the general ignorance of check systems by mockingly asking if those numbers on the bottom of a check actually mean something. To this FBI agent, as to most other checkbook owners, the numbers are just a row of numbers. Their strange forms signal "disregard us" or "not meant for human eyes," in a way similar to barcodes. On a basic semiotic level, they can be recognized as part of the traditional alphanumeric character set, but on a higher semiotic level, the numbers might seem meaningless or random. However, for a successful counterfeiter, paying attention to every sign and its meaning is crucial. Abagnale is eager to increase his knowledge and gains an overall understanding of the system, and he manages to outwit it by being ahead of his pursuers. The size of the knowledge gap becomes evident in the prison scenes, when Abagnale demonstrates his accumulated wisdom for Hanratty and his colleague. Abagnale is the connoisseur that they need to help them solve more check fraud cases. This case demonstrates that typography is not an abstract art form that exists outside materiality and that an expert is required to use all his senses to master it.

The invention of MICR was a technological achievement that led to greater administrative efficiency, but it also created systems that were vulnerable to "hackers" like Abagnale. He was a "paper hacker" rather than a computer hacker in the contemporary sense, but he knew how to shortcut the system by diverting the attention of the human clerks who had become accessories to the system without having the means of controlling it. In real life, after serving his time in prison, Abagnale became a security consultant and helped design checks that are difficult to forge. The security of the "Abagnale personal SuperCheck" relies not on the typeface but on printing qualities such as watermarks, microprinting,

prismatic printing, and fluorescent ink.[40] The machine-readable typeface could provide efficiency by facilitating the processing of large amounts of data, but it could not ensure security, which had to be provided through other means.

1984

The film *Catch Me If You Can* was set in the 1960s. The next example of the E-13B typeface comes from the same decade, although it occurs in a different medium and context—a series of artworks made in 1967 by the American artist Ed Ruscha. His work is difficult to label or to place within a specific art movement, but he is commonly associated with pop art and conceptual art. He trained in commercial art and, in the beginning of his career, worked as a graphic designer.[41] One of his most famous works is his book *Twentysix Gasoline Stations* (1963), which contains photographs of the gasoline stations along Route 66 between Los Angeles and Oklahoma City.[42]

His many paintings depicting printed words or short phrases occupy a prominent place in his oeuvre. The letterforms are often derived from the vernacular visual language of sign makers, but the textual messages are generally enigmatic and laconic, verging on the surreal. In the 1960s, he portrayed mostly single words (for instance, *space, honk, salt, lawyer*) using different perspectives, letterforms, colors, and materials. From the 1970s on, statements began to appear in his works—for instance "Contact lens at bottom of swimming pool" and "A heavy shower of screws."

At the end of his book *They Called Her Styrene*, which contains 575 of his word images, he writes, "Sometimes found words are the most pure because they have nothing to do with you. I take things as I find them. A lot of these things comes from the noise of everyday life."[43] Taken out of the original context—perhaps newspaper articles or advertisements—these snippets of text can be seen as the descendants of the objets trouvés (the ready-made art objects) exhibited by Marcel Duchamp at the beginning of the last century. His bottle rack and his bicycle wheel took on different meanings in an art gallery than in the mundane surroundings they were taken from. Ruscha's word paintings are painstakingly designed and crafted, but they transform letters and words into objects that we are forced to read in a new light.

The objecthood of Ruscha's words has also been highlighted by graphic designer Michael Bierut. Invited to choose one work from the collection of the Museum of Modern Art for its radio series *The Way I See It*, Michael Bierut selected the painting *OOF* by Ruscha. In the program, Bierut comments on Ruscha's interest in the letters as objects: "His painting is more than a picture; it's really a painting, a physicality, a space."[44]

Perhaps Ruscha's least cryptic word images are to be found in the series of drawings and lithographs he made in 1967 with the title and motif *1984*.[45] The reference to George Orwell's *Nineteen Eighty-Four: A Novel* is obvious, which is also corroborated by the artist:

When I drew *1984*—in 1967—I was thinking about the book and the talk at the time that Big Brother was watching you. I put that together with these new funny numerals on my check stubs, and I wondered why they had invented this new vocabulary of numbers. I thought we may never reach that number on our calendar because we might hit some Armageddon. I always liked the idea that it was a few years before its time that I had made this statement in this work. Beyond that, it was fun to make.[46]

Some were drawings made with graphite or gunpowder, some were lithographs, but what they all had in common was that the white painted number was set off against a greyish background. For some variants, Ruscha chose E-13B as the typeface for the year, which made the connotations of the theme of novel state surveillance and control even more evident and visible.

Orwell wrote this classic novel in 1949, when computers were still mainly instruments for computation, and Orwell's Big Brother is carrying out mass surveillance through "Telescreens," a kind of television that can both broadcast and record image and sound and is installed in the homes of all citizens. The message of the novel can be transferred to another time and still be effective. According to Mark Owens and David Reinfurt, "Evoking the dystopian near-future of George Orwell's novel just a year prior to the worldwide student protests of 1968, Ruscha's use of E-13B registers a moment of potent cultural anxiety."[47]

In Ruscha's *1984* images, which are taken out of the context of a check's codeline, the E-13B number has been deprived of its meaning as routing number, account number, and check number. Without the structure of the check—an informational object where the positioning

Figure 3.14 Ed Ruscha, *1984 [#1]*, 1967. Graphite on paper. 14⁵⁄₁₆ × 22¹³⁄₁₆ in. © Ed Ruscha.

Figure 3.15 Ed Ruscha, *1984 [#2]*, 1967. Graphite on paper. 14⁷⁄₁₆ × 23 in. © Ed Ruscha.

of the data is as important as the data itself—the numbers have lost their original meaning. In Ruscha's pictures, the number 1984 hovers in a grey void and becomes meaningless as banking data. However, it assumes a new meaning by signifying a specific year in time and referencing a prominent work in literary history. The change in scale is also of semiotic importance. In Ruscha's pictures, the numbers are many times bigger than the numbers on checks, and against the rather undefined grey background, the numbers appear in all their baroque splendor.

Enlarging was a pictorial device practiced by several other pop artists. Claes Oldenburg became famous for his colossal sculptures of everyday objects such as hamburgers, light switches, and trowels, Roy Lichtenstein made large paintings inspired by cartoons and made visible the dots of the printing process. This *Verfremdungseffekt* (alienating or distancing effect) has also been used in typography. In his book *Typeset in the Future: Typography and Design in Science Fiction Movies*, Dave Addey interviews type designer Stephen Coles about how typefaces like Eurostile and Bank Gothic have become associated with the future. Coles explains that Bank Gothic, a typeface created in the 1930s, was intended for very small sizes suitable for business cards. In order for the linear shapes to appear correct in small print, the type designer made adjustments to the letterforms, such as angled ends to the letter *C*. What was originally a material aspect and a matter of functional design that was not meant to be noticed has become part of the typeface's allure and a reason for its application in science fiction movies. Blown up and projected on a cinema screen, the angled ends are clearly visible and form part of the appeal of the design of the movie.[48]

The big size of the numbers in Ruscha's *1984* pictures makes their forms and the "weird bulges" more prominent. Not all the numbers in the font E-13B are similar in this respect: the strokes of 0, 2, 5, 6, and 7 are even, whereas the strokes of 1, 3, 4, 8, and 9 are uneven. All the numbers of the year 1984 belong to the latter group, which creates a rhythm of thin and thick forms throughout the number. In one of the drawings, *1984 [#2]*, the dash used to delimit parts of numbers on a check is added at the end of the year, like a coda to a musical composition. The visual rhythm of a graphic artwork is not unlike musical rhythm, if one imagines the temporal dimension translated into the visual dimension. Ruscha's portrayals of

E-13B are minimalistic and restrained compared to a Hollywood science fiction movie, but he managed to bring the letterforms to the fore and at the same time, by the choice of the motif 1984, evoke an ominous computerized future. He used only the resources of the original character set, consisting of just fourteen characters. There were soon to be typefaces that applied the visual language of E-13B to the full alphabet.

ADP AND THE VULNERABILITY OF SOCIETY: CONSIDERATIONS AND PROPOSALS

Even government reports are dependent on graphic design to communicate their messages. In the 1970s, Swedish society had become computerized to a high degree. At the time, the term *automatic data processing* (ADP) was commonly used for the field now called *informatics*. Before the advent of digital consumer electronics, which now pervade everyday life, many sensitive societal functions were performed with the help of information technology. The Swedish Ministry of Defence ordered an inquiry in 1977 into the risks this entailed and the measures that could be taken in order to mitigate the vulnerability caused by computerization.[49] The final report from 1979 divides the vulnerability factors into external and internal factors. Among the external factors considered are sabotage, espionage, war, and catastrophes. The internal factors pertain to population registers, geographical and functional concentration, lack of knowledge, dependency on key persons, disaster preparedness, and foreign dependency, to mention a few. Many weak areas were identified, such as the concentration of resources and know-how in a few large computer centers in the major cities in Sweden. Because the domestic computer industry could supply only certain types of computers and peripherals, the country was dependent on foreign manufacturers. The committee in charge of the inquiry recommended an authorizing procedure for actors that would set up registers with personal data, traffic management systems, process control systems, and other sensitive systems, in both the public and private sectors. One area of attention was telecommunications. At the time, computers were connected via the telecommunications network, then still consisting of overhead lines in less densely populated regions in Sweden.

On the cover of the published report, the main title is set in Data 70, and the subtitle is set in Helvetica. The reader is made aware of the subject of the report just as much by the typeface of the main title as by the words themselves. "We are now in the computer age" is conveyed by the typography, more than by the illustrations below. The curious forms of the letters signal that a strange new aspect of society, information technology, must be taken into account and dealt with. The alarming first part of the title, *ADP and the Vulnerability of Society*, set in the alien typeface Data 70, is countered by the use of the most rational of typefaces, Helvetica, for the reassuring second part of the title, *Considerations and Proposals*. With the help of rational measures, society will be less vulnerable.

The acronym *ADP* is printed in green on an ivory background, and the same green is used for the background of the middle part of the cover, which contains three illustrations—black overhead telephone lines, a pair of blue wire cutters wrapped in twine, and an ivory roll of magnetic tape. By the use of color, a connection is created between the green letters *ADP* and the green middle part of the cover and the action that is played out there. The telephone lines and the magnetic tape are easy to associate with information technology, but what are the wire cutters doing here? The three objects do not seem to exist in the same picture space, and they are drawn with different degrees of abstraction and definition. The magnetic tape is two-dimensional, whereas because the telephone pole is shown a little from the side, it appears somewhat three-dimensional. The wire cutters are most clearly defined, and their blue color and the hemp string wound around their jaws make the tool stand out from the other objects. Depth in the cover is created by the overlapping of the objects— the tape at the back, the telephone pole in the middle, and the pair of wire cutters at the front. The billowing lines of the telephone lines and the loose end of the magnetic tape create movement in the picture, but without the wire cutters, the cover would appear quite static and flat. From the upper right corner, the menacing pair of blue cutters is injected into the picture, somewhat above the picture plane, cutting through both the ivory top background and the green middle part of the cover. Were it not for the string and the tidy knot that keeps the string in place, the thrust of the wire cutters would pose a serious threat to the lines and the tape, potentially cutting them off.

Figure 3.16 A report cover using the Data 70 and Helvetica typefaces. *ADP and the Vulnerability of Society: Considerations and Proposals*, SOU 1979:93.

A feasible interpretation is that the telecommunication technologies (telephone poles and lines) and the information in the files (on the storage medium of magnetic tape) are vulnerable to a number of threats, all encompassed in the symbolic wire cutters. However, the proposed safety measures (string that has been wound several times around the tool's jaws) will provide protection for the country, which will also not be *cut off* from the future development of information technology. After all, the three bulky letters *ADP*, given weight by the Data 70 typeface, stand firmly on the ground and acknowledge that the country is irrevocably part of this development.

VISIONS OF THE FUTURE: EXPECTATIONS AND DISILLUSIONS

The end of the 1950s saw the birth of the Space Age, when dreams of venturing into space were fulfilled for the first time. In conjunction with computer technology, space technology was seen as the technology of the future. Other planets were seen not only as places to visit but as potential colonies where the human race could expand its territories. These expectations were subdued after the space shuttle *Challenger* disaster in 1986. In the 1994 article "Will Robots Inherit the Earth?," artificial intelligence researcher Marvin Minsky envisions a future where robots become so advanced that they can take over many of the functions humans perform and even supply human bodies with vital spare parts.[50] However, some researchers were not convinced about the feasibility or even desirability of such scenarios.[51] The following examples show how machine-readable typefaces can be used to invoke both visions of the future as well as the ensuing disappointments when they are thwarted.[52] A 1981 children's book about a robot and a 2016 graphic novel about a lonely cop on the moon are analyzed in this section.

ROBOT

The pop-up picture book *Robot* (1981) by the Polish British author Jan Pieńkowski is a science fiction story that probably was intended for children but can be enjoyed by all ages.[53] The typeface used for the title on the cover and in the body text is a modified version of Data 70, where several of the capitals have been altered (*A*, *D*, *K*, *M*, *N*, *R*, and the lowercase *x* have been altered). The changes give the word *DAD* a slanted look, in contrast to the upright lines of *MUM*. The book is about a family living on another planet, and we get to know them through a postcard sent home from a son who has taken a trip back to earth. A face of a robot, in the form of a printed circuit board, can be discerned on the cover of the book. The most evident facial features are the eyes, which are made up of the two *O*s in the title *Robot*. Just below the *B*, a pink resistor serves as a nose, and a corner of the postcard sticks out from what appears to be the mouth but could also be interpreted as a mail drop. We can read the beginning of the text, "Dear MUM and DAD, Wish U were here. I . . ."

Manchester Literature Festival @McrLitFest · Apr 24, 2020 ...
Robot - Jan Pienkowski
My all time favourite picture book author. He trained Ed Vere. Can you
imagine! His pop up books are the best.

Figure 3.17 A book cover using a modified version of the Data 70 typeface. Jan
Pieńkowski, *Robot* (London: Heinemann, 1981). Manchester Literature Festival, Twitter,
@McrLitFest, April 24, 2020.

The rest of the text runs on the bottom of every spread, and on the
first spread, it continues from the cover, "miss home cooking—xpect
MUM has her hands full with the new." Mum is here seen reading the
postcard, holding it with one of her many arms as she carries out several
other household chores simultaneously. On the remaining five spreads,
the text is continued in the same manner, starting with the last word of
the sentence on the page before or finishing with the initial part of the
next sentence:

baby. Hope DAD's keeping up his Mr. Universe programme.

Is GRANDPA looking after my Earth creature? I bet it's

grown. How's SIS? Still going out with that Neanderthal

boyfriend? I miss riding my bike. C U all 4 Xmas. Love, ROB.

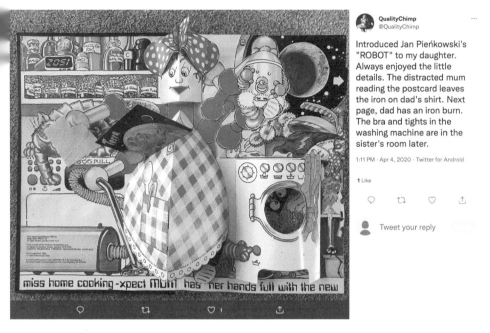

Figure 3.18 The first spread in Jan Pieńkowski, *Robot* (London: Heinemann, 1981). Quality Chimp, Twitter, @QualityChimp, April 4, 2020.

In this way, the reader is prompted to turn the page and read the whole story, a counterforce to the pop-up features that might make the reader want to remain on the page for a long time. On each spread, tabs can be pulled and cause elements of the page to pop out and move, and wheels can be turned. We encounter the family members in their own rooms, busy watching screens, lifting weights, styling their hair, and performing other activities that lend themselves well to be animated. The text is quite succinct compared to the exuberant imagery. The spreads are filled to the rim with a multitude of forms, colors, things, and creatures, so it takes quite a while to understand what is being shown, especially since the central parts are three-dimensional. They are movable landscapes rather than pictures. The text that runs in a single line at the bottom of the page points out the different characters and their attributes. It anchors the pages and provides some stability by being a recurring element on each spread. The Data 70 typography makes the text become part of the overall visual style, and it blends in rather than forms a contrast to the imagery. One might argue that the text needs this kind of vestiture to assert itself.

This is science fiction at its most good-natured. These robots lead lives that are very similar to human lives. On their bookshelf, they have titles such as *Lex Robotica* and *Encyclopaedia Cybernetica* in printed form. Pieńkowski's 1981 picture book is a feel-good version of a postdigital future in space where earth is not lost to humanity but is just a distant destination and family life and its traditional gender roles are intact. In the postdigital and posthuman future, when we have ourselves become robots, we need not fear computer technology.

MOONCOP

The 2016 graphic novel *Mooncop* by Tom Gauld is about a lonely cop who is stuck on a human colony on the moon.[54] We follow him performing his daily duties as he traverses the vast and desolate moon landscape in his little police vehicle. His crime solution rate is 100 percent, mainly because no crimes are committed by the decreasing population. Relocating to the moon has not relieved humans from the nuisances created by incompatible adapters, system failures, and meaningless data collection. The once ultramodern project now seems like a silly idea, according to Mrs. Henderson, one of the first settlers, who is moving back to earth. The cop's application for a transfer is denied. Instead, he is offered a robot therapist that soon runs out of steam and electricity. He finds a companion in the newly arrived cafe attendant and together they contemplate planet earth from the vantage point of a cliff. Gauld has tapped into the science fiction trope of colonizing other planets but has turned it into a melancholy reflection on the human condition.

All the text in the book—in speech bubbles, on signs, and on computer screens—is handwritten. On the front cover, the title is set in Data 70 capitals in silver against the blue void of space. The mooncop is seen walking across the rocky surface of the moon with a map in his hand. Earth is hovering in the upper right corner of the cover. Below the title, the name of the author is set in Futura capitals in white and in a much smaller size. The squareness of *MOONCOP* is contrasted with the pointed forms of the *M* in *TOM* and the *A* in *GAULD*. In Data 70, the letters *O, N,* and *C* have a similar rectangular form, and here in *MOONCOP* they form a group of five siblings protected by the initial *M* and the final *P*.

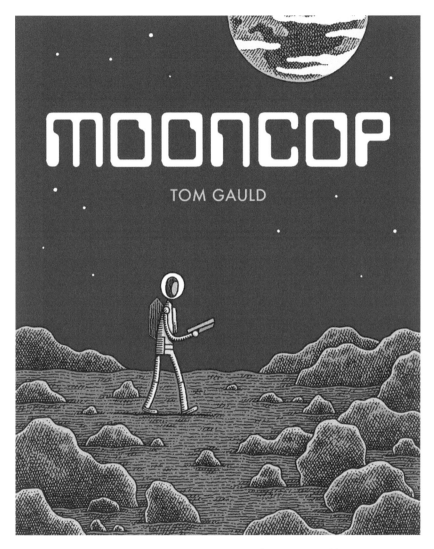

Figure 3.19 A book cover using the Data 70 typeface. Tom Gauld, *Mooncop* (Montreal: Drawn & Quarterly, 2016). © Tom Gauld. Used with permission from Drawn & Quarterly.

Type designer Toshi Omagari, who has written about the typography of arcade video games of the 1970s, 1980s, and 1990s, explains how the appreciation of the typefaces derived from MICR has evolved:

MICR was more or less extinct by the end of the 90s, and only a few games carried on the tradition. The industry had moved on an learned the art of subtlety, no longer relying on wacky details that screamed "Future!" But the appetite for mechanical-looking typefaces has never gone away, and in modern games, typefaces such as DIN, Eurostile, Bank Gothic and similar square designs are commonplace. Today, our tastes have changed and Westminster and Data 70 are considered retro, but we shouldn't forget to respect these elders that were once the face of the future.[55]

Omagari seems to agree with Paul McNeil that Data 70 personifies "a vision of the future from the past."[56] If one takes these connotations into account, using Data 70 in the graphic novel *Mooncop* not only sets the mood of the book but also summarizes the whole story, from the beginning of the colonization project to its end. *Mooncop* looks back at the future of the past, when moon residency was utopian, and lets us know what became of it from a vantage point far into the future. The story and the typeface share a parallel timeline and development. Like the picture book *Robot*, the story in *Mooncop* is set in a future, postdigital era where the technology has become ubiquitous and permeates everyday life but where, in contrast to *Robot*, technology has not fulfilled the promise of a better future.

ALIEN AND DOMESTICATED FORMS

The OCR-A typeface was called "robot type" by Adrian Frutiger and his colleagues in the 1960s. The clunkiness of both OCR-A and E-13B rhymed with robot morphology, both fictional and factual, at the time. We saw in Ed Ruscha's *1984* pictures how the objecthood and physicality of letters can be emphasized. "Robot type" can refer both to the letters as small robots themselves and to typefaces that robots can read.

Scale changes the perception of a typeface and can make its letters seem alien. This effect is notable both in the large size of the E-13B characters in Ed Ruscha's *1984* and in the case of OCR-A in the exhibition catalog *net_condition: art and global media*. In *1984*, the bulges of the characters

are made visible by the enlargement, and in *net_condition*, the pictorial qualities of text are brought to the fore by the large size of the headings set in OCR-A in combination with the multilayered design. These qualities are not conspicuous to the same degree when the typefaces are seen in normal text sizes.

Outlandish typefaces have found a place in the design of science fiction movies, as has been shown in *Typeset in the Future: Typography and Design in Science Fiction Movies.*[57] I would argue that there is a correlation between the alien letterforms of machine-readable typefaces and the alien physiognomies that appear in several science fiction productions. Some films and series about aliens contain creatures with extreme appearances that are far removed from humans. In others, humanoid species differ from humans in subtler ways. The Vulcans and the Bajorans in the television series *Star Trek* are two cases in point—the former distinguishable by their pronounced eye brows and their pointed ears and the latter by their nose ridges. Two prominent representatives are Mr. Spock and Colonel Kira. Like the bulges of E-13B and the slanted forms and angles in OCR-A, these facial characteristics stand out but do not thwart the recognition of them as some sort of typefaces or humans, respectively. We can still read the text and identify with the movie characters as humans.

TRAVELS IN TIME AND SPACE

Although many of the connotations of the machine-readable typefaces can be traced back to their original context of computing, the typefaces have given rise to a surprisingly wide range of possible connotations. The fonts have traveled in time and space from the 1950s to the present day and from the bottom of a check to the big screen. They can give shape to and support utopian and dystopian stories, they can be part of sober designs and postmodern layouts, and they can be stripped of their imaginative overtones and convey more matter-of-fact messages.

The context in which a typeface is used plays a vital role for the creation of meaning and connotations. When the E-13B typeface is used for a solo performance in one of Ed Ruscha's *1984* artworks, it may elicit apprehension in the viewer. When accompanying the movable tableaus of the picture book *Robot*, the E-13B derivative Data 70 reinforces the

visual style of the book and becomes part of the cheerful imagery. When OCR-A is used in ComRegia's visual company identity, it refers to functionality and to the legacy of engineering inventiveness. When used in the exhibition catalog net_condition, functionality is downplayed by the layout that nearly makes the text illegible, and OCR-A instead helps stress the overwhelming character of current technological developments.

In her book *Why Fonts Matter*, designer Sarah Hyndman categorizes the Computer typeface, among others, under the heading "Intergalactic Communication" and points out that "they can suggest an optimistic future utopia, a dark dystopia, or a retro version of the future."[58] Finding and articulating this version do not necessarily mean going back to a historical reality. The digital studies researcher Zach Whalen asked himself why he often encounters OCR-A in contemporary videogames referring to old games, when the typeface was not used in a game context until the 1990s. He concludes that obsolescence is "characteristic of how we tell stories about the futures of technology's past."[59] In the graphic novel *Mooncop*, Data 70 facilitates travel both forward and backward in time. Machine-readable typefaces are what the future looks like in the rear mirror.

POSTDIGITAL ART RESISTING MACHINE-READABILITY AND SURVEILLANCE CULTURE

In his 2001 net_condition essay "Attention in the Media Age," Florian Rötzer discusses the voluntary publishing of intimate life and the sophisticated surveillance strategies of public and commercial spaces.[60] In 1996, an American teenager launched *Jennicam* from her college dorm and became a pioneer of around-the-clock live streaming from home.[61] This was a voluntary act on her part, in contrast to the surveillance of people in public spaces. At the end of the 1990s, a surveillance system was being developed by two British universities that could distinguish between "normal" and "suspicious" behavior in order to identify potential thieves in, for instance, supermarkets and car parks. Rötzer envisions the paranoid behavior this technology will lead to in the future, when people will adopt an "inconspicuous appearance" in order to avoid detection.[62]

In the postdigital age, artists have found different means of defying surveillance culture, and I present two examples here—one concerning facial camouflage and one concerning typography. During the first decade of the millennium, surveillance technology and computer vision continued to be developed toward a goal of face recognition. In 2010, the artist Adam Harvey created the work *CV Dazzle*, which is about how people could avoid being identified by surveillance cameras by applying a camouflage makeup that confuses the system.[63] In contrast to traditional war camouflage that helps soldiers blend in with the vegetation, Harvey's makeup was based on geometric forms and sharp color contrasts. Matching hairstyles with coils of hair hanging in front of the face were meant to further bewilder the surveillance systems. While these looks may divert the attention of surveillance systems, they are bound to attract the attention of fellow humans in the public space.[64] *CV Dazzle*[65] thus suggests an approach far from the "inconspicuous appearance" predicted by Rötzer.[66]

A similar tactic was deployed in 2012 by graphic designer Sang Mun, who designed the typeface ZXX expressly to be machine-unreadable.[67] The name comes from the US Library of Congress's code system for languages, where *eng* stands for English, *lat* for Latin, and *zxx* for "No linguistic content; Not applicable."[68] In Mun's type specimen video, six different styles are presented, four of which are claimed to be unrecognizable by OCR and yet legible to the naked human eye—Camo, False, Noise, and Xed. In order to confuse the OCR software, different strategies of disruption are applied in the four fonts. In Camo, the skeletons of the typeface are furnished with blobs; in False, the small, relevant characters are embedded within larger, false characters; in Noise, the letters are covered with small squares and rectangles; and in Xed, the letters are crossed out. A synthetic voice communicates that "Just like the animals, we need to start adopting new ways to conceal ourselves from autocratic predators, in this case, government and corporations." The presentation ends with suggesting target groups for the typefaces: whistleblowers, activists, and common internet users.[69] According to the artist, "ZXX is a call to action, both practically and symbolically, to raise questions about privacy."[70]

Both artistic projects rely on a postdigital aesthetics that challenges the border between the digital and the analog. *CV Dazzle* is not digital

Present & Correct
@presentcorrect ...

The Dazzle Club will paint your face to disrupt facial
recognition surveillance.

instagram.com/thedazzleclub

3:03 PM · Feb 2, 2020 · Twitter for iPhone

165 Retweets **52** Quote Tweets **621** Likes

Figure 3.20 Face paint inspired by Adam Harvey's *CV Dazzle*. Present & Correct, Twitter, @presentcorrect, February 2, 2020.

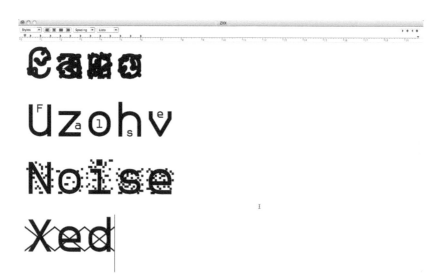

Figure 3.21 A screenshot from Sang Mun's *ZXX Type Specimen Video*, 2012, Vimeo, https://vimeo.com/42675696, @ Sang Mun.

in a concrete technical sense, but the makeup styles and hairstyles are conceived within a digital context as a response to the logic of machine vision.[71] The ZXX typeface is executed by a computer, but the disruption is based on crossing out text and doodling, which are genuinely human gestures reminiscent of hand writing. *CV Dazzle* might seem chaotic at first glance, but it has formal features relating the work to typography. A closer analysis of the different camouflage styles might reveal ascenders, descenders, strokes, swashes, and other body parts of letters. Both projects work in the tradition of the machine-readable typefaces by alienating the conventional forms of an aesthetic practice. When the digital has become invisible and merged into everyday life, postdigital art can contribute to making the technology and its effects visible again.

4

THE MULTISENSORY DOT MATRIX PRINTER

Since its establishment in the mid-twentieth century, the computer industry has experienced a rapid pace of innovation. Technological solutions have succeeded one another, and obsolete equipment has been left to gather dust in basements and attics. This chapter is about one such piece of technology—the dot matrix printer—and the challenges it has presented for typography and its unintended aural potentials. The aim of the chapter is to show how the multisensory features of the printer have been explored, both for utilitarian purposes in the industry and for creative purposes by private persons and artists. The printer has become part of our cultural and technical heritage and has acquired a place in the memory of owners and users. When pictures, advertisements, and other memorabilia are mentioned and posted in online forums and blogs by retro nerds, nostalgic stories appear in the commentary fields. The printer type generates an output with a distinct visual appearance, but sound is arguably its most conspicuous feature, which is why memory practices related to the dot matrix printer involve musical compositions and performances. Key questions being asked are: What typographic challenges did the printer present? How was it marketed? How have the multisensory aspects of the printer been explored? What kind of memory practices are connected to the printer? What are the contemporary applications of dot matrix printing?

THEORY AND METHOD: MATERIALITY AND BRICOLAGE

Just as in chapter 3, Johanna Drucker's model of materiality will be relevant here but in a slightly different manner, since I pay much attention

to the printer as an apparatus. The body of the printer, its modus ope-
randi, and its malfunctions form part of the "physical, substantial aspects
of production" that Drucker regards as one of the two main components
of her model, which also takes the social context into account.[1] I high-
light the social context of the printer by examining how it was marketed
by analyzing manuals and advertisements from the 1980s and how it was
used and reused by tinkerers, artists, and common users during the fol-
lowing decades. In line with Drucker's thinking, the printer and its print-
ing activity will be involved in a process of interpretation that does not
presuppose the existence of any "true" character of the device.

In order to carry out such an interpretation, I have used bricolage as
the method: it is an eclectic method that puts together a variety of meth-
ods and sources in sometimes unorthodox ways.[2] I have done something
similar in the previous chapters as well, but here my inquiry has been
more open-ended, since I had only vague ideas of what I would discover.
To form a picture of what the dot matrix was and still is, I examined
digitized (and therefore searchable) back issues from the archives of aca-
demic journals, the websites of artistic organizations that seem to have
been frozen in time and were last updated in 2012, and current videos on
how to mend a broken printer, among other things. This archaeological
excavation has required an open mind on my part as to what a piece of
technology can be seen as and signify, and it also has made me aware that
a technology might come to mean something entirely different in the
future, despite its position as "dead media" on the market.

Some of this chapter is devoted to different multisensory aspects of the
printer—how sound can be translated into words for the purpose of spy-
ing on the information being printed, how aural and visual impressions
are connected to memories of the device, and how sound and images
have been explored in the making of music. The multisensory approach
and the concept of technostalgia are also explained in later sections.

THE DOT MATRIX PRINTER AND THE PRINCIPLES OF PRINTING

The dot matrix printer had its heyday during the home computer boom
in the 1980s when it became one of the most common computer periph-
erals. In the mid-1990s, it was overtaken by the inkjet printer, which

could print high-resolution color images and made much less noise. Somewhat later, in the late 1990s, the laser printer became the preferred printer for word processing on the home computer market, and the dot matrix was relegated to niche applications, for which it is still used. The Apple LaserWriter was introduced in 1985, and Macintosh and its accompanying software soon took the lead in the desktop publishing trade. Small businesses could now make their own graphic materials without relying on professional typesetters. But Apple solutions were expensive, and other models were more popular on the home computer market, including microcomputers such as the Amstrad CPC, Commodore 64, and TRS-80 and later personal computers like the IBM PC and its many clones. The dot matrix printer was relatively inexpensive, and despite its poor print quality, its flexibility had a great appeal.[3] This was in a period when neat letters were typewritten, and computer output meant uppercase letters in messages from tax authorities printed on line printers attached to mainframe computers. Word processing now made it possible to print both uppercase and lowercase letters and set part of a sentence in italics. It would take a few years before the drop-down menu with a long list of typefaces to choose from would become the standard on most platforms and programs.

Bitmapped images are made up of pixels or dots in a grid, and both computer screens and modern printers are based on such raster graphics. The dot matrix concept had been applied to printing already in the 1920s when the Hellschreiber dot matrix teleprinter was invented, but technology based on the concept did not come into its own until desktop publishing created a demand for fast and flexible printing. Up until the 1970s, the printers most common in the computer industry were similar to typewriters in one important respect: they had a set of fixed characters forged in metal that struck against a color ribbon.[4] Traditional typewriters had hammers, and line printers had drums, chains, or bars where characters were applied. A contemporary competitor to the dot matrix printer was the daisy wheel printer with interchangeable font wheels. These solutions—where each letterform corresponds to one whole piece of solid material—offered high-quality printing, but they were vulnerable because of the many mechanical parts involved in the construction of the printers. They were also inflexible, since changing fonts was complicated

and time consuming, if even possible. The dot matrix printer lacked this kind of precast characters and instead produced letters in the form of dots in a matrix.

A printhead with a number of vertically positioned pins ran across the paper and made a mark on it by hitting a cloth ribbon that had been soaked with colored ink. Simpler models had seven pins, which meant they could not print descenders, such as the parts of g, p, and y that descend below the baseline (see the y and g in figure 4.19). Now these strokes found themselves sitting on the baseline, which gave the text an awkward appearance and disturbed the reading. When new models were advertised, the ads stressed the fact that these printheads were "with descenders." The Epson MX-80, which was released in 1980 and became a common model, had nine pins, and more sophisticated later models had twenty-four pins. Some models could also print graphics.

The dot matrix printer could not compete with its competitors in print quality, but it outdid them in this era with the help of flexibility, speed, and cost per page. It printed on fanfold paper and could handle carbon copies. It could print either in draft mode, which was fast but yielded lower quality, or in "near letter-quality" mode (a term coined for market-ing purposes), which was achieved through multiple passes of the print-head. In draft mode, the gaps between the dots were clearly visible, and in near letter-quality mode, the letters were denser, but the dots were still easily discernible. The maximum resolution for dot matrix printers is 240 dots per inch (dpi), whereas the resolution of inkjet and the laser print-ers are typically 1200 dpi or higher. These printer types are also based on dots, but the dots are smaller in size and appear to merge when printed.

Unlike handwriting, printing is supposed to generate similar results in each run. But mechanical devices have their own individual traits, a fact that was explored by Arthur Conan Doyle in one of his Sherlock Holmes detective stories, "A Case of Identity." Holmes solves the mystery by com-paring typewritten letters and comes to the conclusion that they must have been typed on the same machine on the basis of damaged and worn letters. In the field of forensics, there is a need to identify the manner in which documents have been created and to tie them to a certain type-writer or printer, if possible. Equipment wear, such as a bent pin, is one way of identifying a dot matrix printer. Another way is identification on

Figure 4.1 Characters from a dot matrix font for an Epson printer. All characters are designed to fit within a matrix that is nine dots high and five dots wide. David A. Lean, *Epson MX Printer Manual, GraftraxPlus* (San Diego: CompuSoft, 1982), app. F.

Figure 4.2 The printhead of a dot matrix printer. *Delta User's Manual* (Shizuoka, Japan: Star Micronics, 1983), 75. © Star Micronics Co. Ltd.

Figure 4.3 An Epson MX-80F/T dot matrix printer. Courtesy of Phrontis at Wikimedia Commons. CC-BY-SA-3.0.

Figure 4.4 Two designs of the letter *a* from two different printers. James A. Blanco, "Identifying Documents Printed by Dot Matrix Computer Printers," *Forensic Science International* 59 (1993): 46.

the basis of matrix design and the form of the letters.[5] Although the possibilities for type design for a dot matrix printer are limited, there is still room for variations that make it possible to tell them apart. This kind of document comparison is part of the mundane forensic work carried out by police officers. It is an example of the principle of individualization—that no two objects are identical—on which Kirschenbaum's literary concept "forensic imagination" is based.

FONT FEATURES OFFERED BY DOT MATRIX PRINTERS

The printer manuals from that era reveal a great deal about the approach taken to typography. The manual for Epson MX series printers from 1982 teaches users how to control the printer with the help of BASIC, a programming language that was commonly used at the time. In the introduction, it says, "A good working knowledge of the BASIC* language is all that's required as we begin, with Chapter 1."[6] Before connecting the printer to the computer, the user is encouraged to make a test printout of all of the characters in the printer's memory by turning the printer on and pressing the line-feed (LF) button at the same time. The alphabetic

!"#$%&'()*+,-./0123456789:;<=>?@ABCDEFGHIJKLMNOPQRSTUVWXYZ[\]^_'abcdefghijk!
pqrstuvwxyz{|}~Ø£''`§⌐┤┬└┘|─┴+/"#$%&'()*+,-./0123456789:;<=>?@ABCDEFGHIJKL¡
QRSTUVWXYZ[\]^_'abcdefghijklmnopqrstuvwxyz{/}~Ø

Figure 4.5 A printout of all the characters in the Epson MX-80F/T printer's memory. *Epson MX Printer Manual, GraftraxPlus* (San Diego: CompuSoft, 1982), 1–20.

characters and some additional characters will appear on the paper in regular and italic style.

The three print features that can be varied are character width, type font, and print quality. Normal width refers to what is normal for the pica typewriter font, which is ten characters per inch. If compressed width is chosen, the letterspacing becomes tighter, and more characters can be fitted into a line. The effect can be doubled, so that letterspacing becomes even tighter or wider. The type font feature refers to regular and italic, which were the only styles available. The print quality can be enhanced by making the printer pass over a line a second time. In doing this, the printer shifts up the paper a little bit and then prints the text again: "The effect is to fill in much of the space between the dots and make the characters look more solid. Sort of a 'poor man's' high-speed typewriter."[7] The typographic focus in the manual is on these three different features, which apply to the unspecified, default typeface resident in the printer, and there is no mention of traditional typefaces. At the end of the manual, there is a chapter on advanced graphics and the ways these printer features can help users "Let Those Creative Juices Flow" and design their own typefaces.

The Epson manual was written in a personal and accessible style by David A Lien, a well-known author of books on computers and programming. To add to the light and informal tone of the text, the manual also contains many cartoon-like illustrations. In a manual for another printer, *Delta User's Manual* (for the Star Micronics Delta-10 and Delta-15 printers), the manufacturer assures the owner that (1) the manual is "truly written not just for the person who does his own programming, but for the first-time user or anyone else who prefers to leave the programming to others, and simply inserts his store-bought programs (software) into his computer / printer system. Someone very much like you, perhaps . . ." and (2) it will be a pleasant read "as it's master-minded by solid experts in the arcane art of computer science, and written by equally proficient

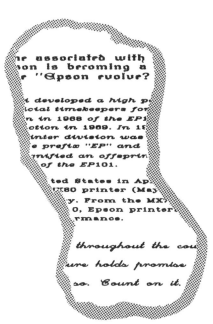

Figure 4.6 Several character fonts created by a user on an Epson printer. *Epson MX Printer Manual, GraftraxPlus* (San Diego: CompuSoft, 1982), 14-9.

practitioners in the art of Plain English!"[8] Nevertheless, neither the Delta nor the Epson manual can disguise the fact that many computer skills are required to take advantage of the printers' features, especially the ones pertaining to typography. This was the transitional period when the microcomputer, which had been a hobby for nerds bent on programming, became the home computer or personal computer, which was of use to a much wider audience.

By today's standards, the typographic possibilities were limited, but at the time, the manufacturers were keen to promote the typographic features of the printers. For instance, the characters available for the Delta printer are referred to as typefaces, as follows:

1. Standard pica type—10 characters per inch
2. Standard elite type—12 characters per inch
3. Condensed type—17 characters per inch
4. Italic pica style—10 characters per inch
5. Emphasized pica—10 characters per inch

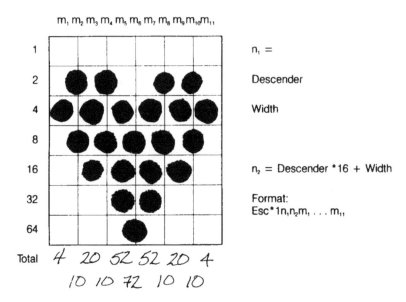

m_1 m_2 m_3 m_4 m_5 m_6 m_7 m_8 m_9 m_{10} m_{11}

$n_1 =$

Descender

Width

$n_2 =$ Descender $*16 +$ Width

Format:
Esc$*1n_1n_2m_1 \ldots m_{11}$

Total 4 20 52 52 20 4
 10 10 72 10 10

Figure 4.7 Instructions from a user manual chapter on "Creating Your Own Characters." *Delta User's Manual* (Shizuoka, Japan: Star Micronics, 1983), 79. © Star Micronics Co. Ltd.

Just like the word *pica*, *elite* is another reference to typewriter typography, defining the letterspacing of the text. Typefaces like Times New Roman and Helvetica are still remote from the world of dot matrix printing. A user who wants more typefaces can design them from scratch and download them into the Random Access Memory (RAM) of the printer with the help of computer program. Comprehensive explanations of how to design characters using a dot matrix are given in chapter 7 of the manual: "You've seen how the engineers at Star designed their characters by using a grid to lay out the dots. Now you can define characters exactly the same way."[9] The symbols chosen as a showcase are the four card suits used for bridge and other card games. The manual provides illustrations reminiscent of knitting patterns and the command syntax to instruct the printer to perform the characters. The instruction in figure 4.7 is similar to the ones in Rüdiger Schlömer's *Typographic Knitting: From Pixel to Pattern*, mentioned in chapter 1. The methods of production are different in knitting and in printing with a dot matrix printer. Knitting is infinitely slower than most computer printers and requires only rudimentary

technology in the form of needles, but the point of departure, a template with a design, is the same.[10]

MARKETING THE PRINTER AS A PRECIOUS NEW FAMILY MEMBER

The printer is not just a means to an end for producing printed text and graphics. It is also a material object in its own right. The first pages of printer manuals are usually devoted to the unpacking, setting up, and testing of the device. The positions and functions of buttons, knobs, switches, levers, and slots are pointed out in drawings and diagrams. But the purpose of these manuals is not just to highlight all the features of the device and the ways they function. They play another role that goes beyond functionality, which is to make the owner form an attachment to the new acquisition. User manuals typically start by congratulating the new owner, and the Epson manual is no exception. In a personal note from the author, David A. Lien says, "Congratulations on your decision to buy an EPSON MX series printer! It is a truly remarkable piece of hardware, and I believe is the best dollar value in computer printers on the market today."[11] On the previous page, there is a drawing of a man dressed in a (white) coat with two pens in his pocket, and a zoomorphic representation of the Epson printer sits beside him like a pet on a table, with eyes and a smiling mouth, wagging its tail, while the man pats it on its head. The man appears to be saying something to the pet, and they are having eye contact. This drawing is emblematic of the view of a newly acquired device as a precious object, cherished like a family member. The way the man is dressed makes him a bit ambiguous. He could either be the engineer behind the design of the printer, now handing over his obedient and yet content creature to its new master, or he could be the new owner/technician now in charge. The coat and the pens in the pocket are another reference to the transition from microcomputers to personal computers and from amateur programmers to users who "simply inserts his store-bought programs (software) into his computer/printer system," as stated in the Delta manual.[12]

A two-page advertisement for a series of Epson printers in the microcomputer magazine *Byte* in 1982 sends a similar message—that the purchase of an appliance can be likened to the inclusion of a new family

Figure 4.8 A man with a "pet" printer. *Epson MX Printer Manual, GraftraxPlus* (San Diego: CompuSoft, 1982), iv.

member. The heading reads "Birth of a legend." The setting is a maternity ward, where three smiling nurses hold three newborn printers wrapped in blankets and present them to the astonished father. The first part of the text below the photograph reads, "A whole new generation of Epson MX printers has just arrived. And while they share the family traits that made Epson famous—like unequalled reliability and ultra-fine printing— they've got a lot more of what it takes to be a legend. For instance, they've got a few extra type styles."[13]

The reference to family is twofold in the advertisement. First, the Epson company is itself a family with "generations" and "family traits."

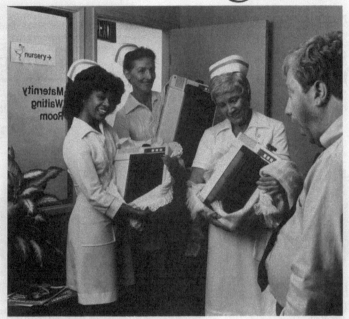

Birth of a legend.

Epson.

A whole new generation of Epson MX printers has just arrived. And while they share the family traits that made Epson famous — like unequalled reliability and ultra-fine printing — they've got a lot more of what it takes to be a legend.

For instance, they've got a few extra type styles. Sixty-six, to be exact, including italics, a handy subscript and superscript for scientific notation, and enough international symbols to print most Western languages.

What's more, on the new-generation MX-80, MX-80 F/T and MX-100, you get GRAFTRAX-Plus dot addressable graphics. Standard. So now you can have precision to rival plotters in a reliable Epson printer. Not to mention true backspace, software printer reset, and programmable form length, horizontal tab and right margin.

All in all, they've got the features that make them destined for stardom. But the best part is that beneath this software bonanza beats the

Figure 4.9 "Birth of a legend": An advertisement for Epson printers. *Byte* 7, no. 8 (August 1982): 396–397.

Uh...three legends.

heart of an Epson. So you still get a bidirectional, logical seeking, disposable print head, crisp, clean, correspondence quality printing, and the kind of reliability that has made Epson the best-selling printers in the world.

All of which should come as no surprise, especially when you look at the family tree. After all, Epson *invented* digital printers almost seventeen years ago for the 1964 Tokyo Olympics. We were the first to make printers as reliable as the family stereo. And we introduced the computer world to correspondence quality printing and disposable print heads. And now we've given birth to the finest printers for small computers on the market.

What's next? Wait and see. We're already expecting.

EPSON
EPSON AMERICA, INC.

3415 Kashiwa Street • Torrance, CA 90505 • (213) 539-9140

FEATURE	ORIGINAL MX-80	GRAFTRAX-80*	ORIGINAL MX-100	MX-80	MX-80 F/T with GRAFTRAX-Plus	MX-100
Bidirectional printing	X	X	X	X	X	X
Logical seeking function	X	X	X	X	X	X
Disposable print head	X	X	X	X	X	X
Speed: 80 CPS	X	X	X	X	X	X
Matrix: 9 x 9	X	X	X	X	X	X
Selectable paper feed			X		X	X
PAPER HANDLING FUNCTIONS						
Line spacing to n/216		X		X	X	X
Programmable form length	X	X	X	X	X	X
Programmable horizontal tabs	X	X	X	X	X	X
Skip over perforation			X	X	X	X
PRINT MODES AND CHARACTER FONTS						
96 ASCII characters	X	X	X	X	X	X
Italics character font		X		X	X	X
Special international symbols				X	X	X
Normal, Emphasized, Double-Strike and Double/Emphasized print modes	X	X	X	X	X	X
Subscript/Superscript print mode				X	X	X
Underline mode				X	X	X
10 CPI	X	X	X	X	X	X
5 CPI	X	X	X	X	X	X
17.16 CPI	X	X	X	X	X	X
8.58 CPI	X	X	X	X	X	X
DOT GRAPHICS MODE						
Line drawing graphics				X	X	X
Bit image 60 D.P.I.		X	X	X	X	X
Bit image 120 D.P.I.		X	X	X	X	X
CONTROL FUNCTIONS						
Software printer reset		X		X	X	X
Adjustable right margin			X	X	X	X
True back space		X		X	X	X
INTERFACES						
Standard — Centronics-style 8-bit parallel	X	X	X	X	X	X
Optional — RS-232C current loop w/2K buffer	X	X	X	X	X	X
RS-232C x-on/x-off w/2K buffer	X	X	X	X	X	X
IEEE-488	X	X	X	X	X	X

*Tandy TRS-80 block graphics only available with GRAFTRAX 80.

ABCDEFGHIJKLMN abcdefghijklmn *ABCDEFGHIJKLMN abcdefghijklmn* Ø1234
ABCDEFGHIJKLMN abcdefghijklmn *ABCDEFGHIJKLMN abcdefghijklmn* Ø1234
ABCDEFGHIJKLMN abcdefghijklmn *ABCDEFGHIJKLMN abcdefghijklmn* Ø1234
ABCDEF abcdef *ABCDEF abcdef* Ø123456
ABCDEFGHIJKLMNOPQRSTUVWX abcdefghijklmnopqrstuvwx *ABCDEFGHIJKLMNOPQRSTUVWX abcdefghijklmnopqrstuvwx* Ø1234567
ABCDEF abcdef *ABCDEF abcdef* Ø123456
ABCDEFGHIJKLMN abcdefghijklmn *ABCDEFGHIJKLMN abcdefghijklmn* Ø1234
ABCDEFGHIJKLMNOPQRSTUVWX abcdefghijklmnopqrstuvwx *ABCDEFGHIJKLMNOPQRSTUVWX abcdefghijklmnopqrstuvwx* Ø1234567

Circle 171 on inquiry card.

Figure 4.9 (continued)

Second, the three new baby printers will be welcomed into the family of the owner, represented by the father who is seeing his newborns for the first time. In the photograph, they are still in the hands of competent professionals, but with the help of the manual, the parents will soon learn how to handle their children. Next to children, pets are often ranked as valuable family members. The man in the Epson manual drawing is portrayed as a benevolent master, already getting along with his new pet. This "family member" marketing strategy was a way for companies to make consumers form a bond with their products.[14] Printers for the home computer market, like the Epson and the Delta models referred to here, had a number of qualities that made them suitable for this strategy. They were the size of a small dog, they obeyed commands, and they "came alive" when printing, making sound and movements.[15]

MULTISENSORY MACHINES

The purpose of printing is to produce visual output. However, just like other printers, the dot matrix printer is a multisensory machine: it emits visual, aural, haptic, as well as olfactory information. Media theorist W. J. T. Mitchell argues that there is no such thing as visual media and that all media are mixed media. Images nearly always engage other senses—notably, the auditory and haptic senses. He takes as examples the pastose painting technique that renders thick layers of paint and the silent movies that were always accompanied by live music when screened in theaters.[16] In spite of the singular quality of dot matrix character sets, it is not the visual appearance of the output that is the defining aspect of the printer. It is the sound it makes while printing. There was generally no mention of the noise in the manuals, probably because the manufacturers did not want to draw attention to what could be seen as a weakness of their product. The line printers had a distinct and very loud sound, but they were locked in computer rooms and not heard by many people. The dot matrix printer was a common appliance in both companies and homes, and its peculiar sound is brought up time and again in memory accounts, as is shown below. But the sound was not only a source of memory. It was also a source of information that could reveal what was

being printed, even to those who were not supposed to lay their hands on that information.

READING SOUND: ACOUSTIC EAVESDROPPING

The sound generated by dot matrix printers arises from multiple sources —the motor, the carriage that moves the printhead back and forth across the page, the pins of the printhead striking against the ribbon, and the movements of other mechanical parts of the printer. Sound is not only a side effect of the printing process. It is a semiotic resource that carries meaning that can be interpreted by humans as well as by machines. When being used for its original purpose of printing text and graphics, the dot matrix printer emits a sound that can reveal to frequent users what kind of output is being sent to the printer. An article on the dot matrix printer in *Paleotronic* magazine touched on this aspect of the printer:

They were loud and distinct, the pins of their print heads hammering through their ribbons and driving ink into the paper trapped below, the act of rendering patterns on tree-pulp also creating unique rhythms you could learn to identify if you heard them enough—"Oh, that's a book report. That's a resumé. Oh, that must be a Print Shop banner!"[17]

A similar reflection was published in the online trade publication and social community for IT professionals, *TechRepublic*, where the backward-looking article "Dot Matrix Printers Still Hammer Away the Days" appeared in 2008:

Work around them long enough and you could tell whether the person was doing a regular letter or something for a formal presentation by the sound of the double strike. Printing graphics would result in the high-pitch squeal of the pins all striking at once.[18]

These two quotes testify to how categories of printout have their characteristic sound, rhythm, and pitch, which are easily discernible to the naked ear. A dot matrix printer can reveal even more information to people who know what they are looking for and who have the right equipment. In contexts where confidential or secret information is being printed on a dot matrix printer, side-channel attacks might be launched in order to get hold of the information.

According to a German study, side-channel attacks "exploit the unpro-
tected area where the computer meets the real world: near the keyboard,
monitor or printer, at a stage before the information is encrypted or after
it has been translated into human-readable form."[19] In 2010, when the
study was carried out, many doctors and banks in Germany still used dot
matrix printers. An experimental in-field attack was conducted in order
to see how much information could be retrieved by recording the sound
of a dot matrix printer when it printed seven fictive prescriptions. The
methodology for processing the recordings was taken from the field of
language technology, which has developed automatic speech recognition
and machine learning techniques for audio processing and document
coherence. The first phase involved "a training phase where words from
a dictionary are printed, and characteristic sound features of these words
are extracted and stored in a database."[20] A word-based approach was
used because of the blurring effect involved in identifying the sound of
individual letters. In an attempt to see how the experiment would work
if some of the parameters of the setup were modified, different font types
and printer models were used. Changing from a monospaced font to a
proportional font or switching to another type of a dot matrix printer
had very little negative effect on the recognition rate. The most com-
monly used built-in monospaced fonts make the text less compact than
the proportional fonts and thus easier to decode. The proportional fonts
increase the blurring effect, making it difficult to discriminate between
the sounds of letters and words. If a domain-specific corpus is used for
the analysis, in this case the medical domain, the recognition rate was 95
percent accurate.

The study concluded that acoustic shielding was one of simplest and
best countermeasures that could be taken.[21] Notable in this experiment is
the use of speech recognition techniques that are intended for the analysis
of the human voice, which implies that the printer has a voice or, rather,
that the printer is a peripheral that gives voice to the computer. A voice
and the ability to speak are main characteristics of most human beings.
Regarding the sound of a dot matrix printer as a voice is another instance
of the anthropomorphism shown by the newborn babies in the Epson
advertisement in *Byte* and the cartoon depicting the printer as a pet in the
Epson manual. The anthropomorphization of voice assistants and robots

is a topic discussed in contemporary research on artificial intelligence.[22] However, the sound of dot matrix printers is far from the uncanny valley effect associated with robots that resemble humans to a high degree and yet differ in ways that are perceived as creepy by humans.[23]

A MEMORABLE SOUND

The sound of dot matrix printers is sometimes graphically described, as in a 2013 post by Benj Edwards on his blog *Vintage Computing and Gaming: Adventures in Classic Technology*, which features an 1983 advertisement for the Star Delta-10 printer. As a toddler, Edwards used to watch the printer printing banners and calendars: "But what I remember most about it, of course, was the sound it made: like a screeching robot mouse spraying lead into tractor-feed paper with a tiny machine gun. Like any dot matrix printer, once you hear one in action, the sound will never leave you."[24] Such a description is bound to trigger memories among the readers. One commenter named technotreegrass wrote this:

I remember being fascinated by the dot-matrix computers in computer class in the early 90s, watching them print out some pic I made from . . . something, I forget, and carefully removed it from the printer to let it sit for a few minutes to make sure all the ink dried. Printers have lost that magic for me ever since, even the high-quality color laser printers. Maybe it was the distinct sound they made that made the experience so magical.[25]

Many bloggers and their commenters share memories of how fascinated they were by watching the printer when they were children, but it is the sound that seems to have left the deepest impression. Edwards's blog entry contains a vivid description of the sound, using a simile containing a little mouse and a machine gun. This rather ambivalent figure of speech is somehow typical for how many writers perceive the sound of the printer simultaneously as cute and violent and as attractive and repellant.

When in normal operation, many machines emit a sound that becomes familiar to its users. A change in that sound functions as an indicator that something is wrong with the machine.[26] In *What Is Media Archaeology?*, Jussi Parikka refers to the historian of mathematics and computer science Gerard Alberts, who claims that attention to sound was a crucial part of the understanding and maintenance of early mainframe computing

in the post–World War II era.[27] But with the dot matrix printer, strange sounds might be a false alarm and not a signal of malfunction. A comment by Carsten Langbo on the YouTube channel *Nostalgia Nerd* read:

I always liked the dot-matrix printers for the fact they sound like they're ripping something apart or having a major on-going malfunction as they work as they where [*sic*] intended.[28]

Langbo, like other commenter and bloggers, expresses his appreciation of dot matrix printers in a way that encompasses both rough and smooth qualities of the device. Music is known to evoke emotional responses in listeners, but other types of sound can have that effect as well.[29]

The instructional video is a popular video genre on the internet and is often used to share knowledge about technology. One private collector of microcomputers who posts videos online is Terry Stewart, New Zealand. He runs the website Terry Stewart's (Tezza's) Webzone for Classic Computers, which "is devoted to the computers and computing culture of those years [1975–1986], from my own personal perspective and often with a 'down under' flavour. The reason for its existence is to preserve some history before it's forgotten by those of us that were there, or so it can be discovered by those that weren't."[30] His YouTube channel, which has nearly eight thousand subscribers, contains a video from 2014, "Matrix Printers. As Seen in Tezza's Classic Computer Collection." In this video, he gives a short overview of printer technologies, starting with line printers and then continuing with the principles of dot matrix printers, with the help of illustrations. Then he turns to a printer sitting on a table, a Panasonic KX-P1081, going through it systematically to show details of the exterior and the interior and taking off the hood to show the printing mechanism, the printer port, and the plug close up. We then get to see it in action when it prints a self-test and a text document. He also shows the manual and then some other printers in his collection: "So there they are, my babies."

Stewart finishes the video by saying that those who lived through this era might not have learn much from the video, but "Hopefully, it generated a little bit of nostalgia for you, seeing these old machines again and hearing them work. If you're younger and you've only heard about dot matrix printers, hopefully this video was informative for you."[31] As

Figure 4.10 A screenshot showing Terry Stewart and a dot matrix printer. Terry Stewart, "Dot Matrix Printers. As Seen in Tezza's Classic Computer Collection," YouTube, October 4, 2014, @ Terry Stewart.

promised on his website, he addresses both target groups. This video is somewhat reminiscent of a printer manual in its methodic and comprehensive style of presentation. Like the drawings in the manual, the video shows the printer from several angles but is also capable of conveying motion and sound, which provides a multisensory experience. Simultaneously seeing and hearing the machines is evocative and may generate nostalgia, a wish Stewart expresses at the end.

For some commenters, this video evoked childhood memories:

rwdplz1
I remember watching the Apple dot matrix printer for the first time as a kid, and just being mesmerized by the text slowly appearing on the page.

William M
I do remember growing up with dot matrix printers—we had one at home and they had them at school—seeing your video brought back the sights, sounds, and smells (there was a distinctive smell of the mechanism of these printers—not sure if it was the ink/ribbon or something on the mechanism)[32]

The sound of the printer is regularly brought up in the context of dot matrix printers, but these two comments are notable—the first one because it highlights the performative aspect of the printer and the second one because it highlights the multisensory character of memory. The

memory is not just of the final product, the printed page. The process of printing is also a source of fascination. To see the text emerging is similar to watching a photograph appearing in the developing tray in an analog photo lab, although the printed page emerges dot by dot, while the photograph emerges as a whole picture, pale at first and then gradually becoming darker. The comment regarding smell is the only one I have come across in the commentary fields of blogs and forums on dot matrix printers. Smell is perhaps not the first thing that comes to mind in connection with computers in general, but they definitely have an olfactory dimension. In the comment above, the memory was triggered by seeing the video, so one sense can be enough to evoke memories involving several senses.[33]

A subcategory to the instructional video is the one devoted to the maintenance and repair of technical appliances—in this case, obsolete computer devices. These videos are of use both to those who are still using out-of-date equipment and to those who want to refurbish their museum artefacts in order to have a functioning collection. The YouTube channel Tech Tangents has nearly 100,000 subscribers and contains videos about a wide range of technical and computer-related issues, among them how to mend broken devices. One such hands-on instructional video is "Fix Dot Matrix Printer Stuck Pin—Micro Tangent," published in 2020.[34] Apart from speaking to the visual and auditory senses, this video appeals to the tactile sense by showing the hands of the channel owner in close-up while he manipulates the different parts of the printer. An Apple ImageWriter is not printing properly because one of the keys is stuck, which is demonstrated by a printout where the lower part of each row of text is missing.

The ImageWriter is a 9-pin printer, and the text printed on the paper ("I'm an 8 pin printer now") can be read with some difficulty. The owner of the channel shows the cause of the problem: ink from the fabric ribbon has become stuck to the pins. Then he starts to unscrew the printhead, while saying "Dot matrix printers were popular when maintenance and serviceability was a key feature people were looking for." A close-up of the printhead shows how much ink has gathered on it. He first brushes ink off it with a toothbrush and then puts the printhead in a solvent. When it is clean, he makes a new test print to show that the printer now works as

Figure 4.11 A screenshot showing a printing problem. "Fix Dot Matrix Printer Stuck Pin—Micro Tangent," YouTube, March 18, 2020. © Shelby Jueden, Tech Tangents.

intended, and the text emerging says, "Back to 9 pins again!" He exclaims, "Ah, yeah, that is much better! [The printer is printing.] I really like dot matrix printers. That sound is really . . . mm, yeah [with emphasis, and he makes an OK gesture with his hand]. I feel like most people have probably heard that sound, either through experiencing these devices themselves or just in line at the DMV." The last twenty seconds of the video focus on the printer in action, without comments. This is an example of mediated materiality. Filmic devices such as close-ups are used for pedagogical reasons but also for conveying a feeling of being immersed in the machinery and in the task. Viewers are encouraged to get their hands dirty and not to be afraid of digging into the inside of the machine. Visual media do not afford direct contact with the material shown, but they can contain tactile and other multisensory clues.[35]

Just like Terry Stewart's video, this video evoked childhood memories for many viewers. As one commenter, AttilaSVK, wrote:

This reminds me of my childhood. In 1996, my mom started working as an accountant, and sometimes she had to work from home, especially when I was sick, and there was nobody to take care of me. She would bring a 386SX laptop home and an Epson LX-100 dot matrix printer. I could tell from the rhythm of printer if she was printing invoices, or the reports from the bank, etc.[36]

This comment gives context to the memory of who used the computer and the printer, what circumstances they were used under, and what their purpose was. It is also specific about what the sound was and how it could be interpreted. However, a human being can identify different types of printing tasks but not discern every single letter, like the speech recognition system in the side-channel attack described above.

A couple of the commenters, such as Bluephreakr, reacted to the statement about maintenance:

[W]hen maintenance and serviceability was a key feature people were looking for[.][*sic*] You do not know the unyielding sadness this phrase had wrought upon me. Why aren't more people looking for this today?[37]

Many of the comments to this video reveal a concern about the rapid pace of obsolescence of computer equipment and about product construction that does not facilitate repair. It is often cheaper and easier to buy a new replacement than to mend a broken device. Many people long for a past when a different, more sustainable mindset was prevalent. But more than the physical objects and the waste of materials are at stake. Skills and knowledge invested in the machines disappear along with the artefacts. The appeal of videos such as the two mentioned here goes further than superficial recognition. It concerns maintaining technological knowledge, of which the channel owners can be regarded as guardians.

MAKING MUSIC FROM NOISE: CREATIVE PRACTICES RELATED TO THE DOT MATRIX PRINTER

A sound can be perceived as annoying depending on several factors, among them loudness and tonality.[38] "Terms like 'Buzz Saw' or 'Hammers From Hell' were appropriately applied to dot matrix printers," according to the HP Computer Museum website.[39] These printers were so loud that accessories were sold that could reduce their noise. A short article on the subject appeared in *Popular Science* in 1983: "Eeek, screech, eeek. The sound of a dot matrix printer—tiny pins slamming on paper—can put family members or co-workers on edge. When I put my Epson MX80 into SoundTrap, a new acoustical housing, I was amazed at the noise reduction."[40] Engineering research was also done at the time on how to reduce

the source of the noise by altering the construction of the printer.[41] Besides loudness, tonality is another factor that can be perceived as annoying, and the dot matrix printer generates significant tonal noise. This can also be regarded as an asset, as it turns the printer into a potential musical instrument or a music machine in its own right.[42]

In *Boing Boing*, a blog where technology and gadgets are common topics, the post "Ah, the Sound of a Dot Matrix Printer!" was published by Jason Weisberger in 2019. He wrote about his memories of the dot matrix printers that were at one of his first jobs in the late 1980s, and the post generated a number of comments. In response to the post, the commenter Purplecat posted a link to the song "Eye of the Tiger" played by a dot matrix printer. To this, one commenter, heh, replied:

Now that's more like it. Good times. I remember dancing to the 2 Star LC-10 printers printing tables in my university computer room. People used to warn each other if a good paper (good meaning lots of tables and graphs, those sounded best) was coming up and throwing a little "dance" party. With beer and (if the it people weren't watching) crisps. Fun times.[43]

This is another expression of the playfulness that characterized computer culture, just like ASCII art in computer centers (see chapter 2). Dancing to the sound of a printer can count as a postdigital practice in the sense of using equipment in a different way than intended.

In the 1950s, the avant-garde musical movement musique concrète took environmental sounds as points of departure for compositions. With the help of the blog commenter heh's dance memory, the dot matrix printer can be seen as making direct and unmediated musique concrète, without the recording and manipulation of the sound material by a composer. An interesting aspect of this memory is the random appearance of suitable dance "tunes," as if the other users who printed their jobs were unwittingly acting as remote DJs. That a certain type of output, documents with tables and graphs, was deemed as most suitable for dancing indicates that a sign system built on alphabetic characters, graphs, and scientific formulas made for the purpose of communicating ideas can be seen as a form of musical notation. This is something I return to below.

In a 2019 *Paleotronic* magazine article on dot matrix printers that was part of a series called "Gadget Graveyard," the printers' capacity for music is similarly acknowledged: "The motors driving the head and the platen

would whir and in some models the head would slam into the sidewalls of the printer, as if completing a techno-anarchic drum kit."[44] In addition to tonal sound, the printer generates rhythmic sound, which is another important element of music. This description of the workings of the printer and the sound generated by its specific parts turns the device into a musical instrument or rather an ensemble of instruments—a drum kit.

In a reaction to the hype of novelty that often surrounds new media, many artists have adopted a media archaeological approach in their use of obsolete technology to make art.[45] One example is the Canadian contemporary art collective [The User], consisting of composer Emmanuel Madan and architect Thomas McIntosh. In 1998, they created *Symphony for Dot Matrix Printers*, a piece that was performed at a number of art festivals, among them Ars Electronica in Austria in 1999.[46] Twelve old printers were donated to the duo by schools and acquaintances, and each printer was attached to a personal computer in a network. The twelve printers served as the orchestra, while a server played the role of conductor: "The 'local area network orchestra' reads from text-file scores made up of letters of the alphabet and other ASCII symbols which, when printed, create the textures, tones and rhythms of the music."[47] The work also included video projections that made it possible for the audience to see the action on the stage in close-up. The artists carefully chose the printers according to their different characteristics so that together they made up an orchestra. "We have our bass section, our tenors and our little soloists that can play very fast and virtuosic things," Madan stated in an interview.[48] This is the kind of work that is difficult to label, but it could be called electronic music or industrial music.

The work can be seen as a critique of the ideal of constant economic growth and fast technological development that leads to a considerable amount of waste, in this case of perfectly functional printers. In a biography for [The User] on the website of the Daniel Langlois Foundation for Art, Science, and Technology, Angela Plohman wrote about the piece *Paper Jam*, which was a precursor of the *Symphony for Dot Matrix Printers*, saying that "it incorporated typewriters and dot-matrix printers, technologies that had become almost obsolete, nostalgic symbols of contemporary society's unrestrained devotion to rapid technological progress.[49] In a subsequent version of the work, *Symphony for Dot Matrix Printers #2*, small

Figure 4.12 An installation view for [The User], *Quartet for Dot Matrix Printers*. Nam June Paik Award exhibition, PhoenixHalle, Dortmund, September 2004. Image: Thomas McIntosh.

video cameras were inserted into the printers so that the movements of the mechanisms could be watched by the audience.[50] When performed at the Avanto festival in Helsinki in 2001, the festival website stated, "The genius of [The User]'s *Symphony for Dot Matrix Printers* lies in the graphic manner it uses to create a continuation from the nostalgic, smoggy 20th century industrialism to the world of the 'microserfs' of the present information society; from the factory to the paperless office."[51] In 2004, yet another version of the work was staged, *Quartet for Dot Matrix Printers*, this time as a gallery installation. In Phoenixhalle in Dortmund, Germany, four printers were put into glass displays. An office chair placed in the middle of the installation offered the visitor a chance to listen to the printers, to watch them printing, and to watch video projections of their interiors on the walls of the gallery. The visitor was thus "immersed in a junk-aesthetic audiovisual environment orchestrated entirely from the composed texts that the printers reproduce," according to the description of the work on the website /Undefine.[52] This example shows in how

many ways the same work can be varied and presented to bring forth the underlying concepts and ideas.

The musical potential of dot matrix printers has been tapped not only by avant-garde artists but also by people with musical and technical skills who do not take part in the contemporary art scene but are part of the DIY culture. They might be anonymous, using aliases and distributing their work primarily in channels like YouTube. What they have in common with the avant-garde artists is the media archaeological approach and the use of tinkering as a methodology.[53] They also demonstrate a postdigital hacker attitude by dismantling devices and putting them to uses that were unintended by the original designers. One example is the Vimeo channel MIDI Desaster, launched by a German man in 2012 with the goal of "Abusing old hardware to play music," according to the website.[54] Two years later, he launched a YouTube channel with the same name and content, stating "What can you do with a dot matrix printer instead of just printing? How obvious! Make music! That is what we did, have fun with the results." In one of the videos, the owner details how he converted an old 24-pin dot matrix printer into a sound generator that was compatible with a musical instrument digital interface (MIDI).[55] The works of [The User] were based on the "natural" behavior and functioning of the printer and were "orchestrated entirely from the composed texts that the printers reproduce,"[56] whereas MIDI Desaster made significant alterations to the device in order to turn it into a musical instrument or even a self-contained orchestra. The channels contain approximately thirty covers of famous songs and musical pieces, among others the Christmas song "O Tannenbaum," in which the printer was decorated with a twig from a fir tree and a tea light was placed on the printhead. A small fire extinguisher completed the scene. Most of the songs show the unadorned printer and start by printing its title and the URLs of the channels. The song with the most views is "Rocky's Printer—Eye of the Tiger on a Dot Matrix Printer" mentioned by Purplecat in the thread on the *Boing Boing* blog.[57] This song takes full advantage of the printer's capacity for both rhythm and melody. While the printhead is moving slowly across the page, many pins are engaged to create polyphony, and a visual trail is created on the paper. It forms a graphic pattern with lighter and darker parts, and in contrast to an intelligible text, it appears as a secret message written in cipher. The

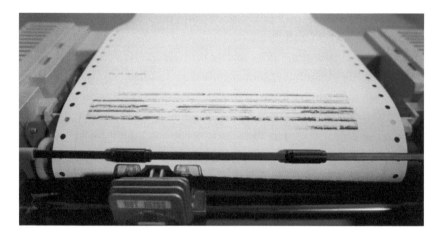

Figure 4.13 A screenshot showing a dot matrix printer. MIDI Desaster, "Rocky's Printer —'Eye of the Tiger' on a Dot Matrix Printer," Vimeo, January 25, 2013. © MIDI Desaster.

function of the printer has been turned on its head: it is the sound that dictates the visual output, not the other way around, as would normally be the case. Some of the commenters pay attention to this:

Kitsune Shan
What is also cool is that you get a literally printed image from the music. A new way of "seeing" music.

Guido Belluomo
This is basically like sheet music, only you need a microscope to read it.

Mithindis
It's like you also made sheet music in the process. It'd be neat to make something that is capable of reading this sheet and playing it back as audio.[58]

The comments quoted open up three different semiotic paths for the interpretation of the printed patterns. The first is what music looks like. The pattern is a way of experiencing music visually, in line with the concept of synesthesia, which means that translations can occur between the senses. The Russian painter Wassily Kandinsky is one of the artists who have explored the idea that music can have a visual equivalent, and in the beginning of the twentieth century, he created many abstract compositions associated with music.[59] While artists can interpret music and translate it into visual form, the printed output appears not to have been processed through a human mind but seems to emerge automatically as

a byproduct of the sound generation. The patterns can thus be seen as indexical signs, like footprints caused by a human foot in the sand.

The second semiotic path for the interpretation of the printer patterns would be to compare the pattern to the standard Western musical notation that is based on the staff with lines and spaces on which notes are written. This is a clear and unambiguous system that was devised to help composers write down their compositions and to help musicians to perform them.[60] The printed pattern created by MIDI Desaster's printers is neither clear nor unambiguous, but the commenter Guido Belluomo finds an ingenious explanation for its impenetrability—the miniscule size of the signs. There is possibly a code system like the traditional musical notation hidden in the pattern, only it is too small to be read by the human eye.

The third path is indicated by Mithindis, who asks whether it would it be possible to reverse the process "to make something that is capable of reading this sheet and playing it back as audio." For each of the above comments, we are distancing ourselves from humans and human capabilities. The first comment was about (supposedly human) vision, the second was about human vision reinforced by a microscope, and the third implies an artificial intelligence system with computer vision capabilities and the ability to perform music. Regarded as a cipher, the pattern could perhaps be deciphered by using forensic chemistry techniques instead of relying on visual inspection. As seen in the YouTube video "Rocky's Printer—'Eye of the Tiger' on a Dot Matrix Printer" as well as in some other songs, the printer deposits very thick layers of ink in some places. The amount of ink is hard to gauge with the naked eye but could possibly be determined with laboratory methods. An additional semiotic path would be that the pattern is a secret code that no one can ever crack.

TECHNOSTALGIA

Information technology is often seen as abstract and immaterial and somehow in opposition to the physical world. As has been shown above, however, information technology is highly dependent on physical devices and their material qualities. The multisensory features of the dot

matrix printer have contributed to making it memorable, which is not to say that other printers lack such features. Line printers, daisy wheel printers, and laser printers make noise, too, but the dot matrix printer was the first consumer printer that a large number of people could relate to and share memories of, as demonstrated by the above quotes from commentary fields. The words *nostalgia* and *nostalgic* recur throughout the quotes. The interest in and devotion to computers and peripherals like dot matrix printers can be seen as a kind of technostalgia. In the *Urban Dictionary*, the term *technostalgia* is defined as "Nostalgia for simpler technologies. Typically induced by technological hypersaturation of the early twenty-first century." The example sentence given in the definition is "At the thought of my teens, I was overcome with technostalgia for the clunky bulk of my first cassette walkman."[61] At *Wiktionary*, *technostalgia* is defined as "Fond reminiscence of, or longing for, outdated technology."[62] Media history researcher Tim van der Heijden defines *technostalgia* as "the reminiscence of past media technologies in contemporary memory practices."[63] For the purpose of the topic of this chapter, the following definition, derived from the previously quoted definitions, is proposed: "technostalgia is a driving force in memory practices involving simpler and outdated technologies." Collecting, refurbishing, and demonstrating old items are examples of such practices.

Originally, nostalgia meant longing for a distant or lost home, but the concept now often refers to longing for the past. Literary scholar Svetlana Boym distinguishes between two main types of nostalgia, restorative and reflective. Restorative nostalgia is at work when a nation-state attempts to restore a heroic past and a common origin. The nation-state takes itself very seriously and would not define itself as experiencing nostalgia but as representing the truth. Those experiencing reflective nostalgia are aware that the feeling is nostalgia, often in a self-mocking and humorous way. Reflective nostalgia does not rely on one single narrative and instead "cherishes shattered fragments of memory."[64]

The technostalgia concerning old dot matrix printers is mostly of the reflective kind. When reminiscing about these printers, people are not claiming that this was the one and only printer type and that it needs to be restored to its former prominent position on the computer market. Rather, the nostalgia surrounding dot matrix printers and other obsolete

Welcome to the Obsolete Technology Website

Figure 4.14 The Links page for the Steve's Old Computer Museum website. © Steven Stengel.

equipment is of the humorous, reflective kind. This is evident not least from the names of websites devoted to evoking the memories of bygone computing days, including *Paleotronic* magazine (with a series of articles named Gadget Graveyard), Binary Dinosaurs, 8-Bit Nirvana, Byte Cellar, Computer Closet, Nostalgia Nerd, and The Silicon Vault. They can have a temporal reference (such as the stone age or the age of the dinosaurs) or a spatial reference (such as secluded places in a house, like a closet, cellar, or vault, or heavenly places, such as Nirvana, a haven for old nerds). Humor and fun prevail not only in the verbal aspects of the websites but also in their visual design. Early computer-associated typefaces like Data 70, buttons, frames, and other elements from Macintosh's first graphical interface and overall web design from the 1990s are common features of technostalgic websites. One example is Steve's Old Computer Museum, which on its Links page has a heading with the text "Welcome to the Obsolete Technology Website" set in the typeface Computer.

The fast-paced technological development and the pressure put on consumers to upgrade have entailed an accelerating obsolescence of computer devices. Paradoxically, many of these mass-produced industrial products have become rare and hard to obtain. The owner of the Steve's Old Computer Museum website thinks that old computers are an endangered species and represent a cultural and technical heritage in need of preservation. This appeal is displayed on the site's About page: "Help save a computer—please notify us of any prospective computer rescue opportunities."[65] It can be argued that the members of the art collective [The User] rescued old equipment by repurposing them for their musical pieces and that the junk aesthetic ascribed to them is tightly connected to nostalgia and the longing for a time when the dot matrix printer was not a piece of junk. At the same time, the irony of the nostalgia of these works is that the printers are fully functioning and by their very operation on stage and in galleries defy the definition of junk, which is why the works fit the definition of reflective nostalgia quite well.

On the website of the HP Computer Museum in Australia, there is a page devoted to the HP dot matrix printer model 2934A: "The 293X printers are still very reliable. The museum has four units, and they all work."[66] This comment by the collector is telling because it highlights both the longevity of the dot matrix printer and also the importance paid by most museums to keeping the equipment in operation. Visitors come to see not just empty shells and relics but working devices.[67] Unlike national museums of art, history, or culture, computer museums are not (yet) considered important for the image of nations and are consequently not housed in imposing museum buildings. Given the importance of information technology for our era, however, a time might come when states need computer museums for conjuring up a heroic past of innovation and entrepreneurship, and at that time, technostalgia could become restorative nostalgia as well. Pedagogical and educational ambition connects these establishments, regardless of size and ownership.

STILL GOING STRONG: CONTEMPORARY USES OF DOT MATRIX PRINTING

The story of technology is often told as a line of constant progress and evolution. In reality, that line meanders or travels on parallel tracks.[68] The traditional dot matrix impact printer is not just a museum object that generates nostalgia. It has lived on and is still manufactured by companies such as Epson and Oki. From its prominence in the 1980s and 1990s, it has now been relegated to the margins of the printer market in the West, where it is mostly used as a utility printer for receipts, warehouse reports, freight documents, and similar purposes. It is still a fully functional device that has some advantages over other printer types in that it can operate in harsh environments, print multipart forms, and, because it is an impact printer, make carbon copies. The cost per page is low, and the lifespan of the printer is long.[69] The dot matrix concept, although performed with the help of other technologies, offers flexibility and makes it possible to print on nonflat surfaces. Legibility is still an issue that readers, human and otherwise, have to deal with. Three examples that highlight both the problems and advantages of the printer and the printing concept are presented in the following

sections. What these examples of the contemporary uses of dot matrix printing have in common is that they do not concern the marketing of products.

ROYAL MAIL AND OPTICAL CHARACTER RECOGNITION (OCR)

In simplistic terms, the side-channel attack experiment referred to above could be described as one computer listening to the voice of another computer in a context where the latter is involuntarily giving away information and not being particularly cooperative. The dot matrix printer is not primarily an aural media. However, even its visual output can be demanding to decipher and often presents problems for optical character recognition (OCR) systems. It can be seen as one computer trying to read what another computer has written when both are semiliterate. Still, using OCR can be more efficient than employing human readers when large volumes of data are involved. For instance, postal services commonly use OCR for reading address labels on letters and other postal items. Dot matrix printed characters are harder to read than other printed text because the character elements, the dots, are disconnected and the shapes of the characters vary to a greater extent.[70] This is evident from the guidelines issued by the Royal Mail in the United Kingdom, "Royal Mail User Guide for Machine Readable Letters & Large Letters."[71] Companies that want to make their large letters eligible for the OCR service have to meet a number of requirements concerning the size and weight of the letters, the graphic design, and the typography. In regard to the print quality of the delivery address, the use of low-resolution dot matrix printers is discouraged, and furthermore, "the characters must not be blurred, smudged, deformed or incomplete. If using dot matrix printing, particularly on polymer, there must be no gaps between the dots."[72] Dot matrix printing is specifically highlighted among the possible issues that can occur in the OCR process. This regards both addresses printed on labels using traditional dot matrix impact printers and addresses printed directly on the envelope using more recent inkjet printers that also use the dot matrix format.

In his book on how the postal system influenced the way literature was created in the nineteenth century, the media theorist Bernhard Siegert

Figure 4.15 Samples of problematic printed addresses for UK mail. "Royal Mail User Guide for Machine Readable Letters & Large Letters," August 27, 2019.

describes how standardization and mechanization of the postal system in England turned it into an efficient communication system available to all citizens. The only thing lacking from a complete mechanization of the system was a machine that could read the mail at the end of the process, according to Siegert. This is not easy to achieve, even with today's technology.[73]

INDIAN RAILWAYS

Many of the YouTube videos on the topic of maintaining and repairing dot matrix printers are in Hindi.[74] Indian Railways still use the printer because of its reliability, the low cost per page, the carbon copy handling, and the flexible font features that allow for different alphabets, among other things. In a thread on Quora, an online forum for questions and answers, the question "Why does Indian Railways still use the same dot-matrix printer?" received a comprehensive answer by Nikunj Bhatia, a former senior engineer at Indian Railways, who explains how the carbon copy function was utilized to make quadruplicates of the reservation chart: "One copy goes to the head office, one to the ticket checker, one on the platform and one the train."[75] This feature is one of the reasons the printer has remained an indispensable piece of equipment at Indian Railways. The story that enfolds in the answer is illustrated with several photographs of trains, stations, and tickets. Bhatia ends his answer with: "Source: My experience." It is an example of a contextualized account of the use of technology of a kind that is seldom found in traditional histories of technology, which are sustained by the idea of constant technological progress.

Figure 4.16 An Indian Railways ticket printed on a dot matrix printer. Nikunj Bhatia, "Why Does Indian Railways Still Use the Same Dot-Matrix Printer?," Quora, December, 2014.

DATE MARKING ON PACKAGING

One major application for contemporary dot matrix printing is date marking in the food packaging industry. Inkjet printers can perform contactless printing on moving objects and hence print on packages while they are being transported on a conveyor belt. In this way, dot matrix printing has gone beyond a typewriter-like set-up with a platen and a paper bail that presupposes printing on a flat piece of paper. Date marking is one of the few contexts where Western consumers still encounter dot matrix printed text. Regulations and recommendations for date marking vary to a great extent from country to country. The labeling guidance issued by the Waste and Resources Action Programme (WRAP) in the United Kingdom says, "The date label must be conspicuous, legible and indelible. Black inkjet on a dark green background, for example, is not acceptable; nor ink-jet onto pictures or other writing."[76] This recommendation pinpoints some of the issues that consumers regularly encounter in food stores. Date markings are often hard to find and difficult to discern on a package. They are sometimes printed on uneven or fragile surfaces, and the text is often broken or wobbly.

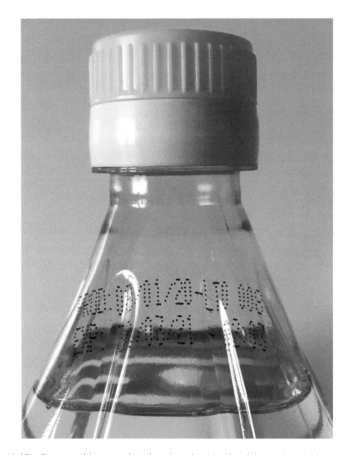

Figure 4.17 Date marking on a bottle printed using the dot matrix printing concept.

Date markings are often embedded in extra information and codes that are not intended to be read by the consumer. Unlike other parts of the packaging design, date marking does not form part of the marketing of the product. One could say that it belongs to the underbelly of graphic design, where speed and convenience in the production process trump legibility and aesthetic qualities. The issues with legibility are acknowledged by a company marketing OCR software that can recognize dot matrix text:

While barcodes have made identifying products easy for machines, a format that can also be easily read directly by human consumers is still very important. To this end, dot-matrix characters as produced by inkjet printers remains the most common form of human-readable text on product packaging. If set

properly, inkjet printers provide legible printing; however, the realities of the production line and the print surface lead to variations/imperfections in the way text is printed. These imperfections make reading for automatic tracking difficult.[77]

Date marking on food packaging is the result of many compromises. It must be reasonably readable both for humans and for nonhuman automated OCR systems. It must be present on the package without occupying any of its valuable marketing surfaces. The ink must be permanent, and the process of applying the marking must be swift. The ideal of high resolution and "near letter-quality" has been abandoned, and the fragmented, modular structure of the letters has been accepted as a necessary concession in the trade-off between efficiency and legibility.

LO-RES AND THE RETURN OF THE DOT

The more advanced printer features described in the printer manuals in the beginning of this chapter were probably intended for computer hobbyists rather than the general home computer consumer. It was not until the late 1990s and the growth of the web that amateurs started to design and exchange typefaces to any significant extent.[78] However, a few professional graphic designers were attracted by the possibilities and constraints of digital technology at an early stage—notably, Zuzana Licko, who created experimental typefaces for the avant-garde graphic design magazine *Emigre* that she and Rudy VanderLans launched in 1984: "Rather than replicate (on a dot matrix printer) typographic forms already adapted from calligraphy, lead and photosetting, Licko used public domain software to create bitmap fonts."[79] Working on an Apple Macintosh desktop personal computer, she designed the Emperor, Oakland, and Emigre typefaces, pioneering bitmapped typefaces that were also sold by Licko and VanderLans's firm Emigre Fonts, a digital type foundry. In 2001, Licko updated and made a synthesis of these and other early fonts, which are now marketed under the family name Lo-Res.[80]

In the text that serves as the type specimen for the family, the Emigre Fonts website explains that low-resolution bitmapped fonts have made a comeback after leading a marginalized life in printing since the advent of high-resolution output devices:

Figure 4.18 Examples of the Lo-Res and Emigre typefaces. © Zuzana Licko.

The reasons for this dramatic comeback are varied. The most obvious is that a new generation of young graphic designers has entered the profession. For these designers, and their audiences, who grew up playing video games and now surf the Internet, low resolution type is no longer an alien, difficult-to-read, crude computer phenomenon. It's been a part of their daily reading experience at home and at school. For this generation, it may be that reading a crude bitmap in print is no different than reading it on the screen. Through our everyday encounters with computers, the idiosyncrasies of bitmaps are disappearing— visible pixels are becoming accepted as the natural mark of the computer, like brush strokes on an oil painting.[81]

In other words, digital media has become habitual media, and the younger generation is at ease living in the postdigital era. The technological constraints generated a form of expression, which shows that it would be a mistake to equate low resolution with low quality. Licko's fonts are made up of rectangles, but the same logic applies to the dot-based fonts. The dot has made several comebacks, starting ten years after its prime. In the early 1990s, Swiss type designers Stephan Müller and Cornel Windlin designed the FF Dot Matrix font family for their label Lineto.[82] They did not expect it to be a success, but the time was right for their retro typeface, although the dot matrix era was not quite over. This statement was issued on Lineto's legacy website:

when we started with the "dot matrix" family in 1991, we didn't think that such a basic design would ever get popular. we were wrong • and decided to

Figure 4.19 A sample of the FF Dot Matrix typeface. © 2022. Screenshot taken from MyFonts at myfonts.com with permission of Monotype Imaging Inc.

Figure 4.20 An H&M store sign using the FF Dot Matrix typeface, 2006. © Stephen Coles.

release a package containing four fonts through fontshop international. in the meantime, every graphic design student must have designed a couple of matrix font him/herself. still, this classic package remains popular and is being widely used.[83]

The variant Std One Regular comes with "false" descenders, just like the early dot matrix printers. FF Dot Matrix was used by the fashion chain H&M for its in-store signs in 2006.[84]

Müller and Windlin assume that every graphic design student must have designed a couple of matrix fonts. Many amateur designers have

also created dot matrix style typefaces that they share for free.[85] What all these reconstructed fonts have in common is that when they are printed using another technology, such as laser printers, the irregularities that are characteristic of dot matrix printers cannot be reproduced. In this respect, new dot matrix typefaces suffer from the same flaw as script typefaces that imitate handwriting without being able to copy its variability.

Due to computer memory constraints, the creators of early video games had only an 8-by-8 grid at their disposal for signing letters and numbers. For lowercase letters, they had to resort to false descenders, just like the designers of the first dot matrix printer fonts. Type designer Toshi Omagari has made an inventory of early videogame typography, and his research goes hand in hand with the growing popularity of retro games.[86] Pixels or dots in a small matrix have now become signifiers of an imagined genuineness of the early days of computing for the masses. In his book, Omagari poses the question, "Why is it that almost everything in videogame history has been thoroughly explored, except for typography?"[87] One reason might be that, as Florian Cramer puts it, "There is a peculiar overlap between on one hand a post-digital rejection of digital high tech, and on the other hand a post-digital rejection of digital low quality."[88] Omagari's revelation of the richness and inventiveness in a domain hitherto unexplored by design history can very well lead to a postdigital reappraisal of "digital low quality." A similar reversal of assessment of quality is also evident in the marketing of the consumer technology company Nothing, established in 2021. The basis of the company's visual identity is a logo in black and white with characters that could have been taken out of a printer manual from the 1980s.

In a promotional video published on Twitter, the concept behind the company is visualized with the help of blots, dots, and grids. In the first part of the animation, the forms are organic and look like ink blots that swell and smear in some liquid. A diffuse grid with numbers appears in the background, and the overall impression is that the viewer is watching an old analog TV monitor or oscilloscope. A voice says that it is easy to copy old ideas but that this company starts from scratch: "A giant reset button for all things innovation. And so we go." At the word "innovation," the blots are replaced by an empty circle, a distinct grid appears, and the circle is filled with black. This dot is then joined by more dots,

Figure 4.21 The logo for the consumer technology company Nothing, printed using a dot matrix typeface. © Nothing Technology Limited.

and the logo is drawn dot by dot on engineering graph paper, as if the designers had obeyed the instructions in Star Micronics's *Delta User's Manual* discussed above: "You've seen how the engineers at Star designed their characters by using a grid to lay out the dots. Now you can define characters exactly the same way."[89] When the company name "Nothing" is spelled out in the end, the sound of a dot matrix printer is discernible. This shift from organic to geometric visual style can be interpreted as a shift from messy and unimaginative design to original design made according to strict engineering principles.

The analog imperfections hinted at earlier are left behind in what can be seen as a combined technostalgic and postdigital attempt at appealing to a younger generation, people who are too young to remember the dot matrix printer firsthand but for whom the dot matrix style has positive connotations. Digital gadgets can no longer be sold as "shining new digital" to a postdigital generation resistant to the narrative of technological revolution. The flaws of dot matrix printing are turned into an advantage, although what is shown in the Nothing promotional video is the ideal of dot matrix printing—not the real-world problems shown by the example from the "Royal Mail User Guide for Machine Readable Letters & Large Letters." The dot matrix typefaces play a role in popular culture similar to the one played by the machine-readable typefaces looked at in chapter 3 as signs of early computer culture. In this last section, we have

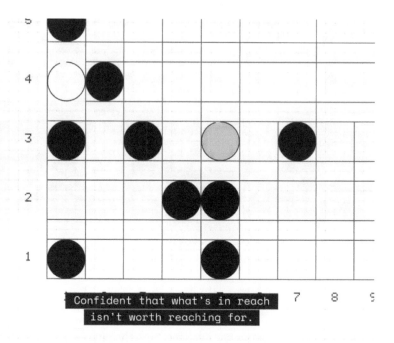

Figure 4.22 A screenshot from a promotional video for the consumer technology company Nothing. © Nothing Technology Limited.

seen the physical printer recede into the background and the concept of dot matrix printing itself occupy a more prominent place. However, the allure of seeing text emerge has remained strong, and the performative aspects of printing can be enacted by an animation, such as the gradual appearance of the Nothing logo in the video cited above, instead of by a physical printer.

What was at first intended as a study on the visual culture of dot matrix printing, with a focus on typography and its gappy, irregular, and low-resolution visual appearance, soon broadened to a multisensory inquiry when I discovered the role that sound played in the memories of its users. The combination of specific visual qualities with specific auditory qualities has made the printer memorable and opened up possibilities for creative practices that were not intended by its designers. Another feature not foreseen by the designers is the semiotic translation that occurs when sound is "read" by a computer system and turned into letters and words.

The printer is now simultaneously obsolete in some contexts and still in use in others. In both cases, there is an emphasis on operationality and maintenance: even as a cultural heritage object, the printer should work. However, its legacy does not rely only on physical objects but also on the dot matrix as such and its visual instantiations in new typefaces and letter styles. This chapter has shown that by the inclusion of a "forgotten" device such as the dot matrix printer into the history writing of typography and computation, the idea of a linear technological progress can be refuted.

5

TYPE HATE AND THE DISCOURSE OF COMIC SANS

In this chapter, I conduct an excavation in the more recent layers of history, up to the present time, when social media and mobile devices have become nearly indispensable for everyday communication. In this new media landscape, typography has been able to expand its role in popular culture. Although I shift the focus on the technical apparatus from obsolete equipment to the technological infrastructure of social media software, I apply the same media archaeological methodology that was used in the previous chapters. This infrastructure has been instrumental to the emergence of the discourse of the Comic Sans typeface. Whereas the availability of social media platforms facilitates the discourse, their software structures and their algorithms restrict and influence it by defining what can be said and how.

The aim of this chapter is to demonstrate how Comic Sans has become a cultural artifact that is symptomatic of the postdigital era, with repercussions far outside the graphic design trade. To say that Comic Sans is a typeface is too restricted. It is rather a typographic phenomenon. The most salient characteristic of the discourse is the hate that has propelled the typeface to fame and turned it into a popular culture antihero. I argue that from the point of view of the platform companies, Comic Sans hate is a productive force because it generates activity on social media, which leads to data that is commercialized by the platform companies.[1] The key questions asked include these: How can the hate against Comic Sans be situated in a historic context of type hate? Which metaphors and other rhetorical devices are deployed in the discourse? How does a typeface become hateable? How can the hatred be exploited? What position does Comic Sans have in postdigital visual culture?

THEORY AND METHOD: DISCOURSE ANALYSIS AND RHETORIC

As is mentioned in chapter 1, discourse analysis was originally a linguistic method for analyzing different aspects of text. The discourse I deal with in this chapter is multimodal and comprised of many types of utterances—visual, textual, as well as aural. With the help of critical multimodal discourse analysis, I map out how Comic Sans is discussed, viewed, and represented.[2] The aim of critical discourse analysis is to reveal power relations and the underlying ideology of statements, which is suitable in the case of a hate discourse. Hatred, even in its milder versions of scorn and mockery, is based on the idea of domination and getting the upper hand of someone or something. Since the hatred against Comic Sans is well documented, there is no need to prove that it exists. It is the point of departure rather than the goal of my inquiry. While I might not be able to find the meaning behind the hatred, I show how it can be seen as *productive*—in other words, what it does. Before the internet and social media, the typographic discourse was mainly carried out among designers. Now readers, who have also become users of typography, have entered the stage, which has changed the power balance.

The discourse analysis I perform is part of the media archaeological toolbox, in that I see my method as an excavation of the archive that the internet constitutes. Media archaeology pays great attention to the archive, and according to Jussi Parikka,

power still resides in the archive, which is now embedded in architectures of software, and the political economy of social media platforms whose revenue streams are based on the fact of individual everyday contributions through activity: Facebook, YouTube, Google, etc., gathering data on user patterns, preferences and consumer desires, for further evaluation, reuse and reselling purposes.[3]

Archaeology and excavation are metaphors for the kind of investigation that needs to be carried out to study media, and they are especially appropriate for new media and the internet, which despite its young age consists of huge numbers of shards waiting to be puzzled together.

Rhetoric and the use of metaphors is a timeless perspective that can be used for both creating and analyzing discourse. Mastering the art of persuasion is important for politicians and other public speakers but also for

writers of light articles, satiric blog posts, nostalgic comments on video platforms, and jocular tweets. Whether the subjects are ordinary or solemn, the goal is the same—to catch the attention of as large an audience as possible. Rhetoric is applicable to literary texts as well as to popular culture texts.[4] Recurring themes of the discourse of Comic Sans are brought into the light with the help of this perspective. I pay special attention to metaphors used in the discourse, since they play an important role in shaping our understanding of the world.[5] According to George Lakoff and Mark Johnson, metaphors are integrated in the way we think and use language, and although we are unaware of them most of the time, they shape the way we perceive the world. In an ontological metaphor, something concrete is represented as something abstract. Personifications are perhaps the most obvious ontological metaphors, and they help us see nonhuman phenomena or abstract notions in the light of human endeavors.[6] The hatred comes in different degrees. Some is rather moderate or mocking in tone, in the tradition of Horatian satire, named after the Roman satirist Horace, who used humor and mockery to address the follies of society. Some is in the tradition of Juvenalian satire, named after the Roman satirist Juvenal, who was much harsher and often contained personal attacks and invectives.

A SHORT HISTORY OF COMIC SANS

Most of this chapter is devoted to Comic Sans, a typeface that has been subject to a great amount of hate.[7] In newspaper articles, this typeface is often introduced in a way that stresses its position as the whipping boy of the design world—for instance, "Comic Sans is widely mocked as the Mickey Mouse tie of typography."[8] Despite or maybe thanks to this, it has reached a fame few other typefaces can claim. Since the invention of desktop publishing, the typeface that has been the target of most abuse is probably Comic Sans.[9] It was created in 1994 for Microsoft Bob, an alternative cartoon-style interface for the Windows desktop that was aimed at children. Users could be guided by a dog, and Vincent Connare, then a typographic engineer at Microsoft, noted that the font used in the dog's speech bubbles, Times New Roman, was too formal and thus inappropriate for a program for children.[10] He set out to design a more

A small brown fox

Figure 5.1 A sample of the Comic Sans typeface. Comic Sans is a trademark of Microsoft Corporation.

fitting font for the program and looked to comic books for inspiration to achieve a rounded, handwritten look. "Comic Sans was NOT designed as a typeface but as a solution to a problem with the often overlooked part of a computer program's interface, the typeface used to communicate the message," Connare states on his website.[11] It was never used in Microsoft Bob but instead appeared instead in Microsoft 3D Movie Maker. Microsoft then decided to include Comic Sans as a standard font in Windows 95, along with Arial, Courier, Times New Roman, and some other fonts.[12] It has been part of Microsoft's operating systems ever since, and there is no sign that it will be removed. The narrative from the previous chapters, about a piece of dead tech that has become obsolete but is still being used, consequently does not apply to Comic Sans.

By being a standard Microsoft font, Comic Sans became one of the most used typefaces in the world. It was the only informal typeface in the standard set and became popular with teachers in primary school as well as in many other contexts. Soon Comic Sans could be seen on birthday party invitations, lost kitten signs, shop signs, wine bottle labels, patient information leaflets, tombstones, and high-voltage warning signs.[13] One of the reasons for its frequent use can be connected to a quality of authenticity that graphic designer Paul McNeil highlights in his characterization of the typeface in his book *The Visual History of Type*:

It is designed to look as if it was not designed at all but rather written hesitantly with a felt-tip or ballpoint pen. Its rounded, asymmetrical features give it an approachable, modest and truthful impression. The sense of authenticity is enhanced by unconnected letters that sit on the bouncily uneven baseline, with a large x-height and an untutored wonkiness particularly evident in the irregular angles of supposedly upright stance.[14]

This interpretation of the visual appearance gives a much more nuanced picture than the common judgment that Comic Sans is simply badly designed. However, although Comic Sans is considered by many designers to be too available and unprofessional, the same can be said about a

riley @_toxicjungle_ · Jun 18 ···
they had the audacity to use **comic sans**

Figure 5.2 A sample of Comic Sans on a restaurant condiment box. riley, Twitter, @_toxicjungle_, June 18, 2022.

number of other typefaces that have not attracted ire to the same degree. In his article "Typographic Hate Lists: Type That We Love to Hate," typographer and writer Allen Haley puts hatred in a historic perspective and proposes four categories to explain why typefaces are hated: "1. The design is overused. 2. It's a copy of another typeface. 3. It's considered poor quality. 4. It's just hateable."[15] While many would say that Comic Sans is overused, Haley concludes that maybe Comic Sans just falls in category 4. Before I go into the broad discourse of Comic Sans hate, I would like to bring up two examples of type hate with a narrower scope, from within the trade, directed toward typefaces marketed by type foundries for professional use.

TYPE HATE BY AND FOR THE COGNOSCENTI

Hatred in the realm of art and design is significantly different from hatred between human beings and groups of people. Still, strong feelings are at stake in the discourse on typography. Disdain for certain typefaces is not something that arrived with the digital age, though it has now become a wider cultural phenomenon, something of a national pastime,

and is no longer restricted to an exclusive club of designers. "Today, type hate has taken on pandemic proportions," according to Allan Haley.[16] Also, the designs of older typographers—such as Frederic Goudy, who was active in the late nineteenth century and early twentieth century, and John Baskerville, who lived and worked in the eighteenth century—encountered their fair share of scorn. Haley can recall a number of hate episodes during his own career, notably toward ITC Souvenir, a typeface that inspired strong negative feelings among designers in the 1970s. The examples of hate discourse given below took place in a professional context, using established trade channels—in the first case, printed media and in the second case, a web-based publication.

ART DIRECTORS AGAINST FUTURA EXTRA BOLD CONDENSE

This example contains a mock hate campaign from the early 1990s against the Futura Extra Bold Condensed typeface, which the designer Jerry Ketel considered overused. He made a twelve-page satirical brochure that targeted his peers, asking them to contribute to the campaign by sending in a petition. The brochure was featured in the journal *Communication Arts* and later included in *Typography 13: The Annual of the Type Directors Club*, where the winning contributions of the 1991 Type Directors Club competition were presented. One page reads "Imagine if Saddam Hussein were a typeface," and the next page reads

Futura Extra Bold Condensed: The mother of all typefaces. It's time for Art Directors the world over to boycott the use of Futura Extra Bold Condensed—the most over-used typeface in advertising history. Destroy the Great Satan of clichés and the Little Satan of convenience, and rally to the cause of a better type selection.

Please fill out the enclosed petition and mail it to our headquarters. It will be used to sway the opinion-makers of our industry toward our just and worthy cause.

Together, we can whip this mother. Art Directors Against Futura Extra Bold Condensed.[17]

A rhetorical analysis of the Futura brochure yields two cases of contrasting personifications—when Futura is compared to the dictator Saddam Hussein and when at the same time it is presented as "The mother of all typefaces," claiming Futura to be the origin of typography. According

Figure 5.3 Samples from "Art Directors against Futura Extra Bold Condensed" using the Futura Extra Bold Condensed typeface. Jerry Ketel, designer, and Carl Loeb, copywriter, "Art Directors against Futura Extra Bold Condensed," brochure, 1991. © Jerry Ketel.

to Ketel, he "used Saddam Hussein as a metaphoric villain to highlight the point [that the typeface was overused]. The Gulf War was a major political theme of the period."[18] Furthermore, the text is based on religious and military metaphors, referring to Satan and using words such as "whip," "destroy," and "rally." Although this brochure addressed its readers directly with the help of the imperatives "Imagine," "Please fill out," and "mail it" and asked them to take action by sending the petition to the group's headquarters, the contribution to the type hate discourse was based on one-way communication and lacked the communicative context afforded by the internet. The next example took place more than a decade after the Futura brochure. It concerns an article in a web publication and the discussion that followed in the commentary field.

TYPE HATE WITH A STING

In 2004, graphic designer Michael Bierut wrote an essay for *Design Observer* with the title "I Hate ITC Garamond."[19] A book that he had intended to read was set in ITC Garamond, and therefore he could not bring himself to read it. There are other typefaces he dislikes, but ITC Garamond elicits a stronger emotional reaction: it "repulses me in a visceral way that I have trouble explaining." Still, he tries to do just that in his article. The typeface is dated and reminds him of the 1970s. The lowercase x-height is far too large. Other designers have dismissed the typeface on the ground that it has strayed too far from the original Garamond. This does not bother Bierut, though, and he concludes the slightly self-ironic piece by stating that "I've come to realize that I don't hate it for any rational reason; I hate it like I hate fingernails on a blackboard. I hate it because I hate it." The article gave rise to 117 comments—by other designers (some of them famous), wannabe designers, some nondesigners, and two of Bierut's children—that agree and disagree with his position and offer further perspectives. The commenters give voice to opinions, express emotions, and offer historical and technical explanations for the design of the typeface. Some of the comments are brief, and some are short essays in their own right. The *Design Observer* website has a simple commenting feature with flat structure without threading, so all comments appear one after the other. Interspersed with the other comments are Bierut's responses to them.[20]

One person reproaches the author and the commentators (himself included) for wasting time being annoyed over a typeface. Another person answers, "Come on, dude, lighten up. It's just a blog, read by a few geeks talking about geeky things." Bierut Jr. remarks, "I'm sorry that there are so many people that are getting hostile over the word 'hate.'" These comments indicate that type hate is part of the jargon in the typography trade and should not be taken at face value, although not everyone is fluent in that jargon. It takes an insider to discern the nuances and the situations when hate is used as a hyperbole and when deeper emotions are involved.

There are several examples of wordings stressing the intensity of the hatred. In one comment, graphic designer Jonathan Hoefler explains that ITC Garamond was an innovation in 1975 that was freed from the restraints of earlier technology, giving room for the designer's wishes. He does not think that the innovation has aged well, though, and states, "All of that said, I hate ITC Garamond. I really, *really* fucking *hate it*, and I commend Michael for making it OK to say so around these parts." In addition to this visceral argument, he gives an intellectual one and concludes by saying that "If someone starts a thread about Optima or Rotis, please let me know." Graphic designer Erik Spiekermann takes up the challenge to hate these two typefaces and states, "Let me confess upfront: I hate all three, with a vengeance. I hate them like Michael does: because I cannot stand them. And I hate them because they each stand for an attitude that I hate." The same kind of emphatic language is used by Steve Mack, who in his comment targets a whole category of typefaces: "I am starting to foster a deep-seeded [*sic*] hatred for the millions and millions of specialty fonts that have flooded modern typography."

The authors resort to various rhetoric techniques—such as repetition, curses, adjectives such as "deep-seated," and expressions such as "with a vengeance"—to emphasize the depth of their emotions about typefaces. But perhaps a way to understand how difficult it is to find a rational reason for type hate would be to turn to affect theory. In a pioneering work on this topic, social theorist Brian Massumi claims that emotion and affect follow different logics: "An emotion is a subjective content, the socio-linguistic fixing of the quality of an experience which is from that point onward defined as personal," whereas affect is bodily and autonomic in nature.[21] Whether it is possible to make such a distinction

between emotion and affect is contested, but for the sake of analytic clarity, it is applied here.[22] Affect is about visceral perceptions, about sensations of the skin, about muscular reactions to sound, about the slowing down or speeding up of the heartbeat. The different sensory modes work together in the realm of affect, so that, for instance, tactile perceptions can be transformed into visual in a synesthetic manner.[23] There are a couple of instances in Bierut's text that point to the influence of affects. He mentions that, although ITC Garamond is not as commonly used as it used to be, it still gives him a "nasty start" when he is taken by surprise by its presence in a place he had not expected to see it. His whole body is affected by the encounter and produces a reflex response. He uses an analogy to describe the nature of his distaste: "I hate it like I hate fingernails on a blackboard." This sound creates an unpleasant sensation that scientists explain by its frequency, roughness, and similarity to screams.[24] By making this comparison, he tries to make most people understand how he feels about the typeface.

After a number of comments from readers of the text, he returns to bodily sensations in a comment of his own, where he states that he has thought the issue through again and still maintains his reasons are irrational: "—if I'm honest, I hate ITC Garamond for the same reason I hate brussel [sic] sprouts." Their bitter taste makes them revolting to some people, who cannot bring themselves to consume this cabbage species. One's attitude toward brussels sprouts actually depends on one's genetic disposition. It is not simply a matter of taste understood as preference: it is taste as an integrated part of one's bodily constitution.[25] These three examples show how Bierut has recruited the visual, auditory, and gustatory senses to make a multisensory case for his hatred for a typeface.[26] Haley also resorts to bodily sensations when describing the strong aversion that existed against ITC Souvenir in his youth. It "was ranked right up there with root canals and paper cuts on the bête noire scale." Physical pain is probably above disgust on this scale and is a sensation that goes deeper into the body. Infected root canals are known to cause acute pain in a vulnerable part of the body. Paper cuts often catch us off guard, since we are not prepared to be attacked by a seemingly harmless piece of paper.

These few examples, taken from Allan Haley's and Michael Bierut's essays, constitute just a small sample of the affective language used by

type designers to conjure up their hatred against certain typefaces and, paradoxical as it might seem, their passion for their art. Red-hot hatred, not love, is probably what it takes to smash Beatrice Warde's crystal goblet.[27] I would argue that the heated debates of the postdigital era have been more successful than the spectacular postmodern graphic design of the 1990s in making the transparent art form of typography visible and a concern of the general public.

TYPE HATE GOES POPULAR: COMIC SANS ON THE INTERNET

In the case of Comic Sans, the antagonism was not kept within professional circles. In 2002, the campaign "Ban Comic Sans" was launched by graphic designers Dave Combs and Holly Combs, who shared a mutual dislike for the font and set up the website bancomicsans.com. It featured a manifesto and a photograph of Vincent Connare, the font's designer, with the text "ban comic sans" added at the bottom, and it called on visitors to print the image on adhesive paper in order to make a sticker and put it in places where Comic Sans is used. The couple also invited comments, suggestions, and photos to be sent to their email address.[28] Although their hatred for the typeface was genuinely felt, a campaign that was begun as an inside joke eventually engaged a worldwide audience. In 2019, Dave Combs thought the joke had been taken too far and was being used as a pretext for bullying people who used Comic Sans, so he changed the name of the campaign to "Use Comic Sans."[29]

Below is the "Ban Comic Sans" manifesto in its original, unabridged version:

We believe in the sanctity of typography and that the traditions and established standards of this craft should be upheld throughout all time. From Guttenberg's letterpress to the digital age, type in all forms is sacred and indispensable. Type is a voice; its very qualities and characteristics communicate to readers a meaning beyond mere syntax.

Early type designers and printers spent hours not only designing these typefaces, but the very painstaking process of setting and printing these faces was so laborious that it is a blasphemy to the history of the craft that any fool can sit down at their personal computer and design their own typeface. Consider how many books may be found in the average home today compared to that of a home in fifteenth century Europe. Technological advances have transformed

Figure 5.4 Original webpage for the "Ban Comic Sans" campaign. © Dave and Holly Combs.

typography into a tawdry triviality. The patriarchs of this profession were highly educated men. However, today the widespread heretical uses of this medium prove that even the ineducate [*sic*] have opportunities to desecrate this art form; therefore, destroying the historical integrity of typography.

Like the tone of a spoken voice, the characteristics of a typeface convey meaning. The design of the typeface is, in itself, its voice. Often this voice speaks louder than the message behind the words. Thus when one is designing a "Do Not Enter" sign the use of a heavy-stroked, attention-commanding font such as Impact or Arial Black is appropriate. However, typesetting such a message in Comic Sans would be ludicrous. Though this is done frequently, it does not justify the usage. Clearly, Comic Sans as a voice conveys silliness, childish naivete, irreverence, and is far too casual for such a purpose. It is as if someone were showing up to a black tie event in a clown costume.

We are summoning forth the proletariat around the globe to aid us in this revolution. We call on the common man to rise up in revolt against this evil of typographical ignorance. We believe in the gospel message "ban comic sans." It shall be salvation to all who are literate. By banding together to eradicate this font from the face of the earth we strive to ensure that future generations will be liberated from this epidemic and never have to suffer this scourge that is the plague of our time.[30]

Just as in the "Art Directors against Futura Extra Bold Condensed" bro-chure, there are instances of personification in the "Ban Comic Sans" manifesto. Type is said to be a voice that is closely related to the human body and hence a metonymy for a person. In addition, Comic Sans is likened to a clown costume, which is another metonymic stand-in for a person. In the "Ban Comic Sans" manifesto, there are some metaphors of violence, but religious metaphors dominate, along with metaphors of revolution and disease. The narrative is biblical, where the plague Comic Sans can be seen as a punishment from God and the only way to repent is to stop using Comic Sans. Typography is sacred and should be handled only by priests. The digital revolution has made the craft too accessible, and typography-illiterate people have caused its decay. The piece is char-acterized by a dichotomic rhetoric, setting sanctity against blasphemy and the educated against the uneducated.

This division is also observed by cultural rhetoric scholar Garrett W. Nichols, who in "Type Reveals Culture: A Defense of Bad Type," con-cludes that the Combses' "rhetoric shuts off the possibility of discussing the reasons some might have for committing such heresies."[31] Nichols suggests that people who use "bad" types might do so deliberately to achieve a rhetorical effect that is one of friendliness and unpretentious-ness. He takes as an example a church bulletin that is designed with a mixture of typefaces and a haphazard structure of headings and that may have been designed in this way on purpose in order to display an open and welcoming attitude to members. This argument—that Comic Sans is not used by mistake or ignorance but on purpose—is in line with Paul McNeil's statement quoted above that it was the purpose of the designer to create Comic Sans the way it is—that "it is designed to look as if it was not designed at all," which gives the typeface a sense of authenticity.[32] These arguments speak against the idea that Comic Sans was created and is used by illiterate people and in support of the idea that its creator and users are aware of the cultural implications of typography.

THE SETTING OF THE DISCOURSE: SOCIAL MEDIA PLATFORMS

It is hard to determine whether the "Ban Comic Sans" campaign was the starting signal for a broader crusade against the typeface that emerged

round the millennium shift, gained momentum around 2010, and is still alive on social media and other media, but the campaign is often been referred to in articles and books about the typeface.[33] Comic Sans is contemporary with the World Wide Web, and the discourse is in many ways a function of the affordances created by personal websites, blogs, online communities, and various social media platforms, such as Facebook, Instagram, Quora, Reddit, Twitter, and YouTube.

In her book *The Culture of Connectivity: A Critical History of Social Media*, media scholar José van Dijck argues that such platforms can be regarded as "techno-cultural constructs," a concept that emphasizes that platforms are realized through a combination of technological and human factors. She distinguishes three main components of these constructs—technology, user and usage, and content. The technological component can, in turn, be broken down into data, algorithms, and interfaces.[34] For instance, when a user posts a tweet on Twitter, a time stamp is generated. The tweet itself can be seen as data, while the time stamp belongs to the category metadata, providing information about the data. Another kind of metadata is the biographical information people enter in the user profile. Both data and metadata are used by Twitter algorithms to decide what content users might be interested in and what tweets should appear at the top of their feed. To indicate the content of a tweet and make it more searchable, a user can add a number of hashtags, which function as keywords (see, for instance, figure 5.7, #womenmarch). The interface of Twitter contains menus to the left and trending topics to the right, and below each tweet are symbols for reply, retweet, like, and share. These and other software features influence and steer user behavior and the ways users can communicate on the platform.

In *The Platform Society: Public Values in a Connective World*, van Dijck and her coauthors Thomas Poell and Martinj de Waal elaborate on the ideas from van Dijck's previous book, especially on platform mechanisms and the commercial aspects of platformization. The importance of this kind of technological infrastructure cannot be overestimated, since it has come to impact most aspects of society.[35] The framework suggested in *The Platform Society* contains a division of platform mechanisms into datafication, commodification, and selection. All kinds of user activities and interactions—such as "rating, paying, enrolling, watching, dating,

and searching but also friending, following, liking, posting, comment-
ing, and retweeting"—can be turned into data. The Twitter functions
mentioned above are just a subset of these interactions, which, when
they have gone through the process of datafication, can be rendered into
commodities in the next step. People can commodify not only activities
but also emotions, ideas, and human relations, according to van Dijck
et al.[36] For instance, Facebook added a feature to the status update that
lets users indicate their current mood—whether they are sad, happy, or
tired. Van Dijck et al.'s third step, selection, means that the content users
are presented with is selected and curated with the help of algorithms
that take the data generated by users as input. This personalization
occurs especially with services and advertisements, but it also deter-
mines the type of topics that are displayed in the feeds of, for instance,
a person's Instagram feed. What might seem opaque to users are, in fact,
deliberate technocommercial strategies implemented by the platform
companies.[37]

TRENDING ON TWITTER: THE CASE OF LEBRON JAMES

Twitter is one of the major social media platforms, a universal messaging
system originally designed to make it possible for people to keep their
friends updated about their present activities.[38] The maximum tweet
length was originally set at 140 characters, the same length as short mes-
sage service (SMS) text messages, and was doubled to 280 characters in
2017. As of 2022, the platform had 229 million users.[39] One example of
how Twitter has been an arena for the discourse of Comic Sans is the
commotion that occurred when basketball player LeBron James decided
to change teams.

The attention given to Comic Sans has spiked in connection with spe-
cific events—notably, when famous or public figures use the typeface in
what are seen as inappropriate ways. Sometimes the preoccupation with
the font has overshadowed the event itself in terms of media attention.
When LeBron James decided to leave the Cleveland Cavaliers to join the
Miami Heat in 2010, the Cleveland team's owner, Dan Gilbert, posted
an open letter on the team's website deploring the decision. The letter
was written in Comic Sans, and soon the typeface topic was trending on

Twitter above the LeBron James topic. With the Twitter algorithm, the position of a topic depends on the increase in use at the moment, not the total frequency over time.[40] Gilbert was derided because of his use of language and punctuation marks and because the choice of typeface clashed with the resentful tone of the letter, which created an unintended comical effect. The sports columnist at the *Wall Street Journal* recommended that "It should be sent to the Smithsonian as a high point in early 21st century comedy."[41] One of the reactions on Twitter was this joke: "Helvetica signs with Miami. Comic Sans stays in Cleveland."[42] In a metonymic play with characters, the "classy" typeface Helvetica has been substituted for LeBron, and the "goofy" Comic Sans for Dan Gilbert. Helvetica is a widely used typeface that is characterized by clarity and neutrality and often is seen as the incarnation of modernism.[43] Pitting Comic Sans against Helvetica or another high-status typeface is a rhetorical device that is frequently used in the discourse on Comic Sans to make it seem laughable.[44]

There have been other events where the (social) media attention paid to Comic Sans has overshadowed the event itself, such as the letter attorney John Dowd wrote to the House Intelligence Committee in connection with the 2019 impeachment inquiry against Donald Trump and the 2021 presentation of the Higgs boson particle discovery by scientists from CERN.[45] The common ingredient in the media storms connected to Comic Sans is that a high-ranking figure in the field is involved—a person who is worthwhile to mock, who "should have known better," but who is obviously clueless about graphic design. It was easy to make jokes at the expense of Cleveland Cavaliers' owner, the CERN scientists, and Trump's attorney, and Twitter and other social media platforms were flooded with jokes and gibes. These reactions became in themselves topics for printed news media.[46]

The LeBron James move from Cleveland to Miami and similar events generate much activity on social media and hence data that is of great value for the platform companies. Such events drive traffic to their sites, recruit new users, keep the existing users, and consequently increase the base for advertising and further data collection. The platform algorithms turn the tweeted jokes and status updates into data and use it for building their decisions about what new content to display for the users involved.

In the LeBron James case, more posts about sports and about Comic Sans would likely have appeared in the users' newsfeeds. This is how the platform mechanisms contribute to maintain, spread, and multiply the Comic Sans discourse.

BAD TASTE AND BATTLES

The discourse of Comic Sans features a number of rhetorical and literary devices—such as metonymy, epithet, comparison, pun, and irony—that have been deployed to mock Comic Sans in both the Horatian and Juvenalian traditions. Jokes, mockery, and scorn form the backbone of the discourse of Comic Sans, and studying jokes is a suitable way to understand its many facets.[47] Jokes can be textual or visual or a combination of both, like setting the oxymorons "**I'm a graphic designer**" or "**I use Comic Sans unironically**" in Comic Sans on ironic T-shirts, on coffee mugs, and in social media posts. Such one-liners are ideal for the short Twitter format and for memes that are shared and remixed on the web.[48] Jokes are instrumental in getting attention, likes, and new followers. The meme category closest associated with Comic Sans is the Doge memes, where a Shiba Inu dog with a funny expression is combined with short phrases in broken English, set in multicolored Comic Sans.

One trend in meme culture is the internet ugly aesthetic, which is characterized by a "celebration of the sloppish and the amateurish," according to comedy writer and editor Nick Douglas.[49] An example of memes that depend on this style are rage comics, which are based on a crude depiction of an angry face. Douglas thinks that the internet ugly aesthetic differs from the trend commonly connected to the postdigital, the New Aesthetic, "which uses QR codes, pixelation, and machine-readable images to reinterpret the physical world through the eyes of computers. Internet ugly is nearly the opposite, an imposition of messy humanity upon an online world of smooth gradients, blemish-correcting Photoshop, and AutoCorrect."[50] Internet ugly emerged out of a need for rapid publication on channels like 4chan, which deleted content after a short time. Meme creators use internet ugly as a sign of authenticity. As soon as the style is usurped by mainstream culture, it evolves into something new, and so it continues in many incarnations.[51]

Comic Sans is sometimes used for memes, but it does not fit into internet ugly in the way that Douglas portrays the style. Most applications of Comic Sans lack the rebellious side that characterizes internet ugly, and the typeface seems to me to be too neat to add anything to the "ugliness" of the style. Although Comic Sans is often deemed as ugly and in bad taste, I would say it is a different type of ugly than internet ugly. By way of its ubiquity, Comic Sans could be seen as the epitome of postdigital visual culture, but it is hard to assign Comic Sans to a specific trend. It is regarded as an outsider in most contexts and has been assigned a position of its own in popular culture. It is readily available and has a distinct, easily recognizable style, which is perhaps why it lends itself well to jokes.

IN BAD TASTE OR NOT

The question of taste in relation to type hate is brought up by the first commentator to Bierut's article "I Hate ITC Garamond" quoted above: "I am delighted to hear you fess up to something as old-fashioned and unfashionable as taste."[52] If taste had fallen out of date by the time of the publication of the article in 2004, it has certainly seen a revival in the past decade in the discourse of Comic Sans. Many of the jokes about the font are about taste or rather the lack of taste. The media scholar Sarah Owens explains how the circular argument regarding the typeface is played out: "Everything everyday designers produce is 'bad design.' Since they use Comic Sans, and since Comic Sans has been badly designed, anything using Comic Sans is bad design. A bad design is easily identifiable by its use of Comic Sans."[53]

Consider the following two statements: "You are the Comic Sans of humans"[54] and "Crocs are the Comic Sans of shoes."[55] The first statement can be found on t-shirts and caps and is intended as an insult to the reader. It is analogous to the second statement, where Comic Sans is an epithet signifying ugliness and bad taste. According to a definition in the *Urban Dictionary*, Crocs are "quite possibly the ugliest but most comfortable shoes ever."[56] The shoes and the typeface share similarities when it comes to popularity, unpopularity, and proliferation. The *Urban Dictionary* definition continues by observing that the shoes are used by people of all ages and social classes, which is also the case with Comic Sans.

The following two statements have been used on protest signs, either set in Comic Sans or handwritten, and can be seen on photos posted on Twitter and similar platforms: "Donald Trump uses Comic Sans"[57] and "Brexit is worse than Comic Sans."[58] In the first statement, the negative qualities often ascribed to the typeface have been transferred to the alleged user. The second statement is based on an absurd comparison between two incongruent entities, where Comic Sans functions as a low-water mark.

These are just a few examples of how Comic Sans has become synonymous with ugliness and bad taste. Although the Comic Sans hostilities involve an element of the cognoscenti reprimanding unenlightened text producers, Pierre Bourdieu's theory of class distinctions fails to explain the complexities of the Comic Sans discourse.[59] Garret W. Nichols argues that the use of Comic Sans can be seen as a working-class tactic that is used to resist the dominant power and its cultural expressions. The use of "bad" typography could be seen as a rhetorical action made with intention and not by accident, Nichols suggests.[60] This could very well be true in many cases, but I would argue, based on the major events involving high-profile people mentioned above, that the use of the typeface is not class related in an unequivocal way. The semiotic codes of typography are not as easily decoded as, for instance, the codes of luxury fashion and luxury fashion advertising, which build on widespread and accessible conventions.[61] The conventions within the field of typography are more subtle and harder to apprehend.

Sometimes people defy the judgments passed on them concerning their choice of typeface. In connection with the stir caused in 2019 by the letter written in Comic Sans by attorney John Dowd, the author Joseph Epstein wrote an op-ed titled "In Bad Taste or Not, I'll Keep my Comic Sans," where he gave his reasons for why the font might be useful for writers:

Undaunted by what is apparently my ghastly taste, I plan to continue using Comic Sans. I like the spaciousness it allows between letters. I can see an entire sentence in it as I can in no other typeface. I feel it provides a clarity for me as a writer that is helpful in revising my writing—and revising, it has been noted, is what writing is really all about.[62]

Instead of giving in to the choir of complaints about his bad taste, Epstein delivers a functional reason for using Comic Sans, similar to the ones usually brought forward in connection with dyslectics.[63]

Melissa / MCreativeJ ...
@MCreativeJ

I couldn't resist! You are the comic sans of humans is now my fave hat! #DesignerJokes #ILoveType

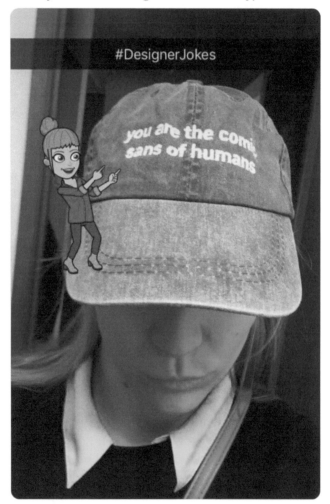

9:25 PM · Nov 10, 2016 · Twitter for iPhone

Figure 5.5 A statement on a hat: "You are the comic sans of humans." Melissa / MCreativeJ, "I couldn't resist! You are the comic sans of humans is now my fave hat!," Twitter, @MCreativej, November 10, 2016.

crocs are the comic sans of shoes

2:31 PM · Apr 7, 2021 · Twitter for iPhone

2 Retweets **3** Quote Tweets **31** Likes

Figure 5.6 A tweet comparing Comic Sans to shoes. Daze & Orla, Twitter, @Dazeand Orla, April 7, 2021.

truly a monster #womensmarch

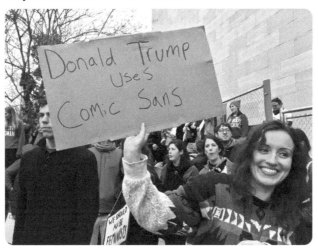

6:09 PM · Jan 21, 2017 · Twitter for iPhone

Figure 5.7 A handwritten sign at a protest: "Donald Trump Uses Comic Sans." Elizabeth Nolan Brown, Twitter, @ENBrown, January 21, 2017.

Óscar Mangas
@ovmn_ ...

#Brexit is worse than comic sans. Thumbs up to this
guy!

8:52 AM · Mar 26, 2019 from Madrid, Spain · Twitter for Android

Figure 5.8 A Comic Sans sign at a protest: "Brexit is worse than Comic Sans." Óscar
Mangas, Twitter, @ovmn_, March 26, 2019.

Famous writers as well as editors of high school newspapers use per-
sonal computers. They are marketed in several price ranges, but most
of them come with Microsoft Office's standard fonts. With the help of
the default set of typefaces, the everyday designer is able to create basic
graphic design materials, but professional designers need access to the
professional resources of type foundries. In order to pursue their craft,
they need both economic capital and cultural capital, another of Bour-
dieu's concepts, meaning the knowledge and education that people have
accumulated and that can provide them with a certain social status.[64]
As demonstrated by the cases of the basketball team owner Dan Gil-
bert, the attorney John Dowd, the CERN researchers, and the writer
Epstein, the issue of taste and Comic Sans does not necessarily depend
on class.

COMBAT AND BLOODSHED

So far, the jokes presented have been rather benign and belong to the Horatian tradition. In this section, I deal with the more aggressive end of the scale of abuse and show how metaphors of war, violence, and pain are used to depict hatred against Comic Sans in the tradition of Juvenalian satire. My findings from the present study agree with those of Nichols's that "a rhetorical framework of crime and punishment pervades Comic Sans discourse."[65] However, I think the framework is broader and also includes war, violence, pain, and illness. These categories and their associated concepts overlap to a certain degree, and there is no clear-cut border between them. War entails violence, crime can be violent, illness can cause pain. They are also sometimes used as metaphors for each other, as in "crime is illness."[66] These metaphors are part of a coherent rhetoric that influences the way we think about the typeface.[67]

Metaphors of war are one of the most common types of metaphor used in public discourse.[68] Military metaphors have been used to promote typography and its importance for conveying culture and education. In a pamphlet published in 1931, type designer Frederic W. Goudy ended his sketch of the heroic history of typography by stating that "I am the leaden army that conquers the world. I am type."[69] Metaphors of war have been used to describe conflicts in the typography trade, such as rivalries in the 1930s between foundries concerning the rights to a certain typeface.[70] A notable battle took place in the 1990s when different font standards for desktop publishing and printing led to conflicts between Adobe, Apple, and Microsoft. These font wars were subsequently resolved, but the concept has lingered on and been applied to other typography-related disputes, as when IKEA changed its typeface from Futura to Verdana in 2009. This switch met with hostile reactions from many people and was nicknamed Verdanagate.[71] Another term used is the portmanteau *fontroversy.* Both terms, *font wars* and *fontroversy*, have been used in connection with Comic Sans—for instance, in a newspaper article on design: "The font wars are raging on the World Wide Web, and it seems that Comic Sans is taking heavy fire."[72]

The military metaphors in the "Art Directors against Futura Extra Bold Condensed" brochure and the metaphors of violence in the "Ban Comic Sans" manifesto are to be found in many of the statements about Comic

Sans. War metaphors are characterized by a fight between combatants, where one side takes the role of the enemy. The next two examples are about battles of different kinds. Both make use of a combination of visual and verbal rhetoric.

Undertale Animation In 2016, a fan game animation titled "Sans Fight Animation: The Final Battle" was posted on a YouTube channel with a large number of subscribers.[73] The owner of the channel, NCHProductions, is an independent animator famous for his computer game parodies. His animation based on the computer game *Undertale* has had more than 3 million views and 20,000 comments and counting as of May 2022.[74] The YouTube interface offers two sorting principles for comments—Newest and Top. This makes it easier for users who want to join the conversation to get an overview of the previous comments. The "Sans Fight Animation" video starts with a collage of requests from subscribers urging the channel owner to make a "Sans fight." In the role-playing game *Undertale*, one of the characters is named Sans, who "speaks" in Comic Sans. He has a brother named Papyrus, and they both appear as skeletons in the game, which is otherwise not about typography but about a war between monsters and humans. This piece of fan fiction is rather an excursion into the discourse of Comic Sans. The character named Sans provokes a group of other fonts, led by Arial, that have taken Papyrus hostage. When a fight starts, Sans defends himself successfully and manages to release Papyrus. Visual variation and diversity are created by a menagerie of typefaces that challenge Sans and are defeated by his superpowers—Broadway, Cooper, Creepy, Impact, Jokerman, Rosewood, Stencil, Tahoma, and Times New Roman. All the typefaces, including Sans, are represented by their font names instead of by anthropomorphic avatars. Sans's adversaries can transform themselves into weapons created out of elements of their letter bodies, and metallic sound illustrations help us perceive them as swords or guns. It is, in its own way, a tribute to the diversity of letterforms in typography.

To create dynamic action scenes, the animator uses many of the standard cartoon pictorial devices, such as speech bubbles, speed lines, and explosions.[75] Arial resents Sans for his popularity and for being abused by humans who do not understand typography. Sans is under attack, but

Figure 5.9 A screenshot showing characters from "Sans Fight Animation." NCHProductions, "Sans Fight Animation," YouTube, November 22, 2016. © NCHProductions.

in this animation, he is more of a hero than a victim. He conquers all the other fonts by using his I-shaped bones and blue laser beams and by merging with Papyrus to become Comic Papyrus in the end. The narrative unfolds according to the "revenge of the underdog" script. Despite a numerical advantage and heavy weaponry, the enemy does not manage to defeat Comic Sans. This ending can be seen as a metaphor for the persistence of Comic Sans, which is still widely used and popular among the general public.

Just as with the Twitter joke about LeBron James's move quoted above ("Helvetica signs with Miami. Comic Sans stays in Cleveland"), the main battle line in the "Sans Fight Animation" is drawn between Comic Sans and Arial, a modernist typeface similar to Helvetica. The *Undertale* animation is a more elaborate contribution to the Comic Sans discourse than a short comment or a tweet. The animation is multimodal in its use of movement as well as visual and textual elements.[76]

"Note to Self: 'Comic Sans'" A cartoon by animation artist Marc Ratner appeared in 2020 in a local US newspaper and on his Instagram account.[77] In this single-panel cartoon, a smiling man with a hat and glasses (a self-portrait of the artist) is sitting at a table with layout work in front of him. He declares that he uses Comic Sans because he wants to be killed

by a graphic designer wielding an X-Acto knife. At the right side of the image, a cat tells the artist that the joke is morbid. At the left side of the image, an uneven cut and blood stains slightly overlap the image of the artist as a composite image made of two layers. The text in the artist's speech bubble is set in Comic Sans, whereas the text in the cat's speech bubble is handwritten. In this image, the user is the target of potential violence, and although the bloodthirsty perpetrator is not shown in the picture, the cut serves as an indexical sign of the knife wielder's presence. Blood is often used as a metaphor for pain. The artist is smiling, but the masochistic statement veers toward the sardonic and puts this joke in the Juvenalian category.[78]

This cartoon takes type hate a step further from verbal abuse into potential physical abuse to be performed with the precision knife that is the hallmark of a designer. Although much of the discourse is about the users of Comic Sans, this cartoon is different in that the main character puts himself in the position of the mocked user, speaking in the first person. His statement that "I always use Comic Sans" makes the cartoon into a parody of an endorsement ad where a smiling celebrity says, "I always use [brand]." There is a jarring contrast between the morbid utterance and the appearance of the man. This is not an unironic user but one who uses Comic Sans deliberately, in cold blood.

The setting and the interface of the online newspaper make the appearance of the cartoon different than the Instagram setting does. In the newspaper, Ratner's cartoons appear as a diversion. They are only a small part of the flow of articles in the section called "Art & Entertainment, cartoons." On Instagram, a collection of the artist's work is highlighted in the matrix that the Instagram interface affords. While the newspaper has provided the cartoon with some tags ("by Marc Ratner," "graphic designer with xacto," "Note to Self: Comic Sans," "Pasadena cartoon," and "single panel"), the artist's Instagram post has a large number of hashtags (#Edmon, #Plume, #EdmonPlume, #text, #font, #type, #typography, #typographic, #comic, #comicsans, #blood, #bloody, #therewillbeblood, #xacto, #knife, #blade, #morbid, #graphic, #graphicdesign, #graphicdesigner, #cattingwithchats, #Georgia, #cartoon, #comicstrip, #funny, #SundayFunny). Some of the tags (#font, #type, #typography, and #comicsans) open up for searches on typography in general and

Figure 5.10 Marc Ratner, "I always use Comic Sans," cartoon, *Colorado Boulevard*, March 1, 2020. @ Marc Ratner.

Comic Sans in particular. Other tags (#blood, #bloody, #therewillbe-blood, #xacto #knife, #blade, and #morbid) point in the direction of violence and pain and reinforce the visual impression made by the picture. This example illustrates how platform features like hashtags can steer the discourse and influence its character and direction.

"WHY DOES EVERYONE HATE COMIC SANS?" THE META DISCOURSE OF COMIC SANS HATE

While a large part of the discourse on Comic Sans can be categorized as type hate directed at a typeface, a non-negligible part of the discourse consists of attempts to explain the hatred and the reasons it has emerged. Thoughts, explanations, and arguments about the hatred have been put forward in social media and in design publications such as *Print*, *Communication Arts*, and *Creative Review*. Some of the most common arguments

can be summarized in three categories, some of which coincide with Allan Haley's typographic hate lists mentioned above:

The usage argument
Comic Sans is overused. It is ubiquitous and can be seen in all kinds of vernacular contexts. (This is in line with Haley's first reason for type hate.)

Comic Sans is used inappropriately. It was once designed as a screen font for speech bubbles in a specific children's application and is now used in serious and formal contexts.

The aesthetic argument
Comic Sans is ugly and violates typographic norms in terms of coherence, stroke modulation, proportion, letterfit, and other design parameters. (This is in line with Haley's second reason for type hate.)

The sociological argument
Comic Sans is an epitome of bad graphic design done by amateur designers who have access to desktop publishing tools they do not master. Professional graphic designers feel they must defend their territory and retain their cultural status as experts and their position in the labor market.[79]

A common counterargument to the first two arguments, the usage argument and the aesthetic argument, is that the same can be said about many other typefaces that have not met with the same degree of hatred. The sociological argument has generated the most debate. It revolves mainly around cultural capital, but economic capital is also at play in this argument, since professional-quality typefaces are commodities and entail a cost for the discerning designer who needs to have access to a large selection of typefaces.

One of the most prominent contributions to the metadiscourse has been made by copywriter Mike Lacher. His satirical piece "I'm Comic Sans, Asshole" was published on McSweeney's website in 2010, where it was set in Comic Sans.[80] The text was also published in print in the magazine *Creative Review* in its standard typeface.[81] If one compares the online version with the print version, it becomes clear that Comic Sans is indispensable for conveying the message of the text. A text set in Comic Sans can never be unmarked, in Johanna Drucker's sense of the word, and can never recede into a grey block on the page.

Lacher's first-person article has since been the subject of remakes, such as animations, and it has also been performed as a spoken monologue.[82] Its tone is aggressive, and it takes a sociological perspective as it addresses

graphic designers who look down on him: "I'm Comic Sans, and I'm the best thing to happen to typography since Johannes fucking Gutenberg."[83] He knows that people slander him, think he is tacky and dull, and are annoyed by seeing the font in notes and signs everywhere. For him, the font's appeal comes down to an unequal access to material resources and an unequal appreciation for modernism, evoking a caricature of a haughty graphic designer, a bore who does not know how to have fun:

We don't all have seventy-three weights of stick-up-my-ass Helvetica sitting on our seventeen-inch MacBook Pros. Sorry the entire world can't all be done in stark Eurotrash Swiss type. Sorry some people like to have fun. Sorry I'm standing in the way of your minimalist Bauhaus-esque fascist snoozefest. Maybe sometime you should take off your black turtleneck, stop compulsively adjusting your Tumblr theme, and lighten the fuck up for once.[84]

He goes on to explain that people love him because he is fun and knows how to enjoy life, in contrast to posh typefaces like Gotham and Avenir. He concludes by saying that, because of his fame, he does not even have to care about what others think about him:

I'm not just a font. I am a force of motherfucking nature and I will not rest until every uptight armchair typographer cock-hat like you is surrounded by my lovable, comic-book inspired, sans-serif badassery.[85]

In Lacher's monologue, Comic Sans is portrayed as a macho and working-class hero who retaliates against anxious, unmanly, bourgeois designers and their prejudices against types like him. This is different from the way Comic Sans is usually characterized, which is as having a disarming and childish personality that is harmless, benign, warm, friendly, and relatable.[86]

In his *Graphic Design: A New History*, art historian Stephen Eskilson argues that from the perspective of the "Ban Comic Sans" manifesto, it might seem that desktop publishing will ruin typography, but from another perspective, it is possible to "argue that distress over Comic Sans is exemplary of the sort of snobbish connoisseurship that besets many artistically minded professions."[87]

Some professional designers cannot resist making fun of Comic Sans and its users. They might not hate it with the same fervor that Michael Bierut hates ITC Garamond, probably because they know that Comic Sans was never designed to be a full-blown typeface in the traditional

sense, but their scorn fuels the general hatred. Other professional design-ers despise people who think they can aspire to be designers and who try to increase their cultural capital by expressing their aversion for the typeface. According to graphic designer Daniel Pelavin, many design dilettantes seem to think that avoiding Comic Sans is a sign of refine-ment, while in fact it reveals that they are narrow-minded and lack any deeper knowledge about typography.[88] I would argue that the sociologi-cal argument is a two-tiered construction, with professional designers looking down on pseudo-elitist Comic Sans avoiders who look down on Comic Sans users.

In his article "The Serious Effects of a Comic Typeface," designer Mitch Goldstein claims that Comic Sans has done typography a great service by virtue of its fame. All the silly and vitriolic jokes about the typeface have created an unprecedented consciousness about graphic design: "Surpris-ingly, this nearly universal disdain has had an ironic and unexpected result: Comic Sans has become the cultural ambassador of graphic design. We all love to hate the goofy typeface, and this notoriety has led to a vast cultural awareness of typography and graphic design itself."[89] Seen from this perspective, Comic Sans hate has been a productive force, not only by generating revenue for platform companies but also by paving the way for graphic design in the mind of the general public. Typography has become part of a visual literacy of the postdigital age.[90] The participants in the meta discourse do not exercise hatred, but they contribute to keep-ing up interest in the subject of Comic Sans. This interaction between the discourse and the metadiscourse can explain the longevity of the topic.

PERSONIFICATION: HOW TO MAKE A TYPEFACE HATEABLE

Many of the examples given in this chapter are based on personifica-tion, while other examples are based on metaphors presenting Comic Sans as an abstract phenomenon. The choice of metaphors influences the way Comic Sans is regarded and the kind of agency ascribed to it. Personification is a common rhetorical device that is used, for instance, by Michael Bierut in his piece "I Hate Garamond ITC," where he claims that the typeface repulses him and pops up in unlikely places. He writes on the life cycles of typefaces in general: they arrive, they wear out, they

go away, they are revived. This is in line with how anthropologist Arjun Appadurai conceptualizes commodities in his book *The Social Life of Things: Commodities in Cultural Perspective*, built on his belief that persons and things are not completely incommensurable entities.[91] Type designer Jungmyung Lee has a similar view on typefaces: "Comic Sans is a good example of why I think typefaces, like people, have their own course of life, their own history, ideas, and feelings."[92]

Sometimes personification plays the lead role in writings about typography. In both "I Am Type" by Frederic Goudy and "I'm Comic Sans, Asshole" by Mike Lacher, type and a typeface are speaking in the first person. An "I" implicates a "you," and this type of address is a way of engaging the reader in interpersonal interactions. A visual equivalent occurs when a person in a portrait seems to look directly at the viewer or when a character in a film speaks directly to the camera.[93]

There are at least two reasons that personification comes naturally to the discourse on Comic Sans. One reason is that in the literature on typography, typefaces are often said to have personalities.[94] In the case of the "Art Directors against Futura Extra Bold Condensed" brochure, personification can involve contradictory personalities, the mother of all typefaces, and a dreaded dictator at the same time.

Another reason is the strongly anthropomorphic language used to describe typefaces and letterforms. An obvious example is the use of *face*, as in *typeface*. "A typeface is like the human body. The skeleton is the structure underlying the letters," according to type designer Nadine Chahine.[95] This way of thinking is ingrained in the whole terminology of typography. In "A Visual Guide to the Anatomy of Typography," Orana Velarde dissects the bodies of letters and breaks down the letterforms into their constituent elements.[96] Words like *spine*, *leg*, *arm*, *shoulder*, and *ear* are used to describe these elements.[97]

This anthropomorphic language continues on the level of text, where the words *body text*, *header*, and *footer* are used to denote different parts of a document and its structure. Although the Latin alphabet, unlike hieroglyphs and other figurative writing systems, is based on abstract signs, its tendency toward anthropomorphization is evident. In Western art, the human body is a constant frame of reference in all art forms—in architecture, painting, and sculpture as well as in typography.[98] Some typefaces

Figure 5.11 An illustration of anthropomorphic letterforms. Matt Yow, "Eyes to C, Arms to E: Anthropomorphism in Typography," *Medium*, March 30, 2017. © Matt Yow.

are literally made up of human body forms, such as those shown in Peter Flötner's woodcut *The Human Alphabet*, which dates back to about 1534, and Peter Bilak's Body Type from 2011, a modern-day version on the same theme based on photographs. The first version of Comic Sans also had a touch of anthropomorphism, or perhaps rather zoomorphism, as the euro sign had an eye on its upper serif. In the *Undertale* animation, Comic Sans has been given one important human trait, an eye in the *A* of Sans and in the *O* of Comic, reminiscent of the eye of the euro sign.

Personification offers a range of different positions and agencies for a typeface. In *Metaphors We Live By*, George Lakoff and Mark Johnson take the phenomenon of inflation as an example of personification. In sentences like "Inflation has attacked the foundation of our economy," the nonhuman entity inflation can be construed as an adversary: "It not only gives us a specific way of thinking about inflation but also a way of acting

Figure 5.12 A euro sign in the Comic Sans typeface.

toward it. We think of inflation as an adversary that can attack us, hurt us, steal from us, even destroy us."[99] Analogously, if the war metaphors quoted above make us think about Comic Sans as a combatant in a battle, perhaps it can attack an enemy and also fight back and defend itself when attacked. There are several ways of drawing the battle line in the Comic Sans font war—as a battle between Comic Sans and Helvetica and other modernist typefaces or as a battle between the Comic Sans users and the Comic Sans haters. To target the users of Comic Sans instead of the type-face itself is a kind of "personification by proxy."

In the examples above, Comic Sans is positioned sometimes as a victim and sometimes as a perpetrator. Personification helps create a hateable object, a more tangible target for the hatred. Some social media discussions raise the question, "How can one hate a typeface?" The answer is that to be hateable, it helps if something is turned into a person or a character. Personification gives an abstract phenomenon like a typeface, which normally exists as a thin layer of ink on a substrate, the possibility of rising from its paper base and becoming a person of flesh and blood. Mike Lacher's piece "I'm Comic Sans, Asshole" concludes with Comic Sans's assertion that he is something more than a human, which challenges personification in terms of power and agency. A force of nature makes humans seem smaller and powerless in comparison, especially the ones that hate Comic Sans.

CAPITALIZING ON COMIC SANS

Much of the material published on the subject of Comic Sans could be called user-generated content, and it is produced by professionals and amateurs alike. Both NCHProductions' *Undertale* animation and Marc Ratner's "Note to Self: 'Comic Sans'" cartoon could be seen as user-generated content that is shared on YouTube and Instagram and also highlights the complexity of situating the user.[100] The creators can be professionals who post their own commissioned and noncommissioned works on a social media platform, but posting commissioned works on such a platform makes them appear differently than they do in the original context. In either case, the content draws attention both to its creator and to the platform owner. According to Van Dijck, cultural content is very valuable to the platform companies:

> More than anything, cultural content—whether text, music, or videos—draws out opinions on what people like or dislike, what they covet or loathe, what interests them and what does not. And while common tastes and desires can be deployed to harness bonds and discover group affiliations, they also provide precious information on social trends and consumer preferences.[101]

However, it is not only social media companies that benefit from the heated debate over Comic Sans. The notoriety of the typeface has made it into a vehicle—even a Trojan horse—for focusing media attention on causes such as medical fundraising and political propaganda. According to graphic designer Tony Seddon, "One of the great things about typefaces that become vilified due to inappropriate application or overuse is they gain a platform from which they can be used to portray irony, sarcasm, satire, dry wickedness, and so on."[102] The two examples discussed below involve fundraising and political propaganda and show how clever marketeers have tapped the energy generated by the Comic Sans discourse by adding another level of irony to it.

In connection with the twentieth anniversary of Comic Sans in 2014, an advertising campaign was launched for the benefit of Cancer Research UK. Designers and artists were invited to make posters on the theme of the Comic Sans typeface, which resulted in an exhibition and a catalog called *Comic Sans for Cancer*.[103] All the contributions were tongue-in-cheek in reference to the reputation of the font. No "candid," "unironic,"

Figure 5.13 The website homepage for the 2014 exhibition *Comic Sans for Cancer* in support of Cancer Research UK. © Chris Flack.

or "folksy" use of the font appeared in the exhibition. The designers used different strategies for making Comic Sans "other." One poster used the typeface to display a list of cancer forms. Another poster was a comic book pastiche in the style of Roy Lichtenstein, with a speech bubble and clearly visible halftone dots. Both examples used text set in Comic Sans. Another strategy abandoned the use of text in the linguistic sense and instead dismantled Comic Sans into abstract forms based on the font's aesthetics. The exhibition challenged the designers to make something "fancy" out of something that was considered bad taste and ugly, without losing sight of the font's air of popular culture. Although there was some online coverage of the *Comic Sans for Cancer* exhibition, it was primarily a physical event that invited the audience to visit the gallery, look at the printed posters, and buy the catalog.

On October 22, 2019, the Twitter account of the Conservative Party in the UK posted a message on Twitter: "MPs must get together and get Brexit done." The slogan was familiar, but the typography was novel. The tweet was set in Comic Sans, which the campaign team intentionally chose to attract Comic Sans haters and to induce them to retweet the message, giving it a larger audience.[104] It took only an hour before Comic Sans

was the top trend on Twitter, as European Union remainers unwittingly propelled the message around the Twittersphere. Warnings were issued to EU remainers against further spreading a message that they did not wish to support, and the Liberal Democrats responded with a cautionary tweet using Chiller, Comic Sans, Impact, and Papyrus, typefaces typically used in memes and internet jokes. Opinions were divided over the suitability of such a cunning strategy, devised by a pair of "digital gurus" from New Zealand who had previously helped the Australian Liberal Party win the election the same year. The story was picked up by major British newspapers such as *The Times*, *The Guardian*, and *The Telegraph*.[105] This example shows how knowledge of platform mechanisms and of the psychological mechanisms that guide user behavior can result in a massive exposure of a political message. Social media is an arena where the platform companies capitalize on the data generated by users, but it also is where certain users can take advantage of other users' usage of platform features, in this case Twitter's like and retweet features. But an agent is needed to start a process like the Brexit tweet, and in this case, Comic Sans hate acted as a productive force.

THE COMIC SANS DISCOURSE AS POP CULTURE

There are several ways in which Comic Sans can be construed as a popular culture phenomenon that is connected to popular culture narratives. I would argue that in postdigital visual culture, the font is a popular culture antihero. Comic Sans is the protagonist in an ongoing participatory soap opera that is played out on social media. As long as Microsoft does not withdraw it from its standard font menu, the typeface has the potential to live on for many seasons.

Personification is a recurring ingredient in the Comic Sans discourse, which facilitates hatred but also narration. Characters are vital parts of narratives. They are the agents that drive the plot forward by dealing with the conflicts presented in the plot. Type hate offers plenty of opportunities for conflicts—for instance, by posing Comic Sans and Helvetica as adversaries. The joke mentioned above in connection with LeBron James's move from the Cleveland Cavaliers to the Miami Heat (the tweet "Helvetica signs with Miami. Comic Sans stays in Cleveland") is an

Conservatives ✓
@Conservatives
 ···

Now is the time for MPs to back the new deal and get
Brexit done.

#GetBrexitDone

MPs MUST COME TOGETHER AND GET BREXIT DONE.

🌳 Conservatives

4:27 PM · Oct 22, 2019 · Twitter for Android

Figure 5.14 Conservatives, Twitter, @Conservatives, October 22, 2019.

Liberal Democrats ✓
@LibDems
 ···

Heads up 🌱
libdems.org.uk/online-ads

if you quote tweet bad content

whether to disagree with it or to just say it's bad

you're just helping the people who make it

spread their awful message

5:32 PM · Oct 22, 2019 · Twitter for Android

Figure 5.15 A reply to the Conservative Party's Brexit tweet. Liberal Democrats, Twitter, @LibDems, October 22, 2019.

example of a short narrative with two characters taking different actions in the plot. This could be fleshed out to form a full story and marketed as a comic book, a television series, a game, or another traditional popular culture format. Most computer games are developed with the help of game engines, software frameworks that facilitate game construction so that developers do not have to start from scratch. Game engines influence what kind of games can be made by both facilitating and putting certain restraints on the design.[106] In a similar vein, I would argue that social media platforms act as "story engines" that facilitate the collective and participatory telling of the ongoing story of Comic Sans. Forwarding and liking are two software features that enable dissemination and feedback. The technological infrastructure and type hate support each other in perpetuating the fame of Comic Sans. Technical as well as rhetorical devices are needed to keep it going.

6

COMMON THEMES AND CONCLUDING REMARKS

In this final chapter, I sum up the book's discussions of the four phenomena of ASCII art, machine-readable typefaces, dot matrix printers, and Comic Sans type hate with regard to eight common themes and concepts—materiality; performance, personification, and narrative voice; displacement; do-it-yourself; and technostalgia and obsolescence.

MATERIALITY AND SURFACES OF INSCRIPTION

The material aspects of typography involve both the printed artefact and the printing process. Materials are semiotic resources that engender different meanings and connotations. Paper is still the principal surface of inscription, and although electronic publishing is gaining ground, the death of paper does not seem to be imminent. In *Post-Digital Print: The Mutation of Publishing since 1894*, Alessandro Ludovico foresees a future where hybrid publishing projects can combine the advantages of both traditional and digital technologies.[1] In the postdigital era, much textual information is not printed in the traditional sense but is presented on screens.

For both magnetic ink character recognition (MICR) typefaces and optical character recognition (OCR) typefaces, the bank check is the object of reference, although these typefaces are also printed on other types of substrates. Checks can be identified based on ink quality, ink thickness, ink smell, paper quality, paper weight, and paper-cutting method. For both line printers and dot matrix printers, an ink ribbon is used to apply the ink onto the paper. Fanfold paper is still used with dot matrix printers. This kind of paper has become a symbol of early computing and its

technical context, whereas standard office paper is associated with laser printers. Standard office paper is the typical postdigital paper—a generic material that is as suitable for printers as it is for handwritten documents and letters sent by physical mail.

The film *Helvetica* includes many examples of Helvetica "in the wild"—from small, mundane signs on garbage trucks to bold posters of fashion houses—in order to show the ubiquity and the versatility of a typeface that permeates our everyday urban surroundings.[2] There is no such celebratory film about Comic Sans. Instead, collections of samples are posted on social media to serve as cautionary examples. An educated guess would be that Comic Sans, despite being made for the screen, has been printed on as many different kinds of substrates as Helvetica. It seems that the more prestigious the material, the more annoyance is caused by the application of Comic Sans on it. A Dutch war memorial made of stone is a case in point.[3]

Materiality is always situated: it is connected to a certain place or circumstance of perception. A form of moving materiality is offered by company vans with lettering on their sides. The text should be readable by pedestrians and other drivers when the vehicle circulates in traffic and when it is parked on a street. The surface itself is affected by outdoor conditions. Rain, mud, dust, and snow affect readability and, by extension, the general perception of the company. Ideally, printing devices and substrates should work in concert, which is not always the case with dot matrix printing. Sometimes cooperation can be troublesome, especially with soft objects like padded envelopes and irregularly shaped, moving packages on a conveyor belt.

PERFORMATIVE AND EMBODIED PERSONIFICATION AND NARRATIVE VOICE

Personification and narrative voice play important roles in the discourse of Comic Sans. The typeface itself is the protagonist of the story that is spun around the type hate against Comic Sans, and it becomes an agent with the help of different rhetorical devices. In the satirical monologue "I'm Comic Sans, Asshole" Comic Sans responds to his adversaries as if he were a man of flesh and blood.[4] In the Undertale animation all the

typefaces involved take on corporeal forms and utter battle cries.[5] However, these instances of personification differ from the ones involving printers and printing.

Writing with a pen is always processual, either in a flow as in cursive script or in a staccato rhythm as in block lettering. Showing the protagonist in the act of writing a letter is a common filmic device and a visual form of storytelling that adds to the tension of the narrative. Similarly, though the aim of printing is normally to produce some kind of printed artefact, the process of printing is in itself fascinating and can be regarded as a performance. Watching text and images emerge on paper from inside of a printer is a spectacle in its own right.[6]

The performative potentials of printing could be developed into a veritable show, as in the example of Edith, the unofficial demonstration program for an IBM line printer.[7] The narrative approach lets the computer address the audience directly, by the use of first-person narration. Unlike a play performed on a theater stage by actors seemingly unaware of the spectators, this performance directly involves the audience gathered around the printer. The setting is akin to campfire storytelling. The voice of the narrator is not audible, but through the oral and dialogic character of the text, the computer is given a clear voice, materialized by the act of printing. The computer appears as a person with its own thoughts and personality.

Another instance of the speaking printer is the video on a defective ImageWriter that says "I'm an 8 pin printer now," where the broken letters let us imagine the sad voice of the printer.[8] The printer is not speaking on behalf of a computer. Instead, it is put forward as an independent person. Both this video and the Edith program are examples of what I call *performative personification*, a different form of personification than the rhetorical device discussed in connection with Comic Sans. In these two cases, the printing devices and the acts of printing, not a specific typeface, are what is foregrounded. The cases are also examples of a staged performance based on a script with the intention of being entertaining. Acoustic eavesdropping can be seen as another form of performance, where the sound a dot matrix printer emits while printing can be translated into written text with the help of automatic speech recognition and machine learning techniques.[9] In this instance, the "script" is not meant

to be performed or be entertaining. The printer cannot help being over-heard. It is not a conscious being that can whisper or lower its voice when it realizes it is being bugged.

The voice and the body of the printer have been used in different ways in artistic and musical performances. *Symphony for Dot Matrix Printers* involved printers that acted as an orchestra, conducted by a server, using a text file as a score.[10] In this case, the printers played the roles of musicians, with microphones fitted onto the printers in order to pick up the sound of their voices. The rhythmic movements of the printheads were visible on an overhead screen. This piece was performed in a theater in front of a seated audience, like a traditional concert. It was a hybrid event, live and at the same time mediated. The conductor was a computer, but the human composers were also present during the performance, tending to the computers like fully visible puppeteers. In another, more recent, example, printers were turned into sound generators that played famous cover songs.[11] These musical performances entail what I call *embodied personification*, a different form of personification than the more verbal performances discussed in the previous paragraph. They do not address or invite audience members to interaction in the same way as Edith or the video about the defective ImageWriter does. Instead, the emphasis is on an audible voice that performs a song without words. The sound of the printer becomes its song voice, which emanates from the printer's body and puts the textual message in the background. Many musicians feel that their instruments become extensions of their bodies. However, instruments cannot become as intimately connected to the human body as the voice, which emerges from within the body and is formed by the constitution of a specific body.[12] Seeing the sound of the printer as a voice is a kind of personification that is connected to the zoomorphization and anthropomorphization that we saw in the Epson printer manual and advertisement.[13]

All the above performances greatly expand the traditional meaning of voice and personality in connection with typefaces and typography. By including the printing device in the setting, a new arena of expression is opened up where more senses are engaged. It is not only the voice of the writer that is heard through the visual appearance of letterforms. In Edith, the thinking computer, through its mouthpiece the printer,

is interacting with the audience. That the computer has a clear bodily awareness becomes evident when it asks the audience to flip switches on the outside of its peripheral body parts. The broken dot matrix printer similarly demonstrates awareness of its body: it knows that one of its pins is defective.

DISPLACEMENT: THE PATHS TO POPULAR CULTURE

All four typographic phenomena discussed in this book belong in Drucker's marked text category. This is a requirement for becoming a character in popular culture. A common typeface used for body text or a common display typeface, however well known it is in the graphic design trade, does not qualify. It must have some eccentric quality, which usually is found in the history of its inception. The four phenomena have made unexpected and hard-to-predict trajectories. They started out in one place and then pushed typography into an expanded field, a bewildering new territory where the usual rules of typography did not seem to apply. It would be wrong to say that the four phenomena have been absorbed by the popular culture. The process can rather be characterized as an exchange.

In previous chapters, I map out the very different paths taken by the four phenomena on their way to popular culture. Irrespective of the differences, their paths have some things in common. All of the phenomena were created for a serious purpose—printing program listings, providing bank checks with codes, printing out word processing texts, and making a screen font that fitted into a user-friendly operating system interface. But programmers, designers, users, and companies saw the potential for other applications of these technological solutions. Programmers created letter art, designers created a full typeface from the restricted MICR character set, users turned the dot matrix printer into a musical instrument, and Microsoft decided to make the screen font available to all their users. These steps were thus taken by private persons and corporate managers—in some cases when the technology was still in use and in other cases when it had been superseded by newer solutions. What matters is not so much the direction or the length of the steps or the final destination. I argue that the *displacement* itself created an opportunity for the font to be taken up by the popular culture. When taking a leap or hanging

in the air, there is a short moment in time when a phenomenon, typo-graphic or otherwise, is available and can acquire new meanings and fit into new contexts. Popular culture creators and practitioners often have a keen sense for such opportunities, which are often connected to shifts in technology.

A TRIBUTE TO EARLY COMPUTING: DIY AND MAKER CULTURE

Typography in general has stepped forward in traditional popular culture. A range of popular practices revolves around typography concerning the printing apparatus and the typefaces. When people make graphic designs themselves, they design typefaces, acquire typefaces, discuss typefaces, assess typefaces, and apply typefaces. Letter art and typewriter art were part of the popular culture long before they became ASCII art. After the deafening noise of the line printers faded out, the art form migrated to home computer printers, bulletin board systems, and the web. The art form is still practiced, both for making simple emails signatures based on a few characters and for making elaborate, photorealistic images. It is not made out of necessity or a lack of better alternatives but rather as a tribute to early computing. ASCII art agrees well with do-it-yourself (DIY) maker culture and craft movements, which are strong currents in postdigital culture.[14] The same is valid for the treatment of old dot matrix printers: some are still used for printing and might need repair, and some are manipulated and turned intro music machines. Both mending and manipulating are part of the maker culture that is gaining ground as an integral part of popular culture.[15] Instruction videos and how-to videos are prominent genres within maker culture, and video making belongs to the toolkit of the typical maker/bricoleur/tinkerer. Such media skills are required in order to take part in social media, which is an important scene for maker culture and DIY. The discussion on platformization that I brought up in connection with Comic Sans is therefore relevant for the other three phenomena as well. The DIY movement uses social media as a means for distribution, and at the same time, it provides the platforms with user-generated content. As José Van Dijck has pointed out, cultural content is a highly valuable asset to the platform companies, especially content that provokes opinions, like Comic Sans.[16]

TECHNOSTALGIA AND OBSOLESCENCE

Technostalgia is a concept I use to analyze the memory practices involving the dot matrix printer. This kind of nostalgia is a longing for past times when technology was simpler and perhaps easier to comprehend. The speed of technological development means that some equipment is becoming obsolete just as the users have gotten accustomed to it and learned how to handle it. Along with scrapped devices go outdated skills and knowledge. Technostalgia could also be applied to ASCII art and to the machine-readable typefaces. An example of technostalgia is a T-shirt with an ASCII art portrait of computer pioneer Alan Turing. Turing died in 1954 before ASCII art became a cultural phenomenon. The image is anachronistic, but ASCII art signifies "an early computer era," and to achieve this, it does not have to be historically accurate. This example also illustrates the tenacity of some of the phenomena covered in this book. Being obsolete is no reason for old media and technology to step down, and some devices seem to have more lives than a cat. This is a media archaeological viewpoint:

Although arguments concerning death-of-media may be useful as a tactic to oppose dialog that only focuses on the newness of media, we believe that media never dies: it decays, rots, reforms, remixes, and gets historicized, reinterpreted and collected. . . . It either stays in the soil as residue and in the air as concrete dead media, or is reappropriated through artistic, tinkering methodologies.[17]

Longevity concerns not only physical devices that are maintained and refurbished but also design objects, such as the machine-readable typefaces, that continue to be used as semiotic resources in science fiction stories.

By way of its age, Comic Sans cannot, as yet, signify obsolescence. Although created in 1994, the font is still a mass-produced artefact in contemporary use. It is available on nearly every computer and is everywhere to be seen. One could pose a hypothetical question: What will happen when the font is discontinued by Microsoft? Will hating Comic Sans become a nostalgic practice in the future? Will collectors use eBay to buy and sell old cafe menus set in Comic Sans? Will reconstructed versions of the program code appear on GitHub and be downloaded by enthusiasts, as they do with dot matrix typefaces? So far, the most persistent thing about Comic Sans seems to be the animosity against it.

HISTORIOGRAPHICAL REFLECTIONS AND SUGGESTIONS FOR FUTURE RESEARCH

This is what history writing looks like when the weed is not weeded out and winding paths are not smoothed out. The book has covered some gaps, but at the same time, it has revealed others. My hope is that it has confirmed the media archaeological point of view that history should not exclude dead ends and losers from its annals. Marginal phenomena might have interesting stories to tell and make the overall picture more comprehensible—or sometimes even less comprehensible, so that the need for further investigation is made obvious.

What has been gained from putting these cases together in one book? By making them join forces, I have highlighted their positions and the move from the margin to the center of attention in a way that would not have been possible by treating them as stand-alone phenomena. They have not always worked in concert, but my conclusion is that they have rubbed against each other and given each other impulses in a productive manner. There is also the chronological aspect and the changes that have occurred over time that would have been lost if the book had been about only one of the four phenomena.

This book contains many examples, but they represent just a fraction of what I found in my research and an even smaller fraction of the material that still exists. But these materials are vanishing. As I state in the chapter on ASCII art, my research should have been conducted ten or twenty years earlier so that more interviews could have been made. What materials will a study on Comic Sans made twenty years from now be able to access? Digital materiality does not rely on bronze or ceramics. It is a question not only of disappearing webpages or broken links but of a technological infrastructure that might not be in use anymore. In a couple of decades, examining the web discourse of Comic Sans might entail first setting up a web server, performing the same laborious work done by the staff of the Computer History Museum to renovate a computer and its peripherals.

Nevertheless, I have some suggestions for future research. There are many more ways that typography, computing, and popular culture could be joined and form the basis for research than the examples in the study

I have presented here. One could, for instance, look more deeply into the way typography in general can become popular culture in its own right, as I did in the case of Comic Sans.

I have touched on the issue of sound, especially in the study on the dot matrix printer. However, the practice of using old computer equipment for making music is not restricted to printers. All sorts of equipment—such as floppy disk drives, hard disks, and scanners—emit sounds and can be used for musical compositions or other sound-based works.[18] My point of departure has been art and visual studies, and I acknowledge the need for competence in music and musicology to advance the auditory aspect.

Gender issues are topical in our time and several of the themes of this book raise questions about gender equality and the representation of gender. Because both the computer industry and the typographic trade are male-dominated areas, the study on ASCII art provides fertile ground for further research on the visual and social aspects of the practice from a gender perspective.

Future research could also entail a wider geographical outlook. This book is mainly Western-oriented, but the four phenomena, or other, similar phenomena, could open up for research involving other parts of the world.

NOTES

CHAPTER 1

1. See, for example, Welby Ings, "When We Go to War: Multimodality and Film Title Design," *Multimodal Communication* 4, no. 2 (2015): 169.

2. A notable postmodern typeface is Dead History, which was created by P. Scott Makela in 1990.

3. The concept of the expanded field refers to Rosalind Krauss's seminal essay "Sculpture in the Expanded Field," *October* 8 (1979): 31–44.

4. See, for instance, this popular article: Gary T. Marx, "The Surveillance Society: The Threat of 1984-Style Techniques," *The Futurist*, June 1985, 21–26, http://web.mit .edu/gtmarx/www/futurist_surv_soc.pdf.

5. One computer manufacturer described it as a "minor European problem."

6. Among other things, I have studied photography in social media and the use of digital visualizations in museum exhibitions.

7. Typography can be seen as part of printed media or digital media, but it can also be seen as a medium in its own right. See Kate Brideau, *The Typographic Medium* (Cambridge, MA: MIT Press, 2021).

8. Michel Foucault, *The Order of Things: An Archaeology of the Human Sciences*, trans. (London: Routledge, [1966] 1989); Michel Foucault, *The Archaeology of Knowledge* , trans. A. M. Sheridan Smith (London: Routledge, [1969] 1989).

9. Erkki Huhtamo and Jussi Parikka, *Media Archaeology: Approaches, Applications, and Implications* (Berkeley: University of California Press, 2019), 20–21.

10. John Storey, *Cultural Theory and Popular Culture: An Introduction*, 9th ed. (New York: Pearson Education, 2021), 8–12.

11. Dustin Kidd, "Popular Culture," *Oxford Bibliographies*, February 28, 2017, https:// www.oxfordbibliographies.com/view/document/obo-9780199756384/obo-9780199 756384-0193.xml.

12. Steven Heller, *POP: How Graphic Design Shapes Popular Culture* (New York: Allworth, 2010), 12.

13. Philip B. Meggs and Alston W. Purvis, *Meggs' History of Graphic Design*, 6th ed. (Hoboken, NJ: John Wiley, 2016); Stephen Eskilson, *Graphic Design: A New History*, 3rd ed. (New Haven, CT: Yale University Press, 2019); Paul McNeil, *The Visual History of Type* (London: Laurence King Publishing, 2017); David Jury, *Reinventing Print: Technology and Craft in Typography* (London: Bloomsbury Visual Arts, 2018).

14. Johanna Drucker and Emily McVarish, *Graphic Design History: A Critical Guide*, 2nd ed. (Upper Saddle River, NJ: Pearson, 2012), 312.

15. Paul E. Ceruzzi, *A History of Modern Computing*, 2nd ed. (Cambridge, MA: MIT Press, 2003), 76–77. A new version of the book includes an image of Snoopy. Thomas Haigh and Paul E. Ceruzzi, *A New History of Modern Computing* (Cambridge, MA: MIT Press, 2021), 60.

16. Alisa Freedman, "Cellphone and Internet Novels," in *The Routledge Companion to Global Internet Histories*, ed. Gerard Goggin and Mark J. McLelland (New York: Routledge, Taylor & Francis Group, 2017), 419–421.

17. Gerard O'Regan, *The Innovation in Computing Companion* (Cham, Switzerland: Springer International, 2018).

18. Edward Webster, *Print Unchained: Fifty Years of Digital Printing, 1950–2000 and Beyond: A Saga of Invention and Enterprise* (West Dover, VT: DRA of Vermont, 2000).

19. Sy Taffel, "Perspectives on the Postdigital," *Convergence* 22, no. 3 (2016): 324–338.

20. Jury, *Reinventing Print*.

21. Wendy Hui Kyong Chun, *Updating to Remain the Same: Habitual New Media* (Cambridge, MA: MIT Press, 2016).

22. David M. Berry, "The Postdigital Constellation," in *Postdigital Aesthetics: Art, Computation and Design*, ed. David M. Berry and Michael Dieter (Houndmills, UK: Palgrave Macmillan, 2015).

23. Alessandro Ludovico, *Post-Digital Print: The Mutation of Publishing since 1894* (Eindhoven, Netherlands: Onomatopee, 2012).

24. Christiane Paul, "From Digital to Post-Digital: Evolutions of an Art Form," in *A Companion to Digital Art*, ed. Christiane Paul (Hoboken, NJ: John Wiley, 2016), 1.

25. Florian Cramer, "What Is 'Post-Digital'?," *APRJA* 3, no. 1 (2014): 18; Kenneth Goldsmith, *Uncreative Writing: Managing Language in the Digital Age* (New York: Columbia University Press, 2011), 72–77.

26. Rodney H. Jones, Alice Chik, and Christopher A. Hafner, eds., *Discourse and Digital Practices: Doing Discourse Analysis in the Digital Age* (London: Routledge, 2015).

27. I have not made participant observations to the extent required to meet Robert Kozinets's definition of the term *netnography*, which is why I do not use the term here. Robert V. Kozinets, *Netnography: The Essential Guide to Qualitative Social Media Research*, 3rd ed. (London: SAGE, 2020).

28. Walter J. Ong, *Orality and Literacy: The Technologizing of the Word* (London: Routledge, [1982] 2002). For research on secondary orality and digital media, see, for

instance, Oren Soffer, "From Textual Orality to Oral Textuality: The Case of Voice Queries," *Convergence* 26, no. 4 (2020): 927–941.

29. Theo van Leeuwen, *Introducing Social Semiotics* (New York: Routledge, 2005), 285.

30. Gunther R. Kress and Theo van Leeuwen, *Reading Images: The Grammar of Visual Design*, 2nd ed. (London: Routledge, 2006), 14.

31. Theo van Leeuwen, "Towards a Semiotics of Typography," *Information Design Journal + Document Design* 14, no. 2 (2006): 139–155.

32. See, for instance, Artin Arshamian and Maria Larsson, "Same Same but Different: The Case of Olfactory Imagery," *Frontiers in Psychology* 5, 2014, article 34.

33. Sarah Hyndman has explored the sense of taste in her book *Why Fonts Matter* (London: Virgin, 2016). Ellen Lupton and Andrea Lipps's *The Senses: Design beyond Vision* (New York: Princeton Architectural Press, 2018), was published in connection with an exhibition at Cooper Hewitt's Smithsonian Design Museum in 2018. An academic journal devoted to this field is *Multisensory Research: A Journal of Scientific Research on All Aspects of Multisensory Processing*.

34. Johanna Drucker, *The Visible Word: Experimental Typography and Modern Art, 1909–1923* (Chicago: University of Chicago Press, 1994), 26.

35. Drucker, *The Visible Word*, 43–44.

36. Matthew G. Kirschenbaum, *Mechanisms: New Media and the Forensic Imagination* (Cambridge, MA: MIT Press, 2008), 10–14.

37. Huhtamo and Parikka, *Media Archaeology*, 21.

38. Jussi Parikka, *What Is Media Archaeology?* (Cambridge: Polity, 2012), chap. 6.

39. My sole participatory observation consisted of contributing a fruit sticker to this archive: Karin Wagner, "Conference Pear Fruit Sticker," Fonts in Use, March 12, 2021, https://fontsinuse.com/uses/39164/conference-pear-fruit-sticker.

40. Fonts in Use, https://fontsinuse.com.

41. The People's Graphic Design Archive, https://www.peoplesgdarchive.org.

42. Letterform Archive, https://letterformarchive.org.

43. Digital Art Museum DAM, https://dam.org/museum.

44. The Movie Title Stills Collection, http://annyas.com/screenshots.

45. *Print*, https://www.printmag.com; *Communication Arts*, https://www.commarts.com; *AIGA Eye on Design*, https://eyeondesign.aiga.org; *Eye*, http://www.eyemagazine.com.

46. *Design Observer*, https://www.designobserver.com.

47. *Smashing Magazine*, https://www.smashingmagazine.com.

48. Computer History Museum, https://computerhistory.org.

49. The Media Archaeology Lab (MAL), https://www.mediaarchaeologylab.com; Computermuseum der Informatik, https://www.f05.uni-stuttgart.de/en/cs/department/computer-museum.

50. *Creative Computing, Personal Computing,* and *Byte* magazines have been digitized and are available at the Internet Archive at https://archive.org/details/creativecom puting, https://archive.org/details/personalcomputingmagazine, and https://archive .org/details/byte-magazine-1982-08/page/n393/mode/2up.

51. *Vintage Computing and Gaming: Adventures in Classic Technology* (blog), https:// www.vintagecomputing.com/index.php/archives/973/retro-scan-of-the-week-star -dot-matrix-printer.

52. *Paleotronic: Electronics, Computing and Video Game History,* https://paleotronic.com /about.

53. *Tedium* (blog), https://tedium.co.

54. Mike Lacher, "I'm Comic Sans, Asshole," *McSweeney's,* June 15, 2010, https:// www.mcsweeneys.net.

55. Kenneth Goldsmith, *Uncreative Writing: Managing Language in the Digital Age* (New York: Columbia University Press, 2011), 72–77.

56. "It could be argued that eBay was one of the earliest social media platforms, connecting buyers to sellers as early as 1995." Giselle Abramovich, "The Evolution of eBay's Social Strategy," *Digiday,* April 8, 2013, https://digiday.com/marketing/the -evolution-of-ebays-social-strategy.

57. Vincent Connare, "Why Comic Sans?," Connare, 2003, http://www.connare.com /whycomic.htm.

58. "ASCII Artwork," Old Technology Collection," http://q7.neurotica.com/Oldtech /ASCII.

59. Ivo Vynckier, "How OCR Works: A Close Look at Optical Character Recognition," How OCR Works, https://how-ocr-works.com; Ivo Vynckier, "Catch the Truth If You Can: Spielberg, Abagnale and OCR," Spielberg-OCR, https://spielberg-ocr.com.

60. For instance, "The History of Printers," GSM Barcoding, https://www.barcoding .co.uk/history-of-printers; "Dot Matrix Printers," MindMachine Associates, https:// mindmachine.co.uk/products/06_Printer_Dot_Matrix_01.html.

61. Dave Addey, *Typeset in the Future: Typography and Design in Science Fiction Movies* (New York: Abrams, 2018). There are many books about space in popular culture— for instance Annette Froehlich, ed., *Outer Space and Popular Culture: Influences and Interrelations* (Cham, Switzerland: Springer International, 2019). However, neither this nor other similar books on the subject touch on typography.

62. Tony Brook and Adrian Shaughnessy, eds., *Letraset: The DIY Typography Revolution* (London: Unit Editions, 2018).

63. Toshi Omagari, *Arcade Game Typography: The Art of Pixel Type* (London: Thames & Hudson, 2019).

64. Steven E. Jones, "Tangible Data: From Bits of Paper to the Cloud," in *Print Punch: Artefacts from the Punch Card Computing Era,* ed. Patrick Fry (London: CentreCentre; 2020), 21.

65. "About CentreCentre," CentreCentre, https://centrecentre.co.uk/pages/about.

66. Rüdiger Schlömer, *Typographic Knitting: From Pixel to Pattern* (New York: Princeton Architectural Press, 2020).

67. Brenda Danet, *Cyberplay: Communicating Online* (Oxford: Berg, 2001).

68. Kristoffer Gansing, "Humans Thinking Like Machines: Incidental Media Art in the Swedish Welfare State," in *Place Studies in Art, Media, Science and Technology: Historical Investigations on the Sites and the Migration of Knowledge*, ed. Andreas Broeckmann and Gunalan Nadarajan (Weimar, Germany: VDG, 2008).

69. Stephen Jones, *Synthetics: Aspects of Art and Technology in Australia, 1956–1975* (Cambridge, MA: MIT Press, 2011).

70. Mark Owens and David Reinfurt, "Pure Data: Moments in a History of Machine-Readable Type," *Visual Communication* 4, no. 2 (2005): 144–150.

71. Tim van der Heijden, "Technostalgia of the Present: From Technologies of Memory to a Memory of Technologies," *NECSUS: European Journal of Media Studies* 4, no. 2 (2015): 103–121.

72. John Campopiano, "Memory, Temporality, & Manifestations of Our Technostalgia," *Preservation, Digital Technology & Culture* (PDT&C) 43, no. 3 (2014): 75–85.

73. Karin Bijsterveld and José van Dijck, *Sound Souvenirs: Audio Technologies, Memory and Cultural Practices* (Amsterdam: Amsterdam University Press, 2009).

74. Kate Brideau and Charles Berret, "A Brief Introduction to Impact: 'The Meme Font,'" *Journal of Visual Culture* 13, no. 3 (2014): 307–313.

75. Keith M. Murphy, "Fontroversy! Or, How to Care about the Shape of Language," in *Language and Materiality: Ethnographic and Theoretical Explorations*, ed. Jillian R. Cavanaugh and Shalini Shankar (Cambridge: Cambridge University Press, 2017), 79–80.

76. Sarah Owens, "On the Professional and Everyday Design of Graphic Artefacts," in *Design Culture: Objects and Approaches*, ed. Guy Julier, Anders V. Munch, Mads Nygaard Folkmann, Hans-Christian Jensen, and Nils Peter Skou (London: Bloomsbury Visual Arts, 2019).

77. Garrett W. Nichols, "Type Reveals Culture: A Defense of Bad Type," in *Type Matters: The Rhetoricity of Letterforms*, ed. Christopher Scott Wyatt and Dànielle Nicole DeVoss (Anderson, SC: Parlor Press, 2018).

CHAPTER 2

1. Barrie Tullett, *Typewriter Art: A Modern Anthology* (London: King, 2014), 23.

2. Byron H. Kretzman, *The New RTTY Handbook* (Toronto: Cowan, 1971); *RTTY Journal* (1982): 72–74; Dale Sinner, "Don Royer, WA6PIR Pioneer of RTTY Art," *New RTTY Journal* 47, no. 3 (August 1999): 4–5; Alexis C. Madrigal, "The Lost Ancestors of ASCII Art," *The Atlantic*, January 30, 2014, https://www.theatlantic.com/technology/archive/2014/01/the-lost-ancestors-of-ascii-art/283445. The Connections Museum has a collection of RTTY art and a YouTube Channel available at https://www.you

tube.com/c/ConnectionsMuseum. The screenshot in figure 2.2 is taken from the video at https://youtu.be/Ywf0IaCzLuc.

3. In 1974, the Association for Computing Machinery's Special Interest Group on Computer Graphics and Interactive Techniques (ACM SIGGRAPH) held its first annual conference, and its conference proceedings offer a good opportunity for following developments within the computer graphics field. See ACM SIGGRAPH, https://www.siggraph.org. For an account of the prehistory of computer graphics, see Jacob Gaboury, *Image Objects: An Archaeology of Computer Graphics* (Cambridge, MA: MIT Press, 2021).

4. Darrel Ince, "ASCII Art," in *A Dictionary of the Internet*, 4th ed. (Oxford: Oxford University Press, 2019).

5. Kate O'Riordan, "ASCII Art," in *Encyclopedia of New Media: An Essential Reference to Communication and Technology*, ed. Steve Jones (Thousand Oaks, CA: SAGE, [2003] 2007), 15–16.

6. Media theorist Charlie Gere calls the first shift figure/ground oscillation. He also discusses ASCII art from the point of view of Jacques Derrida's take on writing and image. Charlie Gere, "The Hauntology of the Digital Image," in *A Companion to Digital Art*, ed. Christiane Paul (Chichester, UK: John Wiley, 2016), 206–211.

7. Eryk Salvaggio argues that ASCII art is "an excellent modern representation of the Zen Aesthetic." He states that "Only through the breakdown of the written language can we express an image with more clarity, a sort of digital vow of silence, or the Internet speaking in tongues." Eryk Salvaggio, "Zen & ASCII," *frAme: Online Journal of Culture and Technology*, no. 6 (2001), https://dtc-wsuv.org/elit/trace/frame6/eryk.htm.

8. Xuemiao Xu, Linling Zhang, and Tien-Tsin Wong, "Structure-Based ASCII Art," *ACM Transactions on Graphics* (SIGGRAPH 2010 issue) 29, no. 4 (July 2010): 1–10.

9. Joe Yuska, "Old Naked Woman ASCII Art," Google Groups, April 28, 1999, https://groups.google.com/g/alt.folklore.computers/c/i-fJcVXkCLU?pli=1.

10. CalComp, promotional plotter video showing a digital *Mona Lisa*, California Computer Products, 1968, https://www.digitalmonalisa.com/video.html.

11. James Vincent, "A Look Back at the First Computer Art Contests from the '60s: Bullet Ricochets and Sine Curve Portraits," *The Verge*, July 13, 2015, https://www.theverge.com/2015/7/13/8919677/early-computer-art-computers-and-automation.

12. H. Philip Peterson, "The Digital *Mona Lisa*," *Computers and Automation*, December 1965, 13.

13. Theodor H. Nelson, *Computer Lib / Dream Machines*, special supplement to the third printing, 1975, 119, http://worrydream.com/refs/Nelson-ComputerLibDream Machines1975.pdf.

14. A. Michael Noll, "Early Digital Computer Art at Bell Telephone Laboratories, Incorporated," *Leonardo* 49, no.1 (2016): 55–65.

15. Leon D. Harmon and Kenneth C. Knowlton, "Computer-Generated Pictures," in *Cybernetic Serendipity: The Computer and the Arts*, a Studio International special issue edited by Jasia Reichardt (September 1968): 87.

16. K. G. Pontus Hultén, *The Machine as Seen at the End of the Mechanical Age* (New York: Museum of Modern Art, 1968); Jasia Reichardt, "Introduction," in *Cybernetic Serendipity*.

17. Ken Knowlton, "Portrait of the Artist as a Young Scientist," *YLEM Journal* 25, no. 2 (January–February 2005): 8–11, https://www.kenknowlton.com/pages/04portrait .htm; Nanette Crist, "Computer Art Pioneer Ken Knowlton," *Arts Advocates*, November 7, 2019, https://www.artsadvocates.org/about/what-s-new/computer-art-pioneer -ken-knowlton.

18. Johanna Drucker and Emily McVarish, *Graphic Design History: A Critical Guide*, 2nd ed. (Upper Saddle River, NJ: Pearson, 2012), 312.

19. Rachel Price and Giampaolo Bianconi, "Rachel Price on Waldemar Cordeiro's Computer Art," Post: Notes on Art in a Global Context, Museum of Modern Art, May 23, 2018, https://post.moma.org/rachel-price-on-waldemar-cordeiros-computer-art.

20. *Thinking Machines: Art and Design in the Computer Age, 1959–1989*, exhibition, Museum of Modern Art, November 13, 2017–April 8, 2018, https://www.moma.org /calendar/exhibitions/3863; *MoMA Highlights: 375 Works from The Museum of Modern Art* (New York: Museum of Modern Art, 2019). Another artist who worked with abstract ASCII art was Frederick Hammersley. See Patrick Frank, *Sharing Code: Art1, Frederick Hammersley, and the Dawn of Computer Art* (Santa Fe: Museum of New Mexico Press, 2020).

21. George Dickie, *Art and the Aesthetic: An Institutional Analysis* (Ithaca, NY: Cornell University Press, 1974). See further Hans Van Maanen, *How to Study Art Worlds: On the Societal Functioning of Aesthetic Values* (Amsterdam: Amsterdam University Press, 2009), 17–29.

22. compArt daDA: the database Digital Art, http://dada.compart-bremen.de.

23. Torley Wong, "Eight Inspiring Stories of ASCII Art," January 25, 2009, *Smashing Magazine*, https://www.smashingmagazine.com/2009/01/8-inspiring-highlights-of-ascii -art. The portrait of Norris appears in *Fortune*, February 1968, 127.

24. See Stephen Jones, *Synthetics: Aspects of Art and Technology in Australia, 1956– 1975* (Cambridge, MA: MIT Press, 2011), 32, 35–36. "But were any of these pictures in any way even approaching art? Was there any kind of aesthetics attached to them? It may appear from the material that I have found, so far, in Australia that the clear answer is no, and that their only relationship to any future development of electronic arts was in that they formed the outcome from various programming experiments that led towards the capacity to make much more complex, detailed and more original images later on." Jones, *Synthetics*, 37. A shortened version of Jones's book was published on the web in 2018 at https://the-synthetic-image.com. Portraits were nevertheless a popular motif of ASCII art, and they were not only of company executives in *Fortune*. On a 1972 back cover of *Rolling Stone*, there is an ASCII picture of the programmer Pam Hart, founder of the group Resource One. See Tim Findley, "Grand Juries: Farewell to the Fifth Amendment," *Rolling Stone*, December 7, 1972, at Computer History, https://archive.computerhistory.org/resources/access /text/2021/05/102711733-05-01-acc.pdf. More recent examples I have come across are T-shirts with portraits printed on them of computer pioneers Charles Babbage

and Alan Turing, anachronistic as they may be. Another example is Corey Holms's poster of Steve Jobs, which he made for the film *Jobs*. See Corey Holms, https://www.coreyholms.com/jobs-1.

25. Darko Fritz, "International Networks of Early Digital Arts," in *A Companion to Digital Art*, ed. Christiane Paul and Dana Arnold (Hoboken, NJ: John Wiley, 2016), 54.

26. Ken Knowlton, "Portrait of the Artist as a Young Scientist," *YLEM Journal* 25, no. 2 (January–February 2005): 10–11, https://www.kenknowlton.com/pages/04portrait.htm.

27. Jim Boulton, "Studies in Perception: A Digital Restoration Story," *Medium*, March 14, 2021, https://jimboulton.medium.com/studies-in-perception-a-restoration-story-241cd8c75ab1.

28. *The New Hacker's Dictionary*, version 4.2.2, (1975) 2002, https://archive.org/stream/jarg422/jarg422.txt.

29. John Regehr, "Explaining Code Using ASCII Art," *Embedded in Academia* (blog), February 18, 2019, https://blog.regehr.org/archives/1653.

30. This informant was a retired male engineer born in the early 1940s.

31. Katherine E. Isaacs and Todd Gamblin, "Preserving Command Line Workflow for a Package Management System Using ASCII DAG Visualization," *IEEE Transactions on Visualization and Computer Graphics* 25, no. 9 (2019): 2804–2820.

32. For a more thorough presentation of Alan Head's work, see Jones, *Synthetics*, 33–36.

33. Alan K. Head, "The Computer Generation of Electron Microscope Pictures of Dislocations," *Australian Journal of Physics* 20 (1967): 557–566; Stephen Jones, "Data Visualisation and Computer Graphics," *Synthetics: Aspects of the History of Electronic Art* (blog), 2018, https://the-synthetic-image.com/home/data-visualisation-and-computer-graphics.

34. A collaboration between the University Hospital in Uppsala, Elema-Schönander AB, and Uppsala University Data Center (UDAC).

35. *Computers in Radiotherapy and Clinical Physiology: Presentation of a Development Project*, internal report, EC60.470.B01E, Siemens-Elema, 1972, 21.

36. This is also how the hexadecimal system is usually represented.

37. There are two characters that are used only for drawing lines—the asterisk and the dollar sign.

38. *Computers in Radiotherapy and Clinical Physiology*, 26.

39. Kristoffer Gansing, "Humans Thinking Like Machines: Incidental Media Art in the Swedish Welfare State," in *Place Studies in Art, Media, Science and Technology: Historical Investigations on the Sites and the Migration of Knowledge*, ed. Andreas Broeckmann and Gunalan Nadarajan (Weimar, Germany: VDG, 2008).

40. *The Dictionary of Digital Creation*, https://diccan.com/Eipi.htm.

41. Jones, *Synthetics*, 32. This is also suggested by Kristoffer Gansing: "The Icelandic composer Jóhann Jóhansson, who in 2006 released a composition based on 1401 recordings by his father, suggests that the 'singing' of the 1401 system can be seen as a way for the workers to 'humanise' this opaque technology." Gansing, "Humans Thinking Like Machines," 80.

42. Honeywell International, "Abbey National picked a Honeywell computer system," advertisement, *New Scientist* 21, no. 381 (March 5, 1964): 589.

43. Computers were also marketed with the help of brochures. The Computer History Museum has many marketing brochures in its collection. See "Selling the Computer Revolution: Marketing Brochures in the Collection (1948–1988)," Computer History Museum, https://www.computerhistory.org/brochures.

44. "Digital Computer Lab in the 1960s," video, Illinois Media Space, University of Illinois, https://mediaspace.illinois.edu/media/Digital+Computer+Lab+in+the+19 60s/1_hazllmgz.

45. Gansing is reasoning along the same lines: "However, this music also had the function of presenting the work-place to the public and arose out of the necessity to demonstrate the marvels of the modern machinery in a way that was aesthetically understandable, since the technology in itself would be too opaque for a casual bystander to get a grasp of." Gansing, "Humans Thinking Like Machines," 81.

46. UNIVAC Art, photo of a man holding a printout of caricatures of US statesmen Dwight Eisenhower and Adlai Stevenson printed by a Universal Automatic Computer, March 13, 1957, photo by Keystone/Getty Images, https://www.gettyimages .se/detail/nyhetsfoto/caricatures-of-us-statesmen-dwight-eisenhower-and-adlai -nyhetsfoto/3433378?adppopup=true.

47. The Hulton Archive, Fleet Street's Finest, https://www.fleetstreetsfinest.com /partner/the-hulton-archive.

48. Olavi Kaskisuo, *ASCII Pinup 1964*, Computing Center of the City of Helsinki, December 11, 1964, Wikimedia Common, https://commons.wikimedia.org/wiki /File:ASCII-pinup-1964.jpg#filelinks.

49. "Uddevallavarvets nya datamaskin pressar kostnaderna (The new computer of the shipyard at Uddevalla drives down the costs)," *Varvet och vi* 1 (1967), https:// drive.google.com/file/d/1x0GDeh4ExuacIbthJj-hHsUR6i2LftnD/view. The photograph was taken at the inauguration of the computer center: Arne Andersson, *Head of punch cards Lars Westlund with the portrait of Brigitte Bardot*, DigitaltMuseum, https:// digitaltmuseum.se/011014299669/invigning-av-datacentral.

50. "Uddevallavarvets nya datamaskin pressar kostnaderna," 14.

51. Nelson, *Computer Lib / Dream Machines*, 50.

52. Phil Servedio, "How Jimmy Carter and Ronald Reagan Launched My Software Career: Or How a Single Phone Call Can Change a Destiny," Heartspace, 2012, http:// heartspace.org/career.

53. Peter Lunenfeld, *Snap to Grid: A User's Guide to Digital Arts* (Cambridge, MA: MIT Press, 2000), 84.

54. Larry "Harris" Taylor, "ASCII Art," http://www-personal.umich.edu/~lpt/Divegeek
/snoopy.htm. ASCII art is still used as a pedagogical tool in basic computer education.
See, for instance, Erin Flanagan, "Coding with Text Art: ASCII Art in the Classroom,"
Erintegration, October 22, 2018, https://www.erintegration.com/2018/10/22/coding
-with-text-art-ascii-art-in-the-classroom.

55. "ASCII Art from Impact Printer, 1972–1974," Catalog Number 102773972,
Computer History, https://archive.computerhistory.org/resources/access/text/2021
/05/102773972-05-01-acc.pdf.

56. Klemens Krause, email to the author, May 11, 2021.

57. Ed Post, "Real Programmers Don't Use Pascal," *Datamation* 29, no. 7 (July 1983):
263–265.

58. *The Best of Creative Computing*, vol. 1, 1976, Atari Archives, https://www.atariar
chives.org/bcc1/showpage.php?page=i6.

59. Mike Loewen, "ASCII Artwork," interview with Samuel P. Harbinson, 2009, Old
Technology Collection, Neurotica, http://q7.neurotica.com/Oldtech/ASCII.

60. Abigail Solomon Godeau, "The Other Side of Venus: The Visual Economy of
Feminine Display," in *The Sex of Things: Gender and Consumption in Historical Perspec-
tive*, ed. Victoria De Grazia and Ellen Furlough (Berkeley: University of California
Press, 1996), 113–150.

61. Maria Elena Buszek, *Pin-up Grrrls: Feminism, Sexuality, Popular Culture* (Durham,
NC: Duke University Press, 2006), 236–244. In this book, Buszek also explores how
the genre was appropriated by female artists in the 1970s to convey a feminist
message.

62. See further Brenda Danet, *Cyberplay: Communicating Online* (Oxford: Berg, 2001),
194–240.

63. IKEA had an IBM System/360 Model 40 that was manufactured from 1964
through 1977. *Datacentral IKEA, Älmhult*, photo of a man working in a computer
center, December 20, 1971, DigitaltMuseum, https://digitaltmuseum.se/0210180
76293/datacentral-ikea-almhult.

64. See, for instance, "Job Separator Pages," IBM, https://www.ibm.com/docs/en/zos
/2.1.0?topic=jobs-job-separator-pages; https://i.stack.imgur.com/wOoE8.jpg.

65. Loewen, "ASCII Artwork," interview with Samuel P. Harbinson.

66. Loewen, "ASCII Artwork," interview with Samuel P. Harbinson.

67. Ian Parberry, "Adventures in ASCII Art," *Leonardo* 47, no. 3 (2014): 262–263.

68. Loewen, "ASCII Artwork," interview with Samuel P. Harbinson.

69. CuriousMarc, "ASCII art demo with vintage HP 85 computer, HP 7970E 9-track
tape and HP 2631G dot matrix printer," YouTube, February 1, 2016, comment by
Douglas787, 2018, https://www.youtube.com/watch?v=YS9dGYUbNd0&feature=you
tu.be.

70. Mail interview with Klemens Krause. This also was mentioned in a comment
to a video running the Edith program: "But there was also a remarkable print of

a steam locomotive, the BIG BOY; about 5 feet long," CuriousMarc, "The IBM 1401mainframe runs 'Edith,'" YouTube, June 2, 2018, comment by Worldbestpilot, 2019, https://www.youtube.com/watch?v=LtlrITxB5qg&t=19s.

71. Stick E. Note, "How a Google Office Became a Sticky-Note Art Gallery," The Keyword, Google, April 29, 2019, https://blog.google/inside-google/life-at-google/sticky-note-pixel-art; "Post-It War between Two Office Buildings Ends with Epic Finale," Bored Panda, 2016, https://www.boredpanda.com/building-post-it-war-notes-nyc-manhattan/?utm_source=google&utm_medium=organic&utm_campaign=organic.

72. Bob Neill, *Bob Neill's Book of Typewriter Art* (Zennor, UK: Weavers Press Publishing, 1982).

73. Loewen, "ASCII Artwork," interview with Samuel P. Harbinson.

74. CuriousMarc, "ASCII art demo with vintage HP 85 computer, HP 7970E 9-track tape and HP 2631G dot matrix printer," YouTube, February 1, 2016, comment by Mystereit, 2018, https://www.youtube.com/watch?v=YS9dGYUbNd0&feature=youtu.be.

75. Benj Edwards, "Woman Needs Help with ASCII Banner for Uncle's Memorial," *Vintage Computing and Gaming*, May 8, 2013, http://www.vintagecomputing.com /index.php/archives/979/woman-needs-help-with-ascii-banner-for-uncles-memorial.

76. Vuk Cosinc, *Instant ASCII kamera*, art installation, Kontejner, 1999, https://www .kontejner.org/en/projekti/device_art-festival/device_art-5/izlozba-17/instant-ascii -kamera.

77. Dag Spicer, a senior curator at the Computer History Museum, occasionally promotes the museum through ASCII prints on his Twitter account. See Dag Spicer, "Science Officer Spock of the USS Enterprise saying hello from the distant Genesis planet via the Computer History Museum's 1959 IBM 1403 line printer. The 1403 can shoot 600 lines per minute (lpm) or more out the back of the printer, a page every three seconds." Twitter, August 1, 2019, @dag_spicer, https://twitter.com/dag _spicer/status/1156799211813384192, and Dag Spicer, "Today is Stardate 47634.44. Portrait of Mr. Spock, Science Officer of the USS Enterprise, printed on the IBM 1403 printer at @ComputerHistory. This printer is connected to our IBM 1401 data processing system, a running computer from 1959! https://computerhistory.org/exhibits /ibm1401/ #StarTrekTOS." Twitter, April 22, 2022, @dag_spicer, https://twitter.com /dag_spicer/status/1253024791134531585.

78. Marcel Mauss, "Essai sur le don. Forme et raison de l'échange dans les sociétés archaïques," *L'année sociologique*, nouvelle série, 1 (1925): 30–186; Marcel Mauss, *The Gift: Forms and Functions of Exchange in Archaic Societies*, trans. Ian Cunninson (Glencoe, IL.: Free Press, 1954).

79. Eric S. Raymond, "Homesteading the Noosphere," 2000, Catb, http://catb.org /~esr/writings/homesteading/homesteading/index.html.

80. Loewen, "ASCII Artwork," interview with Samuel P. Harbinson.

81. Julia Velkova, "Open Cultural Production and the Online Gift Economy: The Case of Blender," *First Monday*, 21, no. 10 (2016), https://journals.uic.edu/ojs/index .php/fm/article/download/6944/5627?inline=1#p8.

82. Neill, *Bob Neill's Book of Typewriter Art*.

83. Ele Carpenter, "Open Source Embroidery: Curatorial Facilitation of Material Networks," CCCB Lab, Centre de Cultura Contemporània de Barcelona (CCCB), June 28, 2010, https://lab.cccb.org/en/open-source-embroidery-curatorial-facilitation-of-material-networks.

84. Rüdiger Schlömer, *Typographic Knitting: From Pixel to Pattern* (New York: Princeton Architectural Press, 2020). See further Alicia Gibb, *Building Open Source Hardware: DIY Manufacturing for Hackers and Makers* (Boston: Addison-Wesley, 2014).

85. Open Source Craft, https://github.com/opensourcecraft.

86. Guy Fedorkow, "About the Computer History Museum's IBM 1401 Machines," *CHM Blog* (blog), February 19, 2015, Computer History Museum, https://computerhistory.org/blog/about-the-computer-history-museums-ibm-1401-machines; "The IBM 1403 Printer," IBM, https://www.ibm.com/ibm/history/exhibits/supplies/supplies_5404 PH09.html.

87. It probably also was adapted to run on other computer systems and circulated in more countries than the United States, Germany, and Sweden, which I have found evidence of in this limited study.

88. I wrote to the IBM corporate archives and was told that the company does not have information about this program in the archives.

89. Matthew G. Kirschenbaum, *Mechanisms: New Media and the Forensic Imagination* (Cambridge, MA: MIT Press, 2008), 9.

90. Benj Edwards, "The Never-Before-Told Story of the World's First Computer Art (It's a Sexy Dame)," *The Atlantic*, January 24, 2013, https://www.theatlantic.com/technology/archive/2013/01/the-never-before-told-story-of-the-worlds-first-computer-art-its-a-sexy-dame/267439.

91. Zbigniew Stachniak, "Software Recovery and Beyond," *IEEE Annals of the History of Computing* 41, no. 4 (2019): 110–118.

92. H. Philip Peterson, *Mona by the Numbers*, physical object, 1965, Computer History Museum, catalog no. X1028.90, https://www.computerhistory.org/collections/catalog/X1028.90; *ASCII Art from Impact Printer*, poster, 1972–1974, Computer History Museum, catalog no. 102773972, https://www.computerhistory.org/collections/catalog/102773972.

93. "ASCII Art," Collections, Victoria and Albert Museum, https://collections.vam.ac.uk/search/?q=ascii%20art.

94. Leon Harmon and Ken Knowlton, *Studies in Perception I*, laser print, 1997. https://collections.vam.ac.uk/item/O239963/studies-in-perception-i-print-harmon-leon.

95. Leon Harmon and Ken Knowlton, *Computer Nude (Studies in Perception I)*, laser print, 1997, Wright Auctions, https://www.wright20.com/auctions/2017/07/art-design/147; Waldemar Cordeiro, *Three Works*, offset lithographs, MutualArt, https://www.mutualart.com/Artist/Waldemar-Cordeiro/49E78EB7BC71909B.

96. Item listed on eBay, https://www.ebay.com/itm/Extremely-Rare-Star-Trek-Mr-Spock-ASCII-Art-Chaintrain-Line-Print-1979-/193793453724 [discontinued].

97. "Ultra Rare Mr Spock Star Trek ASCII Art Work / Poster Princeton Computer Lab 1973," item listed for sale on eBay, https://picclick.com/Ultra-Rare-Mr-Spock-Star-Trek-ASCII-Artwork-142438666559.html.

98. Matthew Bird, "Design History Research in the Digital Age," *Design and Culture* 6, no. 2 (2014): 243–249.

99. Dydia DeLyser, Rebecca Sheehan, and Andrew Curtis, "eBay and Research in Historical Geography," *Journal of Historical Geography* 30, no. 4 (2004): 764–782. See also Megha Rajguru, "At Your Bidding: eBay as An Archival Resource," *History of Art and Design Blog* (blog), June 15, 2021, School of Humanities, University of Brighton, https://blogs.brighton.ac.uk/hoad/2021/06/15/at-your-bidding-ebay-as-an-archival-resource.

100. See, for instance, "8 Best Free ASCII Art Generator Software For Windows," List of Free Software, https://listoffreeware.com/free-ascii-art-generator-software-windows, and "ASCII Art Generator," ASCII Art Club, https://asciiart.club. Some image processing programs include filters that can render images in ASCII art style. See Zoltan Erdokovy, "ASCII Art," Filter Forge, https://www.filterforge.com/filters/9148.html.

101. "Case Study: From ASCII Art to Subpixel ASCII+ Art," Underware Case Studies, June 2017, https://underware.nl/case-studies/subpixel-ascii-plus-art. See also research in computer science with a focus on increasing the speed of making ASCII images: for instance, Nenad Markuš, Marco Fratarcangeli, Igor S. Pandžić, and Jörgen Ahlberg, "Fast Rendering of Image Mosaics and ASCII Art," *Computer Graphics Forum* 34, no. 6 (2015): 251–261; Yuji Takeuchi, Koji Nakano, Daisuke Takafuji, and Yasuaki Ito, "A Character Art Generator Using the Local Exhaustive Search, with GPU Acceleration," *International Journal of Parallel, Emergent and Distributed Systems* 31, no. 1 (2016): 47–63.

102. VRichard86, "Snoopy Calendar Is Forever (C++)," *The Abandoned Place* (blog), August 10, 2012, https://vrichard86.wordpress.com/2012/08/10/snoopy-calendar-is-forever-c.

103. dosfanboy, "Making a Snoopy Calendar in Unix," *Mike's Computer Nerd Blog* (blog), January 5, 2017, https://dosfanboy.wordpress.com/2017/01/05/making-a-snoopy-calendar-in-unix.

CHAPTER 3

1. For a discussion of how computer vision is making the everyday increasingly machine-readable, see Katja Kwastek, "How to Be Theorized: A Tediously Academic Essay on the New Aesthetic," in *Postdigital Aesthetics: Art, Computation and Design*, ed. Michael Dieter and David M. Berry (New York: Palgrave Macmillan, 2015), 72–85.

2. Some of the cases could have been fitted into more than one category, but I have chosen the one I found most relevant.

3. Beatrice Warde and Henry Jacob, *The Crystal Goblet: Sixteen Essays on Typography* (London: Sylvan Press, 1955).

4. Johanna Drucker, *The Visible Word: Experimental Typography and Modern Art, 1909–1923* (Chicago: University of Chicago Press, 1994), 94–98.

5. Drucker, *The Visible Word*, 43–44.

6. Theo Van Leeuwen and Carey Jewitt, *Handbook of Visual Analysis* (London: SAGE, 2001); Per Ledin and David Machin, *Doing Visual Analysis: From Theory to Practice* (Thousand Oaks, CA: SAGE, 2018). For an analysis of moving images, see Karin Wagner, "The Guest and the Intruder," *Film International* 15, no. 4 (2017), 25–36.

7. Amy Weaver Fisher and James L. McKenney, "The Development of the ERMA Banking System: Lessons from History," *IEEE Annals of the History of Computing* 15, no. 1 (1993): 44–57. A European variant based on lines was also developed.

8. Digital Check, "Why Does the Magnetic MICR Printing on Checks Use Such a Weird Font?," https://www.digitalcheck.com/micr-weird-font-magnetic-printing.

9. Mark Owens and David Reinfurt, "Pure Data: Moments in a History of Machine-Readable Type," *Visual Communication* 4, no. 2 (2005): 147.

10. Some classic book covers are recurring in the literature. See, for instance, Charles Jencks, *Architecture 2000: Predictions and Methods* (London: Studio Vista, 1971); Maurice Trask, *The Story of Cybernetics* (London: Studio Vista, 1971), set in Westminster; Ruth Leavitt, ed., *Artists and Computer* (New York: Harmony Books, 1976), set in Computer; and the titles for John Berger's TV series *Ways of Seeing*, set in Data 70.

11. Jane Lamacraft, "Rub-Down Revolution," *Eye* 22 no. 86 (2013): 80, http://www.eyemagazine.com/feature/article/rub-down-revolution; Tony Brook and Adrian Shaughnessy, eds., *Letraset: The DIY Typography Revolution* (London: Unit Editions, 2018), 28.

12. Owens and Reinfurt, "Pure Data: Moments in a History of Machine-Readable Type," 147. The stories of the MICR and OCR typefaces are also briefly told in David Jury, *Reinventing Print: Technology and Craft in Typography* (London: Bloomsbury Visual Arts, 2018), 107–108.

13. Paul McNeil, *The Visual History of Type* (London: Laurence King Publishing, 2017), 396.

14. Adrian Frutiger, Heidrun Osterer, and Philipp Stamm, *Adrian Frutiger—Typefaces: The Complete Works* (Basel: Birkhäuser, 2009), 178. The United States of America Standards Institute (USASI) is now the American National Standards Institute (ANSI).

15. Frutiger, Osterer, and Stamm, *Adrian Frutiger—Typefaces*, 176.

16. ISO 1073-1:1976 and ISO 1073-2:1976.

17. Frutiger, Osterer, and Stamm, *Adrian Frutiger—Typefaces*, 178.

18. Paola Antonelli, "Digital Fonts: 23 New Faces in MoMA's Collection," *Inside/Out*, January 24, 2011, https://www.moma.org/explore/inside_out/2011/01/24/digital-fonts-23-new-faces-in-moma-s-collection. There were also other less successful attempts made in this design niche, such as Viafont, an OCR typeface that the company Viatron obtained a patent for in 1971. This font was short-lived on the optical character recognition market, but ten years later, it found an afterlife in the remake Buzzer Three. Stephen Coles, "*America* by Andy Warhol," Fonts in Use, March 13, 2019, https://fontsinuse.com/uses/25587/america-by-andy-warhol.

19. Frutiger, Osterer, and Stamm, *Adrian Frutiger—Typefaces*, 184.

20. Hubert L. Dreyfus, *What Computers Can't Do: A Critique of Artificial Reason* (New York: Harper & Row, 1972); Joseph Weizenbaum, *Computer Power and Human Reason: From Judgment to Calculation* (San Francisco: Freeman, 1976).

21. Louise Kehoe, "Engineers Get Personal with Computers," *Personal Computing*, October 1981, 24–32.

22. Peter Weibel and Timothy Druckrey, eds., *net_condition: art and global media* (Cambridge, MA: MIT Press, 2001).

23. Jennifer L. S. Moldwin, "*net_condition: art and global media*," review, *Library Journal* 126, no. 8 (2001): 80.

24. "*net_condition: art and global media*," review, *Publishers Weekly*, https://www.publishersweekly.com/978-0-262-73138-6.

25. Rick Poynor, *No More Rules: Graphic Design and Postmodernism* (London: Laurence King, 2003), 99.

26. Johanna Drucker and Emily McVarish highlight *Wired* as an exponent for digital culture in the 1990s: "Text and images overlapped and intersected, disrespecting traditional boundaries and rules." Johanna Drucker and Emily McVarish, *Graphic Design History*, 2nd ed. (Upper Saddle River, NJ: Pearson, 2012), 318, fig. 15.9.

27. Lisa Lynch, "Net_Condition: Art and Global Media," Resource Center for Cyberculture Studies (RCCS), https://web.archive.org/web/20020206011555/http://www.com.washington.edu/rccs.

28. Weibel and Druckrey, eds., *net_condition*.

29. Natalie Bookchin, "The Intruder," https://bookchin.net/projects/the-intruder.

30. Natalie Bookchin, "The Intruder," in Weibel and Druckrey, *net_condition*, 86.

31. Marc Lafia, "Vanndemar Memex or Lara Croft Stripped Bare by Her Assassins, Even," in Weibel and Druckrey, *net_condition*, 208–209; Mark Lafia, Gabrielle Marks, Darin Fong, Mark Meadows, and Josh Draper, "Vanndemar Memex or Lara Croft Stripped Bare by Her Assassins, Even," Memex Engine, http://memexengine.net/process/index.html. The title alludes to Marcel Duchamp's famous artwork *The Bride Stripped Bare by Her Bachelors, Even*, 1915–1923.

32. Drucker, *The Visible World*, 140–168.

33. Claudia S. Quiñones Vilá, "What's in a Name? Museums in the Post-Digital Age," *Santander Art and Culture Law Review* 2, no. 6 (2020): 177–198.

34. David C. Gompert and Martin Libicki, "Towards a Quantum Internet: Postpandemic Cyber Security in a Post-digital World," *Survival* 63, no. 1 (2021): 113–124.

35. Interview with Zel Bettman, March 18, 2021. Bettman was the designer in charge of the project and the owner of Lövheden Cengiz communications agency.

36. Paul N. Edwards, *The Closed World: Computers and the Politics of Discourse in Cold War America*, (Cambridge, MA: MIT Press, 1996).

37. "Public Believes Computers Make Life Better but Expresses Major Concerns," *Computer* 5, no. 1 (1972): 15–16, https://doi.ieeecomputersociety.org/10.1109/C-M.1972.216859.

38. Lars Ilshammar, "When Computers Became Dangerous: The Swedish Computer Discourse of the 1960s," *Human IT* 9, no. 1 (2007): 6–37.

39. Ilshammar, "When Computers Became Dangerous," 27.

40. "Prevent Personal Check Fraud Nationwide with Abagnale SuperCheck," Safe Checks, https://www.safechecks.com/our-checks/abagnale-personal-supercheck.php.

41. Michael Dooley, "Ed Words: Ruscha in Print," *Print* 48, no. 5, (1994): 32–42, 125.

42. Edward Ruscha, *Twentysix Gasoline Stations*, 3rd ed. (Alhambra, CA: Cunningham Press, 1969).

43. Edward Ruscha, *They Called Her Styrene* (London: Phaidon, 2000), 9 pages from the end.

44. "Michael Bierut, Ed Ruscha, and the Punch of Language," interview with Michael Bierut, *The Way I See It*, radio show, BBC and Museum of Modern Art, February 24, 2020, https://www.moma.org/magazine/articles/232.

45. He made several versions that differ slightly in size and material. The size of *1984 #1* is 14⁵⁄₁₆ inches × 22¹³⁄₁₆ inches, the size of *1984 [#2]* is 14⁷⁄₁₆ inches × 23 inches. They are both made with graphite on paper. Other versions were made with gunpowder and pencil on paper. Edward Ruscha, Category: Paintings, Works on Paper, All, https://edruscha.com/search-works/?works_title=1984.

46. Alison Martino, "1984 Didn't End the World after All. Artist Ed Ruscha on the Apocalypse That Wasn't," *Los Angeles Magazine*, July 16, 2014, https://www.lamag.com/the80s/1984-didnt-end-the-world-after-all.

47. Owens and Reinfurt, "Pure Data: Moments in a History of Machine-Readable Type," 147.

48. Dave Addey, *Typeset in the Future: Typography and Design in Science Fiction Movies* (New York: Abrams, 2018), 46.

49. *ADB och samhällets sårbarhet: Överväganden och förslag* (ADP and the Vulnerability of Society: Considerations and Proposals), SOU 1979:93, https://weburn.kb.se/metadata/833/SOU_8350833.htm.

50. Marvin Minsky, "Will Robots Inherit the Earth?," *Scientific American* 271, no. 4 (October 1994): 108–113.

51. See Dreyfus, *What Computers Can't Do*; Weizenbaum, *Computer Power and Human Reason*.

52. Walter A. McDougall, "A Melancholic Space Age Anniversary," *Remembering the Space Age: Proceedings of the 50th Anniversary Conference* (Baltimore: Johns Hopkins University Press, 2010), 389–396.

53. Jan Pieńkowski, *Robot* (London: Heinemann, 1981).

54. Tom Gauld, *Mooncop* (Montreal: Drawn & Quarterly, 2016).

55. Toshi Omagari, *Arcade Game Typography* (London: Thames & Hudson, 2019), 130.

56. McNeil, *The Visual History of Type*, 396.

57. Addey, *Typeset in the Future.*

58. Sarah Hyndman, *Why Fonts Matter* (London: Virgin, 2016), 52.

59. Zack Whalen, "OCR and the Vestigial Aesthetics of Machine Vision," paper presented at the 2013 Modern Language Association Annual Convention, January 3, 2013, at Zach Whalen, http://www.zachwhalen.net/posts/ocr-and-the-vestigial -aesthetics-of-machine-vision.

60. Florian Rötzer, "Attention in the Media Age," in Weibel and Druckrey, *net_condition.*

61. Barry Smith, "Jennicam, or the Telematic Theatre of a Real Life," *International Journal of Performance Arts and Digital Media* 1, no. 2 (2005): 91–100.

62. Rötzer, "Attention in the Media Age," 69.

63. CV Dazzle was Harvey's graduation project at the Interactive Telecommunications Program (ITP) at New York University. See further Adam Harvey, "CV Dazzle," AHProjects, https://ahprojects.com/cvdazzle; Yana Welinder, "A Face Tells More Than a Thousand Posts: Developing Face Recognition Privacy in Social Networks," *Harvard Journal of Law & Technology* 26, no. 1 (Fall 2012): 165–240; Becky Kazansky, Stefania Milan, Astrid Mager, and Christian Katzenbach, "'Bodies Not Templates': Contesting Dominant Algorithmic Imaginaries," *New Media & Society* 23, no. 2 (2021): 363–381.

64. Welinder, "A Face Tells More Than a Thousand Posts"; Scott Contreras-Koterbay and Lukasz Mirocha, *The New Aesthetic and Art: Constellations of the Postdigital* (Amsterdam: Institute of Network Cultures, 2016), 159–162; "Computer Vision Dazzle Camouflage," CVDazzle, June 15, 2020, https://cvdazzle.com.

65. Adam Harvey, "CV Dazzle," AHProjects, https://ahprojects.com/cvdazzle.

66. The camouflage styles do not offer generic protection but have to be adjusted for specific algorithms. See further Cameron Bishop and Luci Pangrazio, "Art as Digital Counterpractice," *CTHEORY* (2017): 1. https://journals.uvic.ca/index.php /ctheory/article/view/17034/7275.

67. Sang Mun, "Making Democracy Legible: A Defiant Typeface," *The Gradient*, June 20, 2013, https://walkerart.org/magazine/sang-mun-defiant-typeface-nsa-privacy. The ZXX typeface was included in an exhibition at the San Francisco Museum of Modern Art in 2016: Ellen Shapiro, "SFMOMA Reopening Celebrates Graphic Design," *Print*, June 13, 2016, https://www.printmag.com/post/sfmoma-celebrates -graphic-design. See further Studio Mun at https://studiomun.com.

68. "MARC Code List for Languages," MARC Standards, Library of Congress, https:// www.loc.gov/marc/languages/language_code.html.

69. Sang Mun, "ZXX Type Specimen Video," 2012, Vimeo, https://vimeo.com /42675696.

70. Mun, "Making Democracy Legible."

71. On CV Dazzle and "the computational eye," see further Justin Hodgson, *Post-digital Rhetoric and the New Aesthetic* (Columbus: Ohio State University Press, 2019), 89–91, https://kb.osu.edu/bitstream/handle/1811/87060/5/HODGSON_final_KU_210 pp.pdf.

CHAPTER 4

1. Johanna Drucker, *The Visible Word: Experimental Typography and Modern Art, 1909–1923* (Chicago: University of Chicago Press, 1994), 43–47.

2. Ainslie Yardley, "Bricolage as Method," *SAGE Research Methods Foundations*, ed. Paul Atkinson et al. (London: SAGE, 2019), https://dx.doi.org/10.4135/978152642 1036830409.

3. "SIC 3577 Computer Peripheral Equipment, Not Elsewhere Classified," *Encyclopedia of American Industries*, https://www.referenceforbusiness.com/industries/Machinery-Computer-Equipment/Computer-Peripheral-Equipment-Elsewhere-Classified.html.

4. Thomas Kraemer, "Printing Enters the Jet Age," *American Heritage Invention & Technology*, spring 2001, 18–27.

5. James A. Blanco, "Identifying Documents Printed by Dot Matrix Computer Printers," *Forensic Science International* 59, no. 2 (1993): 35–47.

6. David A. Lien, *Epson MX Printer Manual Graftrax Plus* (San Diego: CompuSoft Publishing, 1982), ix.

7. Lien, *Epson MX Printer Manual*, 4–8.

8. *Delta User's Manual* (Shizuoka, Japan: Star Micronics, 1983), iii.

9. *Delta User's Manual*, 76.

10. Rüdiger Schlömer, *Typographic Knitting: From Pixel to Pattern* (New York: Princeton Architectural Press, 2020).

11. Lien, *Epson MX Printer Manual*, v.

12. *Delta User's Manual*, iii.

13. "Birth of a Legend," advertisement for Epson, *Byte*, August 1982, 396–397.

14. See further Giuseppe Pedeliento, *Analyzing Attachment and Consumers' Emotions: Emerging Research and Opportunities* (Hershey, PA: IGI Global, 2018).

15. There are many other examples of printers that were marketed with the help of a similar strategy. See, for instance, this advertisement from 1983 for HP dot matrix printers, where they are made to play the parts of well-behaved pupils in a classroom: "Introducing Four Very Well Mannered HP Printers," advertisement for Hewlett Packard, HP Museum, http://www.hpmuseum.net/upload_htmlFile/Print Ads/Ad1983_Dec_2563A-293XPrinters-35.jpg.

16. W. J. T. Mitchell, "There Are No Visual Media," *Journal of Visual Culture* 4, no. 2 (2005): 257–266.

17. "Gadget Graveyard: Dot-Matrix Printers," *Paleotronic*, August 26, 2019, https://paleotronic.com/2019/08/26/gadget-graveyard-dot-matrix-printers.

18. John Sheesley, "Dot Matrix Printers Still Hammer Away the Days, *TechRepublic*, October 2, 2008, https://www.techrepublic.com/blog/classics-rock/dot-matrix-printers-still-hammer-away-the-days.

19. W. Wat Gibbs, "How to Steal Secrets without a Network," *Scientific American*, May 2009, 59.

20. Michael Backes, Markus Dürmuth, Sebastian Gerling, Manfred Pinkal, and Caroline Sporleder, "Acoustic Side-Channel Attacks on Printers," *Proceedings of the 19th USENIX Security Symposium, August 11–13, 2010, Washington, DC* (Berkeley, CA: USENIX Association, 2010), 307.

21. Backes et al., "Acoustic Side-Channel Attacks on Printers," 11.

22. Alisha Pradhan, Leah Findlater, and Amanda Lazar, "'Phantom Friend' or 'Just a Box with Information': Personification and Ontological Categorization of Smart Speaker-Based Voice Assistants by Older Adults," *Proceedings of the ACM on Human-Computer Interaction* 3, no. CSCW (2019): 1–21.

23. Tiina Männistö-Funk and Tanja Sihvonen, "Voices from the Uncanny Valley," *Digital Culture & Society* 4, no. 1 (2018): 45–64.

24. Benj Edwards, "[Retro Scan of the Week] Star Dot Matrix Printer," advertisement for the Star Micronics Delta-10 dot matrix printer, *Personal Computing*, November 1983, 28, in *Vintage Computing and Gaming: Adventures in Classic Technology*, April 8, 2013, http://www.vintagecomputing.com/index.php/archives/973/retro-scan-of-the-week-star-dot-matrix-printer.

25. Edwards, "[Retro Scan of the Week] Star Dot Matrix Printer."

26. Muhammad H. Al-Haboubi and Shokri Z. Selim, "Noise Change as an Indicator of Maintenance Requirement," *Journal of Quality in Maintenance Engineering* 6, no. 1 (2000): 20–27; Admin, "The Sounds Made by Failed Hard Drives and What They Mean for Hard Drive Recovery," *Tierra Data Recovery*, https://tierradatarecovery.co.uk/the-sounds-made-by-failed-hard-drives-and-what-they-mean-for-hard-drive-recovery [discontinued].

27. Jussi Parikka, *What Is Media Archaeology?* (Cambridge: Polity, 2012), 94. See further Gerard Alberts, "Why Computers Were Not Silent: Computer Technology and Sensuousness," paper presented at the Data Drive Seminar, April 7, 2015, https://datadriveseminar.wordpress.com/2015/03/30/7-april-1600-1800.

28. Nostalgia Nerd, "Bringing Dot Matrix Printing into 2021," YouTube, November 27, 2020, https://www.youtube.com/watch?v=UV6OSheyQzk.

29. Mark Grimshaw-Aagaard, Mads Walther-Hansen, Martin Knakkergaard, Erkin Asutay, and Daniel Västfjäll, "Sound and Emotion," *The Oxford Handbook of Sound and Imagination*, vol. 2. (Oxford: Oxford University Press, 2019), chap. 23.

30. Terry Stewart's (Tezza's) Webzone for Classic Computers, https://www.classic-computers.org.nz.

31. Terry Stewart, "Dot Matrix Printers: As Seen in Tezza's Classic Computer Collection," YouTube, October 4, 2014, https://www.youtube.com/watch?v=UWM2O ZGF8v0.

32. Stewart, "Dot Matrix Printers."

33. Mitchell, "There Are No Visual Media," 262.

34. Tech Tangents, "Fix Dot Matrix Printer Stuck Pin—Micro Tangent," YouTube, March 18, 2020, https://www.youtube.com/watch?v=Wxz82Yv40GY.

35. For an exploration of how tactility is evoked in the paintings of Francisco de Zurbarán, see Norman Bryson, *Looking at the Overlooked: Four Essays on Still Life Painting* (London: Reaktion, 1990), 60–95.

36. Tech Tangents, "Fix Dot Matrix Printer Stuck Pin."

37. Tech Tangents, "Fix Dot Matrix Printer Stuck Pin."

38. Joonhee Lee and Lily M. Wang, "How Tonality and Loudness of Noise Relate to Annoyance and Task Performance," *Noise Control Engineering Journal* 65, no. 2 (2017): 71–82.

39. "Printers-Accessories," HP Computer Museum, http://www.hpmuseum.net /exhibit.php?class=5&acc=17.

40. John Free, "Computer Add-Ons Cool and Cut Noise," *Popular Science*, August 1983.

41. Toshifumi Kosaka and Masaharu Takano, "Study on Noise Reduction of a Dot Matrix Printer," *Journal of the Japan Society for Precision Engineering* 45, no. 539 (1979): 1315–1320.

42. Making music with printers was not an idea that originated with dot matrix printers. Music had previously been made with line printers. See Kristoffer Gansing, "Humans Thinking Like Machines: Incidental Media Art in the Swedish Welfare State," in *Place Studies in Art, Media, Science and Technology: Historical Investigations on the Sites and the Migration of Knowledge*, ed. Andreas Broeckmann and Gunalan Nadarajan (Weimar, Germany: VDG, 2008), 75–80.

43. Jason Weisberger, "Ah, the Sound of a Dot Matrix Printer!," *Boing Boing*, February 17, 2019, https://bbs.boingboing.net/t/ah-the-sound-of-a-dot-matrix-printer/139111/41.

44. "Gadget Graveyard: Dot-Matrix Printers."

45. Erkki Huhtamo and Jussi Parikka, *Media Archaeology: Approaches, Applications, and Implications* (Berkeley: University of California Press, 2019).

46. Thomas McIntosh and Emmanuel Madan [The User], *Symphony for Dot Matrix Printers*, [The User], http://www.theuser.org/dotmatrix/en/intro.html; Thomas McIntosh and Emmanuel Madan [The User], *Quartet for Dot Matrix Printers*, Undefine, http://www.undefine.ca/en/projects/symphony-for-dot-matrix-printers/quartet; "[The User] *Quartet for Dot Matrix Printers* @ Phoenixhalle Dortmund (De) 2004," Vimeo, 2009, https://vimeo.com/undefinemtl; Joab Jackson, "Dot Matrix Printers Return to Make Music," *Network World*, May 28, 2010, https://www.networkworld .com/article/2210728/dot-matrix-printers-return-to-make-music.html. An earlier example of an art installation involving dot matrix printers is *Ursonate* by Hans Breder

from 1986. See Herman Rapaport, "Intermedia: A Consciousness-Based Process," interview with Hans Breder, January 2010, *PAJ: A Journal of Performance and Art* 33, no. 3 (2011): 11–23, https://www.mitpressjournals.org/doi/pdf/10.1162/PAJJ_a_00051.

47. Thomas McIntosh and Emmanuel Madan [The User], *Symphony #1 for Dot Matrix Printers*, 1998, Undefine, http://www.undefine.ca/en/projects/symphony-for -dot-matrix-printers/symphony-1-for-dot-matrix-printers.

48. Joab Jackson, "Dot Matrix Printers Return to Make Music," *Network World*, May 28, 2010, https://www.networkworld.com/article/2210728/dot-matrix-printers-return -to-make-music.html.

49. Angela Plohman, "[The User]," Daniel Langlois Foundation for Art, Science, and Technology, 2000, https://www.fondation-langlois.org/html/e/page.php?Num Page=83.

50. Thomas McIntosh and Emmanuel Madan [The User], *Symphony #2 for Dot Matrix Printers*, 1999, Undefine, http://www.undefine.ca/projects/symphony-for-dot-matrix -printers/symphony-2.

51. "[The User]," Avanto festival, August 11, 2001, http://www.avantofestival.com/ avanto2001/2001_live/lp_user.html.

52. Thomas McIntosh and Emmanuel Madan [The User], *Quartet for Dot Matrix Print-ers*, 2004, Undefine, http://www.undefine.ca/en/projects/symphony-for-dot-matrix -printers/quartet. Another version of the installation was shown in 2008 at the Museum of Contemporary Canadian Art in Toronto. See also Randy Gagne, "Sound Containers: Recent Sound Art in Toronto," *The Senses & Society* 4, no. 1 (2009): 111–116.

53. Garnet Hertz and Jussi Parikka, "Zombie Media: Circuit Bending Media Archae-ology into an Art Method," *Leonardo* (Oxford) 45, no. 5 (2012): 424–430.

54. MIDI Desaster, "31 Videos," Vimeo, https://vimeo.com/mididesaster.

55. MIDI Desaster, "Benny Hill Theme & How It's Done," Vimeo, 2013, https://vimeo .com/57960146?utm_campaign=5370367&utm_source=affiliate&utm_channel=affil iate&cjevent=b361de0d6ae311eb813a007c0a18050c.

56. McIntosh and Madan, *Quartet for Dot Matrix Printers*.

57. Jason Weisberger, "Ah, the Sound of a Dot Matrix Printer!," *Boing Boing*, February 17, 2019, https://bbs.boingboing.net/t/ah-the-sound-of-a-dot-matrix-printer/139111/41.

58. MIDI Desaster, "Rocky's Printer—Eye of the Tiger on a Dot Matrix Printer [HD]," YouTube, February 15, 2014, https://www.youtube.com/watch?v=u8I6qt_Z0Cg.

59. There are also contemporary artists who merge visual art and music. See, for instance, Grégoire Pont, a French artist who has become known for a performance concept he calls Cinesthetics, which means that he makes animated drawings during live musical performances. Grégoire Pont, https://www.gregoirepont.com.

60. Apart from staff notation, other notation systems have been invented: "Musi-cal notation is no one singular thing: it is multi-purpose, interdisciplinary, cultur-ally conditioned, and technologically dependent." Thor Magnusson, *Sonic Writing:*

Technologies of Material, Symbolic, and Signal Inscriptions (New York: Bloomsbury Academic, 2019), 95.

61. *Urban Dictionary*, s.v. technostalgia, entry by MC Le Roux, August 2, 2008, https://www.urbandictionary.com/define.php?term=technostalgia.

62. *Wiktionary*, s.v. technostalgia, https://en.wiktionary.org/wiki/Technostalgia.

63. Tim Van Der Heijden, "Technostalgia of the Present: From Technologies of Memory to a Memory of Technologies," *NECSUS: European Journal of Media Studies* 4, no. 2 (2015): 103–121. See also John Campopiano, "Memory, Temporality, & Manifestations of Our Tech-nostalgia," *Preservation, Digital Technology & Culture* (PDT&C) 43, no. 3 (2014): 75–85.

64. Svetlana Boym, "Nostalgia," Atlas of Transformation, http://monumenttotrans formation.org/atlas-of-transformation/html/n/nostalgia/nostalgia-svetlana-boym .html. See further Svetlana Boym, *The Future of Nostalgia* (New York: Basic Books, 2001).

65. Steve's Old Computer Museum, http://oldcomputers.net.

66. HP Computer Museum, http://www.hpmuseum.net/display_item.php?hw=319.

67. Another example of this strategy is the Living Computers museum in Seattle, which states on its website: "At Living Computers: Museum + Labs we empower people through the active use of computing technology. Most museums put glass in front of their stuff—we put a chair." "About LCM+L," Living Computers: Museum + Labs, https://www.livingcomputers.org/About-LCML.aspx.

68. Jussi Parikka, *What Is Media Archaeology?* (Cambridge: Polity, 2012), 5; Siegfried Zielinski and Gloria Custance, *Deep Time of the Media: Toward an Archaeology of Hearing and Seeing by Technical Means* (Cambridge, MA: MIT Press, 2006).

69. "Why Dot Matrix Printers Are Still Being Used Today?," Smart Print Supplies, August 27, 2019, https://smartprintsupplies.com/blogs/news/why-dot-matrix-print ers-are-still-being-used-today; "Best Dot Matrix Printer 2022 • 7 Dot Matrix Printers Reviews," Venture Beat, September 19, 2022, https://venturebeat.com/product -comparisons/best-dot-matrix-printer-reviews.

70. Berrin A Yanikoglu, "Pitch-Based Segmentation and Recognition of Dot-Matrix Text," *International Journal on Document Analysis and Recognition* 3, no. 1 (2000): 34–39.

71. "Royal Mail User Guide for Machine Readable Letters & Large Letters," Royal Mail, August 27, 2019, https://www.royalmailtechnical.com/rmt_docs/User_Guides _2019/Machine_Readable_Letters_and_Large_Letters_20190827.pdf.

72. "Royal Mail User Guide for Machine Readable Letters & Large Letters," 2019, 12.

73. Bernhard Siegert, *Relays: Literature as an Epoch of the Postal System* (Stanford, CA: Stanford University Press, 1999), 121.

74. For instance, Ultimate Hindi Tips, "Epson LQ310 Dot Matrix Printer All Problem Sloution [*sic*] Fix|| [*sic*] Head Cleaning," YouTube, December 24, 2019, https://www .youtube.com/watch?v=XiLsZz6VkbU.

75. "Why Does Indian Railways Still Use the Same Dot-Matrix Printer?," Quora, December, 2014, https://www.quora.com/Why-does-Indian-Railways-still-use-the-same -dot-matrix-printer.

76. Labeling guidance by Waste and Resources Action Programme (WRAP), https:// food.ec.europa.eu/system/files/2021-05/fw_lib_dm_labelling-guide_wrap.pdf.

77. "Matrox SureDotOCR: The World's Most Comprehensive Solution for Reading Dot-Matrix Text," Matrox Imaging, https://www.matrox.com/en/imaging/products /software/suredotocr.

78. Brenda Danet, *Cyberplay: Communicating Online* (Oxford: Berg, 2001), 289–344.

79. Rhonda Rubinstein, "Reputations: Zuzana Licko," *Eye*, Spring 2002, http://www .eyemagazine.com/feature/article/reputations-zuzana-licko.

80. Zuzana Licko, "Lo-Res," 1985 and 2001, Emigre Fonts, https://www.emigre .com/Fonts/Lo-Res. Kirschenbaum touches on the subject of low-resolution displays, electronic letterforms, and Licko's design. He states that what was once an effect of material limitations is today an "integral aspect of the medium's aesthetic identity." Matthew G. Kirschenbaum, *Mechanisms: New Media and the Forensic Imagination* (Cambridge, MA: MIT Press, 2008), 30n9.

81. "Lo-Res: A Synthesis of Bitmap Fonts," Emigre, https://www.emigre.com/PDF/Lo -Res.pdf.

82. Stephan Müller and Cornel Windlin, "FF Dot Matrix," 1994, Linotype, https:// www.linotype.com/535413/ff-dot-matrix-family.html [discontinued].

83. "Lineto," version 1.0, Legacy.Lineto, https://legacy.lineto.com/1.0/content_6.html.

84. "H&M In-Store Signs, 2006," 2006, Fonts in Use, January 9, 2012, https://fontsi nuse.com/uses/169/hand-m-in-store-signs-2006.

85. One website where such fonts are shared is DaFont at https://www.dafont.com. Other similar sites are 1001 Fonts at https://www.1001fonts.com, Font Squirrel at https://www.fontsquirrel.com, and Free-Fonts at https://www.free-fonts.com. Robin Eckert intended his FM Matrix font family to look like text printed by the Epson FX 9-pin printer and the Epson FX-80 dot matrix printer. "FM Matrix Font Family," Const-iterator, http://const-iterator.de/fxmatrix. Another example is Nikita Zimin, who created a dot matrix font by restoring the characters from the ROM of a Robo- tron 9-pin printer. What was gained by this more technical approach was authen- ticity. nzeemin, "Robotron-Dotmatrix-Font," Github, April 26, 2019, https://github .com/nzeemin/robotron-dotmatrix-font.

86. Toshi Omagari, *Arcade Game Typography: The Art of Pixel Type* (London: Thames & Hudson, 2019); "Retrogaming's Growth: The Enduring Popularity of Classic Games and Characters," Plarium, November 18, 2020, updated May 19, 2022, https://plarium.com/en/blog/the-rise-in-popularity-of-retro-games.

87. Omagari, *Arcade Game Typography*, 8. For instance, Arthur Asa Berger, *Video Games: A Popular Culture Phenomenon* (New Brunswick, NJ: Transaction, 2002), does not deal with typographic aspects of the games.

88. Florian Cramer, "What Is 'Post-digital'?," *APRJA* 3, no. 1, (2014): 15.

89. *Delta User's Manual*, 76.

CHAPTER 5

1. Cristina Alaimo and Jannis Kallinikos, "Encoding the Everyday: The Infrastructural Apparatus of Social Data," in *Big Data Is Not a Monolith: Policies, Practices, and Problems*, ed. Cassidy R. Sugimoto, Hamin R. Ekbia, and Michael Mattioli, 77–90 (Cambridge, MA: MIT Press, 2016); José Van Dijck, Thomas Poell, and Martijn De Waal, *The Platform Society: Public Values in a Connective World* (New York: Oxford University Press, 2018).

2. David Machin and Andrea Mayr, *How to Do Critical Discourse Analysis: A Multimodal Introduction* (Los Angeles: SAGE, 2012); Rodney H. Jones, Alice Chik, and Christoph A. Hafner, *Discourse and Digital Practices: Doing Discourse Analysis in the Digital Age* (London: Routledge, 2015).

3. Jussi Parikka, *What Is Media Archaeology?* (Cambridge: Polity, 2012), 115.

4. Barry Brummett, *Rhetoric in Popular Culture*, 3rd ed. (Thousand Oaks, Calif: SAGE, 2011).

5. George Lakoff and Mark Johnson, *Metaphors We Live By* (Chicago: University of Chicago Press, [1980] 2003); Paul H. Thibodeau and Lera Boroditsky, "Metaphors We Think With: The Role of Metaphor in Reasoning," *PLoS ONE* 6, no. 2 (2011): e16782, https://doi.org/10.1371/journal.pone.0016782.

6. Lakoff and Johnson, *Metaphors We Live By*, 33; Aletta G. Dorst, "Personification in Discourse: Linguistic Forms, Conceptual Structures and Communicative Functions," *Language and Literature* 20, no. 2 (2011): 113–135.

7. Casper van Alfen, "The Most Hated Font of All Time: Comic Sans," *TurnThePage*, issue 21, July 2017, https://medium.com/turnthepage/the-most-hated-font-of-all -time-e400a6f4374a.

8. Kevin Bayliss, "The Saturday Miscellany: How to Write Well: A Defence of Comic Sans; Sam Riviere's Bookshelf," *The Independent*, May 2, 2014. Another typical example is the phrase "Comic Sans, the hapless punching bag of the font world," that occurs in Phil Harrison, Andrew Mueller, and Graeme Virtue, This Week's Best Talks, *The Guardian*, May 9, 2015, https://www.theguardian.com/culture/2015/may/09 /this-weeks-best-talks. The name of the typeface is often preceded by "much" in combination with a negative adjective such as "the much-maligned Comic Sans." See, for instance, Errol Morris Hear, "All Ye People; Hearken, O Earth (Part 1)," *New York Times*, August 8, 2012. Other popular variations of the theme include these: the "much ridiculed font Comic Sans," in Ayesha Hazarika, "It's a Joke . . . Got It?," *Evening Standard*, October 23, 2019; the "much hated Comic Sans#," in Paige Leskin, "'This One Is Ugly and Frankly Hurts My Eyes': People Are Freaking Out about Snapchat's New Logo, and Some Are Even Threatening to Delete the App (SNAP)," *Business Insider*, August 16, 2019; the "much derided Comic Sans," in Cheryl McGregor, "No Style, No Fun and, No Surprise, No Policy," *Newcastle Herald*, March 28, 2011;

the "much-reviled font Comic Sans," in Mark Molloy, "Comic Sans Creator Reveals Bizarre Reason Why Font Was Made," *The Telegraph Online*, March 29, 2017; the "much despised Comic Sans," in Tom Sutcliffe, "How's about That for a Perfect Exit?," *The Independent*, November 11, 2011. Many more examples can be found in Dow Jones's Factiva database.

9. Keith M. Murphy, "Fontroversy! Or, How to Care about the Shape of Language," in *Language and Materiality: Ethnographic and Theoretical Explorations*, ed. Jillian R. Cavanaugh and Shalini Shankar (Cambridge: Cambridge University Press, 2017), 79–80.

10. Times New Roman is one of the most widely used typefaces. It is considered "neutral" by many, but it also is an example of how typefaces always carry certain connotations. Ames Hawkins gives the following reasons for not using Times New Roman: "I avoid Times New Roman because of an embodied rejection of this particular form of masculinity, this legacy of civilization, this assumed superiority of Western thought and accomplishment." Ames Hawkins, "Why I Hate Times New Roman, and Other Confessions of a Creative-Critical Scholar," in *Type Matters: The Rhetoricity of Letterforms*, ed. Christopher Scott Wyatt and Dànielle Nicole DeVoss (Anderson, SC: Parlor Press, 2018), 165.

11. Vincent Connare, http://www.connare.com/whycomic.htm.

12. A podcast about the blame for the ubiquitousness of Comic Sans finishes with this statement: "So, the next time you see Comic Sans in the wild, don't curse the designer or hate the letters, question the executives at Microsoft, who took a typeface completely out of context and unleashed it onto an unassuming type illiterate populace." molly, "Don't Blame Comic Sans," SoundCloud, 2017, https://soundcloud.com/user-23428488/dont-blame-comic-sans.

13. See collections of Comic Sans applications at conicsans, "Anti-Comic Sans Initiative," Instagram, https://www.instagram.com/conicsans, and at Steve Van Velzen, "Comic Sans Used in Real Life Is Something You'll Never Get Use To," The Best Social Media, July 9, 2019, https://www.thebestsocial.media/blog/comic-sans-used-in-real-life-is-something-youll-never-get-used-to.

14. Paul McNeil, *The Visual History of Type* (London: Laurence King Publishing, 2017), 531.

15. Allan Haley, "Typographic Hate Lists: Type That We Love to Hate," *Communication Arts*, March–April 2012, https://www.commarts.com/columns/typographic-hate-lists.

16. Haley, "Typographic Hate Lists."

17. Type Directors Club, *Typography 13: The Annual of the Type Directors Club* (New York: Watson-Guptill, 1992), 110, https://www.dandad.org/awards/professional/1992/direct-mail/27959/art-directors-against-futura-extra-bold-condensed.

18. Email communication with the author, January 22, 2022.

19. Michael Bierut, "I Hate ITC Garamond," *Design Observer*, October 1, 2004, https://designobserver.com/feature/i-hate-itc-garamond/2577.

20. Most comments were made in 2004, when the piece was published, but new comments kept appearing until 2013, which indicates that the article attracted attention for a long time and probably is still read. The *Design Observer* started out as a blog in 2003. According to designer Jarrett Fuller, "The posts were thoughtful and researched and the comments were often just as exciting and as interesting. It was not uncommon for those comments to be as well-written and as long as the posts themselves." Jarrett Fuller, "Culture Is Not Always Popular: 15 Years of (Reading) Design Observer," *Jarrett Fuller* (blog), December 10, 2018, https://www.jarrettfuller .blog/2018/12/culture-is-not-always-popular.

21. Brian Massumi, "The Autonomy of Affect," *Cultural Critique*, no. 31, The Politics of Systems and Environments, pt. 2 (Autumn 1995): 88.

22. Karen Simecek, "Affect Theory," *The Year's Work in Critical and Cultural Theory* 25, no. 1 (2017): 418–435.

23. Massumi, "The Autonomy of Affect," 96.

24. Sam Wong, "The Feeling You Get When Nails Scratch a Blackboard Has a Name," *New Scientist*, February 28, 2017, https://www.newscientist.com/article /2123018-the-feeling-you-get-when-nails-scratch-a-blackboard-has-a-name; Sukhbinder Kumar, Katharina Von Kriegstein, Karl Friston, and Timothy D. Griffiths, "Features versus Feelings: Dissociable Representations of the Acoustic Features and Valence of Aversive Sounds," *Journal of Neurosciences* 32, no. 41 (2012): 14184–14192.

25. Ryan M. Carey and Robert J. Lee, "Taste Receptors in Upper Airway Innate Immunity," *Nutrients* 11, no. 9 (2019).

26. Sensorial engagement with typefaces concerns the whole spectrum of negative to positive affect and emotions (valence). The intricate relationship between taste and typography has been explored by Sarah Hyndman, who has experimented with changing a typeface to make food taste differently. Sarah Hyndman, "Type Tasting as a Forum for Research," *Why Fonts Matter* (London: Virgin, 2016.)

27. Beatrice Warde and Henry Jacob, *The Crystal Goblet: Sixteen Essays on Typography* (London: Sylvan Press, 1955).

28. The original homepage for the "Ban Comic Sans" campaign can be found at "Ban Comic Sans," Wayback Machine, http://web.archive.org/web/20021210154438 /http://bancomicsans.20megsfree.com/index.html.

29. "Use Comic Sans," Facebook, https://www.facebook.com/usecomicsansdotcom; Kings County Productions, AOL, Huffington Post, "Influencers and Innovation— Comic Sans," Vimeo, 2013, https://vimeo.com/76603722?fbclid=IwAR3Cu4KySRxvh -Jmp3ZB0vazh4ZGzAiBWgfMaoXvTqxTLCqt3H_14iY81Vc; Chelsey Gould, "How a Mutual Hate for Comic Sans Brought 2 People Together," *CBC Radio*, October 25, 2019, https://www.cbc.ca/radio/thecurrent/the-current-for-oct-25-2019-1.5335493/how -a-mutual-hate-for-comic-sans-brought-2-people-together-1.5336205.

30. Ban Comic Sans manifesto, http://web.archive.org/web/20021210155638/http:// bancomicsans.20megsfree.com/about.html.

31. Garrett W. Nichols, "Type Reveals Culture: A Defense of Bad Type," in *Type Matters: The Rhetoricity of Letterforms*, ed. Christopher Scott Wyatt and Danielle Nicole DeVoss (Anderson, SC: Parlor Press, 2018), 48.

32. McNeil, *The Visual History of Type*, 531.

33. See, for instance, Patrick Kingsley, "In Defence of the Comic Sans Font," *The Guardian*, June 20, 2010, https://www.theguardian.com/artanddesign/2010/jun/20/in-defence-comic-sans-font; Simon Garfield, *Just My Type: A Book about Fonts* (London: Profile, 2010), 24–28.

34. José Van Dijck, *The Culture of Connectivity: A Critical History of Social Media* (New York: Oxford University Press, 2013), 28.

35. Van Dijck et al., *The Platform Society*, 46.

36. Van Dijck et al., *The Platform Society*, 32.

37. Van Dijck, *The Culture of Connectivity*; Van Dijck et al. *The Platform Society*.

38. Katrin Weller, ed., *Twitter and Society* (New York: Peter Lang, 2014).

39. "Number of Monetizable Daily Active Twitter Users (mDAU) Worldwide from 1st Quarter 2017 to 1st Quarter 2022," Statista, August 3, 2022, https://www.statista.com/statistics/970920/monetizable-daily-active-twitter-users-worldwide.

40. Van Dijck et al., *The Platform Society*, 30–31; "Twitter Trends FAQ," Help Center, Twitter, https://help.twitter.com/en/using-twitter/twitter-trending-faqs.

41. Jason Gay, "LeBron James Gets It; Return to Cleveland Is a Nice Story, but There's No Need for Forgiveness," *Wall Street Journal*, October 30, 2014.

42. NY Neo-Futurists, "Helvetica signs with Miami. Comic Sans stays in Cleveland," Twitter, @nyneofuturists, July 8, 2010, https://twitter.com/nyneofuturists/status/18089184670?s=20.

43. Helvetica was created in Switzerland in 1957 by Eduard Hoffmann and Max Miedinger, and the name of the typeface refers to the Latin name for their country, Helvetia.

44. In an advertising campaign for Swiss Air in 2011, one advertisement read, "Think of us as a nice Helvetica in a world of Comic Sans."

45. Dowd stated, "Folks don't have enough to do. I love the font. It is easy on the eye. In 30 years of use, NO ONE has ever questioned it even in the most serious matters." Brittany Shammas, "Lawyer John Dowd Responded to Impeachment Probe in Comic Sans: Even the Font's Creator Cringed," *Washington Post*, October 10, 2019; Louise McWhinnie, "Beyond Words: How Fonts Make Us Feel," *The Conversation*, October 27, 2013.

46. See, for instance, Patrick Kingsley, "Higgs Boson and Comic Sans: The Perfect Fusion," *The Guardian*, July 4, 2012, https://www.theguardian.com/artanddesign/2012/jul/04/higgs-boson-comic-sans-twitter.

47. For an example of research on the role of humor in digital culture, see Viriya Taecharungroj and Pitchanut Nueangjamnong, "Humour 2.0: Styles and Types of

Humour and Virality of Memes on Facebook," *Journal of Creative Communications* 10, no. 3 (2015): 288–302. The study concludes that "although sarcasm and silliness are the two most prevalent types of humour used in Internet memes, no obvious differences can be observed in the effects of seven types of humour—comparison, personification, exaggeration, pun, sarcasm, silliness and surprise—on virality" (288).

48. According to the *Oxford English Dictionary*, a meme is "An image, video, piece of text, etc., typically humorous in nature, that is copied and spread rapidly by internet users, often with slight variations." See further Limor Shifman, *Memes in Digital Culture* (Cambridge, MA: MIT Press, 2014); Ryan M. Milner, *The World Made Meme: Public Conversations and Participatory Media* (Cambridge, MA: MIT Press, 2016). Know Your Meme is a site that keeps track of and documents memes, and it has an article on Comic Sans. See Ogreenworld, "Comic Sans," Know Your Meme, 2011, updated by andcallmeshirley in 2019, https://knowyourmeme.com/memes/comic-sans.

49. Nick Douglas, "It's Supposed to Look Like Shit: The Internet Ugly Aesthetic," *Journal of Visual Culture* 13, no. 3 (2014): 314.

50. Douglas, "It's Supposed to Look Like Shit," 315

51. Douglas, "It's Supposed to Look Like Shit," 316–317.

52. Bierut, "I Hate ITC Garamond."

53. Sarah Owens, "On the Professional and Everyday Design of Graphic Artefacts," in *Design Culture: Objects and Approaches*, ed. Guy Julier, Anders V. Munch, Mads Nygaard Folkmann, Hans-Christian Jensen, and Nils Peter Skou (London: Bloomsbury Visual Arts, 2019).

54. srturk, "You are the comic sans of humans," message on t-shirts, Red Bubble, https://www.redbubble.com/i/t-shirt/You-are-the-comic-sans-of-humans-by-srturk/33363390.NL9AC.

55. Louise Rose, "#crocs are the comic sans of shoes," Twitter, @lrose1138, September 27, 2018, https://twitter.com/lrose1138/status/1045312226402463745.

56. *Urban Dictionary*, s.v. croc, entry by PisceanPrince, May 30, 2022, https://www.urbandictionary.com/define.php?term=crocs.

57. Elizabeth Nolan Brown, "truly a monster #womensmarch," Twitter, @ENBrown, January 21, 2017, https://twitter.com/ENBrown/status/822853656974426113.

58. woodrow phoenix, "BREXIT IS WORSE THAN COMIC SANS," Twitter, @mrphoenix, March 23, 2019, https://twitter.com/mrphoenix/status/1109477042469388293.

59. Pierre Bourdieu, *Distinction: A Social Critique of the Judgement of Taste*, trans. Richard Nice (Routledge: London, [1979] 1984).

60. Nichols, "Type Reveals Culture," 52–55.

61. Advertisements signal luxury with the help of exclusive locations that are populated by wealthy and successful people who radiate self-confidence. See, for instance, Jae-Eun Kim, Stephen Lloyd, Keji Adebeshin, and Ju-Young M. Kang, "Decoding Fashion Advertising Symbolism in Masstige and Luxury Brands," *Journal of Fashion Marketing and Management* 23, no. 2 (2019): 277–295.

62. Joseph Epstein, "In Bad Taste or Not, I'll Keep My Comic Sans," *Washington Post*, October 25, 2019, https://www.washingtonpost.com/opinions/2019/10/25/i-dont -care-what-others-say-this-is-typeface-me/?arc404=true.

63. Lauren Hudgins, "Hating Comic Sans Is Ableist," *The Establishment* April 15, 2019, https://theestablishment.co/hating-comic-sans-is-ableist-bc4a4de87093/#.vukjzcz1b.

64. Bourdieu, *Distinction*.

65. Nichols, "Type Reveals Culture," 48. One example of the use of the crime meta-phor is the site Comic Sans Criminal by Matt Dempsey, https://www.comicsan scriminal.com. Another example is the blog *Berlin Typography*, which showcases shop signs and other types of vernacular typography seen in the urban landscape of Berlin. It has a "Type Crimes" category where all signs are in Comic Sans, https:// berlintypography.wordpress.com/2017/09/27/type-crimes-part-one.

66. Michael Hanne, "Crime and Disease: Contagion by Metaphor," in *Criminalising Contagion: Legal and Ethical Challenges of Disease Transmission and the Criminal Law*, ed. Catherine Stanton and Hannah Quirk (Cambridge: Cambridge University Press. 2016), 35–54.

67. Comic Sans has been accused of spreading like a virus, being contagious, and infecting websites. One illness reference appears in the video "Comic Sans Must Die," where it is stated that "Over the last two decades, Comic Sans has spread like some sort of sans serif syphilis through poorly thought out stationary." Gabriel Virata Alves, "Comic Sans Must Die—The Feed—SBS2," Vimeo, 2014, https://vimeo .com/108892803. See also Kyle Munzenrieder, "MOCA's Website Infected by Comic Sans in the Name of Art," Miami New Times, March 15, 2010, https://www.miami newtimes.com/arts/mocas-website-infected-by-comic-sans-in-the-name-of-art -6485072; Cory Arcangel, *The Sharper Image*, 2010, https://coryarcangel.com/things -i-made/2010-017-http-wwwmocanomiorg.

68. Stephen J. Flusberg, Teenie Matlock, and Paul H. Thibodeau, "War Metaphors in Public Discourse," *Metaphor and Symbol* 33, no. 1 (2018): 1–18.

69. Frederic W. Goudy, *The Type Speaks* (Philadelphia: Lansten Monotype Machine Company, 1938).

70. Simon Loxley, "Font Wars: A Story on Rivalry between Type Foundries," *Smashing Magazine*, May 14, 2012, https://www.smashingmagazine.com/2012/05/font -wars-story-on-rivalry-between-type-foundries.

71. Garfield, *Just My Type*, 79–82.

72. Vanessa Farquharson, "Typeface of Disgrace: The Font Comic Sans May Just Have to Go," *National Post*, January 28, 2004.

73. NCHProductions, "Sans Fight Animation," YouTube, November 22, 2016, https://www.youtube.com/watch?v=AGjTkFkZo2g&list=RDCMUCCFojyUl6NkLz4 u8RQNVPow&start_radio=1&t=1; "NCHProductions," Know Your Meme, https:// knowyourmeme.com/memes/people/nchproductions.

74. Undertale, https://undertale.com.

75. Scott McCloud, *Understanding Comics: The Invisible Art* (New York: HarperCollins, 1994).

76. Another example of a multimodal Comic Sans joke is the mock computer game *Kill Comic Sans*, a simplified version of a first-person shooter game created by Objective in 2011. In this game parody, the player gains points by shooting the text "Comic Sans" that is moving across the screen of an old, black-and-white TV monitor. *Kill Comic Sans*, Objective, 2021, https://www.objectiveinc.com/kill-comic-sans; Popstar350ofcp, "Kill Comic Sans," YouTube, April 8, 2016, https://www.youtube.com/watch?v=bOwGaZB0cTw.

77. Mark Ratner, "Note to Self: 'Comic Sans,'" cartoon, ColoradoBoulevard.net, March 1, 2020, https://www.coloradoboulevard.net/note-to-self-comic-sans. This "I always use Comic Sans" cartoon can also be found on Instagram at https://www.instagram.com/p/B9Mi--ojt01.

78. Other examples of violence are cartoons where users are being hit for using Comic Sans. See, for instance, "10 Hilarious Comic Sans Meme to Light Up Your Day," *Logo Design Team* (blog), February 6, 2018, https://www.logodesignteam.com/blog/10-hilarious-comic-sans-meme-light-day.

79. This argument is put forward at Karen Kavett DIY, "Comic Sans: What's All the Fuss About?," YouTube, February 20, 2012, https://www.youtube.com/watch?v=ep-K_Xvq2zY.

80. Mike Lacher, "I'm Comic Sans, Asshole," *McSweeney's*, June 15, 2010, https://www.mcsweeneys.net/articles/im-comic-sans-asshole.

81. Mike Lacher, "I'm Comic Sans, Asshole," *Creative Review*, August 2010, 49.

82. The piece was performed by the Jeonju Players in Jeonju, South Korea. See deanjcrawford, "I'm Comic Sans, Asshole. By Mike Lacher *From McSweeney's 'Short Imagined Monologues,'" from *Comic Sans: An Evening of Short Plays*, scene 13, YouTube, December 16, 2014, https://www.youtube.com/watch?v=d87L6MQgCWY.

83. Lacher, "I'm Comic Sans, Asshole."

84. Lacher, "I'm Comic Sans, Asshole."

85. Lacher, "I'm Comic Sans, Asshole."

86. Garfield, *Just My Type*, 298; Stephen Eskilson, *Graphic Design: A New History*, 3rd ed. (New Haven, CT: Yale University Press 2019), 419.

87. Eskilson, *Graphic Design: A New History*, 419.

88. Steven Heller, "The Post-Postmodern Lettering of Daniel Pelavin," *Print*, October 2, 2015, https://www.printmag.com/imprint/the-post-postmodern-lettering-of-daniel-pelavin.

89. Mitch Goldstein, "The Serious Effects of a Comic Typeface," *Communication Arts*, November–December 2015, https://www.commarts.com/columns/the-serious-effects-of-a-comic-typeface.

90. In 2007, when the documentary *Helvetica* appeared, Michael Bierut had similar expectations: "Like many, I have high hopes that this will be the moment that

our field finally breaks through to the general public." Michael Bierut, "Our Little Secret," Design Observer, April 6, 2007, https://designobserver.com/feature/our -little-secret/5367.

91. Arjun Appadurai, *The Social Life of Things: Commodities in Cultural Perspective* (Cambridge: Cambridge University Press, 1986).

92. Marie Hoejlund, "The Emotional Life of Typefaces: An Interview with J-LTF," *The Gradient*, January 15, 2019, https://walkerart.org/magazine/the-emotional-life-of -typefaces-an-interview-with-jungmyng-lee-from-jung-lee-type-foundry.

93. Gunther R. Kress and Theo Van Leeuwen, *Reading Images: The Grammar of Visual Design*, 2nd ed. (London: Routledge, 2006), 116–118.

94. See, for instance, Nick Carson, "5 Traits That Define a Typeface's Personality," Creative Bloq, April 25, 2018, https://www.creativebloq.com/features/5-traits-that -define-a-typefaces-personality; Eva Brumberger, "The Rhetoric of Typography: The Persona of Typeface and Text," *Technical Communication* 50, no. 2 (2003): 206–223. Type designer and researcher Sarah Hyndman describes the typeface Baskerville as "Intellectual, academic, wise" on her blog. Sarah Hyndman, "Happy Birthday Baskerville," *Type Tasting Blog* (blog), January 28, 2016, https://typetastingnews.com /tag/baskerville.

95. Nadine Chahine, "A Type Design Brief: What Is in It, and Why Does It Matter?," *Smashing Magazine*, February 18, 2014, https://www.smashingmagazine.com/2014 /02/a-type-design-brief-arabic-typography-calligraphy.

96. Orana Velarde, "A Visual Guide to the Anatomy of Typography," infographic, Visme, November 30, 2017, https://visme.co/blog/type-anatomy.

97. Rob Carter, Philip B. Meggs, Ben Day, Sandra Maxa, and Mark Sanders, *Typographic Design: Form and Communication*, 6th ed. (Hoboken, NJ: John Wiley, 2014), 31–48.

98. Ellen Lupton, *Thinking with Type: A Critical Guide for Designers, Writers, Editors, & Students* (New York: Princeton Architectural Press, 2004), 15–17; Matt Yow, "Eyes to C, Arms to E: Anthropomorphism in Typography," *Medium*, March 30, 2017, https://medium.com/s/about-face/eyes-to-c-arms-to-e-a034793cbf49.

99. Lakoff and Johnson, *Metaphors We Live By*, 34.

100. Jean Paul Simon, "User Generated Content—Users, Community of Users and Firms: Toward New Sources of Co-innovation?," *Info* 18, no. 6 (2016): 4–25.

101. Van Dijck, *The Culture of Connectivity*, 35.

102. Tony Seddon, *Thou Shall Not Use Comic Sans* (Sydney, Australia: University of New South Wales Press, 2012), 14.

103. "Can Comic Sans Have a Positive Effect on Society?," Bēhance, https://www .behance.net/gallery/28726337/Comic-Sans-For-Cancer-Campaign-Exhibition.

104. On the use of metaphors in the Brexit discourse, see Andreas Musolff, "Metaphor, Irony and Sarcasm in Public Discourse," *Journal of Pragmatics* 109 (2017): 95–104.

105. Jim Waterson, "Tories Hire Facebook Propaganda Pair to Run Online Election Campaign," *The Guardian*, October 23, 2019, https://www.theguardian.com/politics /2019/oct/23/tories-hire-facebook-propaganda-pair-to-run-online-election-campaign.

106. Mia Consalvo and Dan Staines, "Reading Ren'Py: Game Engine Affordances and Design Possibilities," *Games and Culture* 16, no. 6 (2021): 762–778.

CHAPTER 6

1. Alessandro Ludovico, *Post-Digital Print: The Mutation of Publishing since 1894* (Eindhoven, Netherlands: Ononatopee, 2012), 153–156.

2. Gary Hustwit, dir., *Helvetica*, 2007.

3. Stephen Coles, "War Memorial in Geffen, NL," Fonts in Use, October 23, 2012, https://fontsinuse.com/uses/2274/war-memorial-in-geffen-nl.

4. Mike Lacher, "I'm Comic Sans, Asshole," *McSweeney's*, June 15, 2010, https://www.mcsweeneys.net/articles/im-comic-sans-asshole.

5. NCHProductions, "Sans Fight Animation," YouTube, November 22, 2016, https://www.youtube.com/watch?v=AGjTkFkZo2g&list=RDCMUCCFojyUl6NkLz4u8RQNV Pow&start_radio=1&t=1.

6. In Priska Falin et al., "Practitioners' Experience in Clay 3D Printing," *FormAkademisk* 14, no. 2 (2021), the printing process is likened to a musical performance, in that it follows a code that corresponds to a score.

7. CuriousMarc, "The IBM 1401Mainframe Runs 'Edith,'" YouTube, June 2, 2018 https://www.youtube.com/watch?v=LtlrITxB5qg&t=19s.

8. Tech Tangents, "Fix Dot Matrix Printer Stuck Pin—Micro Tangent," YouTube, March 18, 2020, https://www.youtube.com/watch?v=Wxz82Yv40GY.

9. Michael Backes, Markus Dürmuth, Sebastian Gerling, Manfred Pinkal, and Caroline Sporleder, "Acoustic Side-Channel Attacks on Printers," *Proceedings of the 19th USENIX Security Symposium, August 11–13, 2010, Washington, DC* (Berkeley, CA: USENIX Association, 2010), 307.

10. Thomas McIntosh and Emmanuel Madan [The User], *Symphony for Dot Matrix Printers*, [The User], http://www.theuser.org/dotmatrix/en/intro.html.

11. MIDI Desaster, "Rocky's Printer—Eye of the Tiger on a Dot Matrix Printer [HD]," YouTube, February 15, 2014, https://www.youtube.com/watch?v=u8I6qt_Z0Cg.

12. Paul Atkinson, "Opera and the Embodiment of Performance," in *Body/Embodiment: Symbolic Interaction and the Sociology of the Body*, ed. Dennis D. Waskul and Phillip Vannini (London: Routledge, 2016), 95–108.

13. Epson MX Printer Manual, GraftraxPlus (San Diego: CompuSoft, 1982); "Birth of a Legend," advertisement for Epson, *Byte*, August 1982, 396–397.

14. On the ethos of DIY and making graphic design accessible to the general public, see Ellen Lupton and Kimberly Bost, *D.I.Y.: Design It Yourself* (New York: Princeton Architectural Press, 2006).

15. Emit Snake-Beings, "Maker Culture and DIY Technologies: Re-functioning as a Techno-Animist Practice," *Continuum* 32, no. 2 (2018): 121–136; Deborah A. Fields, Alecia Marie Magnifico, Jayne C. Lammers, and Jen Scott Curwood, "DIY Media Creation," *Journal of Adolescent & Adult Literacy* 58, no. 1 (2014): 19–24.

16. José Van Dijck, *The Culture of Connectivity: A Critical History of Social Media* (New York: Oxford University Press, 2013), 35.

17. Garnet Hertz and Jussi Parikka, "Zombie Media: Circuit Bending Media Archaeology into an Art Method," *Leonardo* 45, no. 5 (2012): 424–430.

18. Pawel Zadrożniak, "The Floppotron," YouTube, July 6, 2016, https://www.you tube.com/watch?v=Oym7B7YidKs.

INDEX